THE BEST OF
BROCHURE DESIGN II

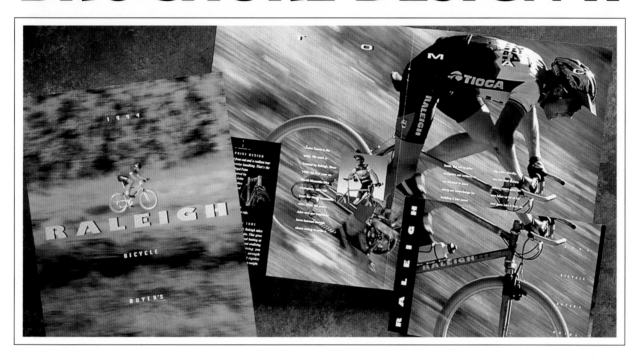

Designer/Production **Sara Day Graphic Design**
Production Manager **Barbara States**
Production Assistant **Pat O'Maley**
Additional Photography **Kevin Thomas Photography**
Cover Photograph **Howard Ash Photography**

First published in the United States of America by:
Rockport Publishers, Inc.
146 Granite Street
Rockport, Massachusetts 01966
Telephone: (508) 546-9590
Fax: (508) 546-7141
Telex: 5106019284 ROCKORT PUB

Distributed to the book trade and art trade in
the U.S. and Canada by:
North Light, an imprint of
F & W Publications
1507 Dana Avenue
Cincinnati, Ohio 45207
Telephone: (513) 531-2222

Other Distribution by:
Rockport Publishers, Inc.
Rockport, Massachusetts 01966

ISBN 56496-092-7

10 9 8 7 6 5 4 3 2 1

Printed in Hong Kong

THE BEST OF
BROCHURE DESIGN II

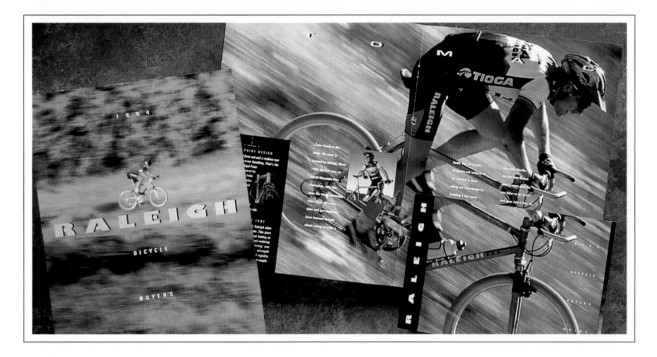

ROCKPORT PUBLISHERS, ROCKPORT, MASSACHUSETTS
DISTRIBUTED BY
NORTH LIGHT BOOKS, CINCINNATI, OHIO

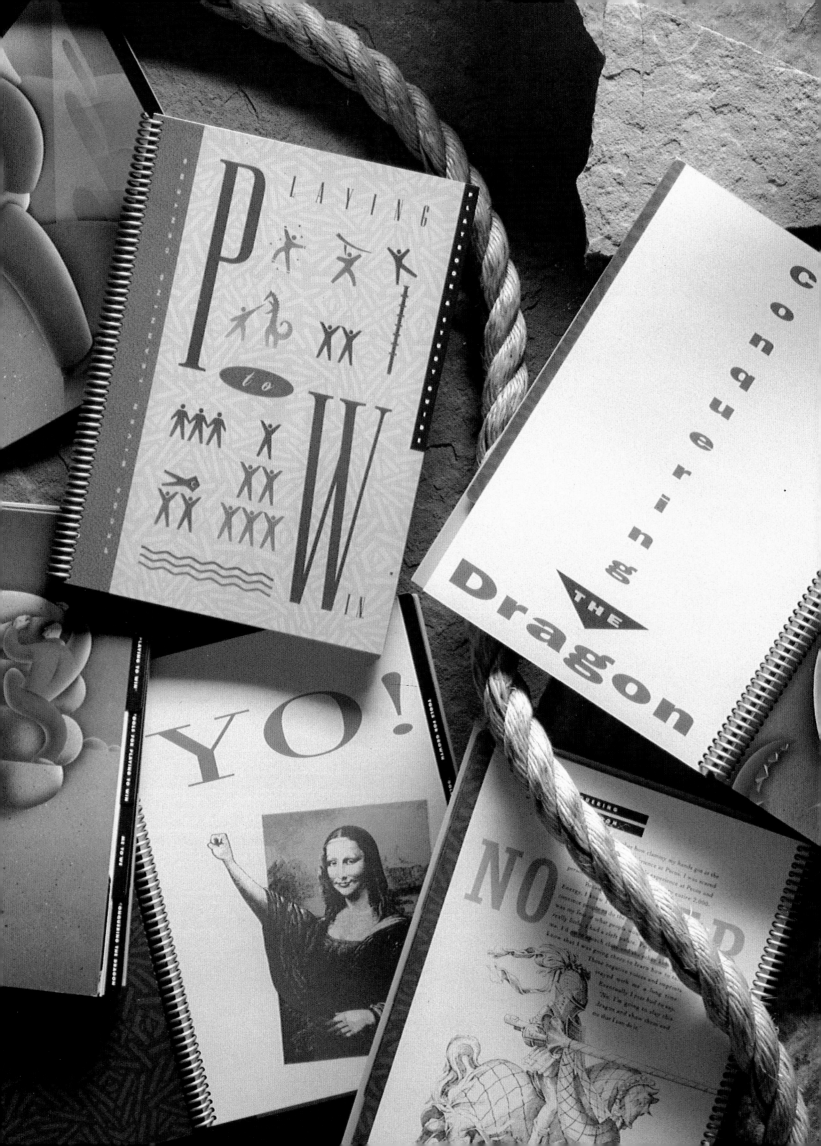

CONTENTS

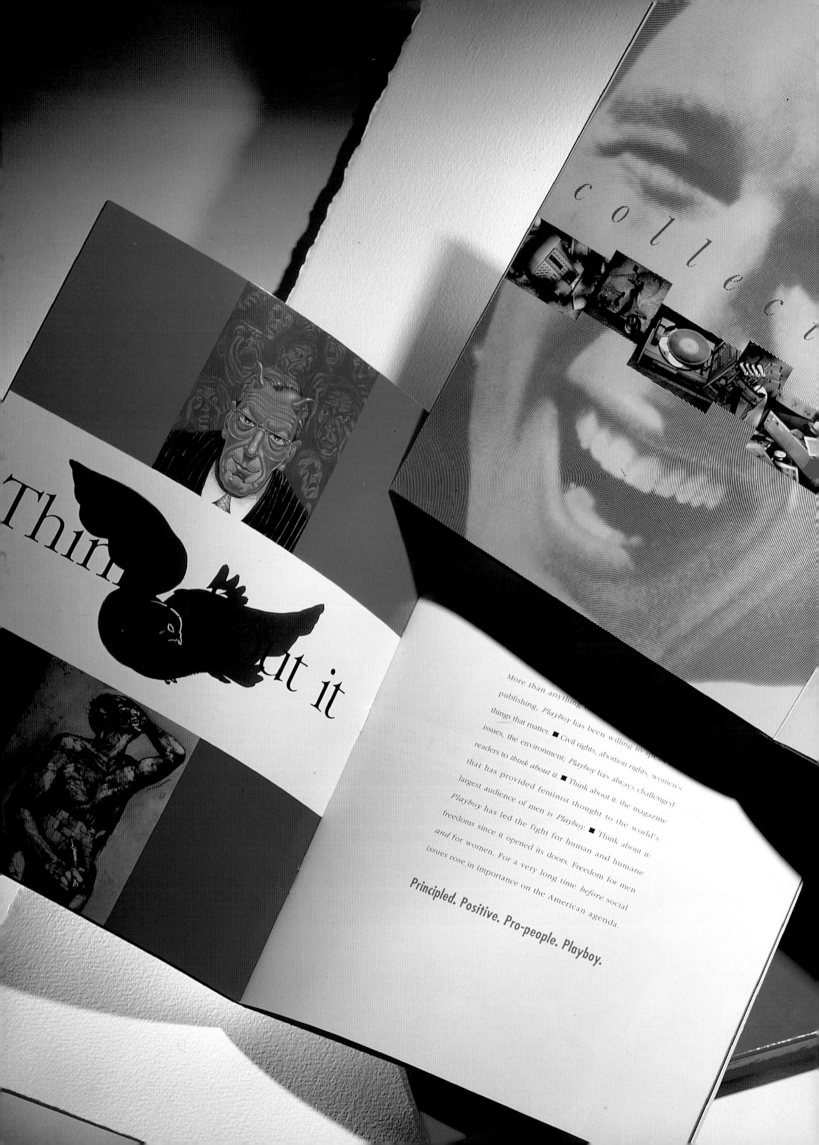

Thin... ...ut it

More than anything ...
publishing, *Playboy* has been willing to spe...
things that matter. ■ Civil rights, abortion rights, women's
issues, the environment; *Playboy* has always challenged
readers to *think about it. Playboy* has always challenged
that has provided feminist thought to the world's
largest audience of men is *Playboy*. ■ Think about it:
Playboy has led the fight for human and humane
freedoms since it opened its doors. Freedom for men
and for women. For a very long time *before* social
issues rose in importance on the American agenda.

Principled. Positive. Pro-people. Playboy.

INTRODUCTION

Last month my wife and I decided to take a cruise to Alaska. A trip to the travel agent yielded a lofty pile of those infamous 8 $\frac{1}{2}$ x 11 saddle-stitched collections of words and pictures which we commonly refer to as the "brochure." In a perfect world, you know...the one with 72 hours in a day, I wouldn't need a brochure. I'd be able to choose my cruise with a little first-hand experience. I'd visit corporate headquarters, have a little chat with the president of each cruise line. Following a tour of each ship, a quick perusal of each menu, and few sample meals, I'd know which cruise line would be most likely to expand my waste-line. A short inspection of the rooms would not only give me a better idea which ship I'd be most comfortable on, but which type of room I should choose. Who has the friendliest, most helpful, most informed crew? I'd spend a little time with each of them. And I'd finish my research with a little checkout of some of the people on board. As you can see I like to make informed decisions about everything, an annoying trait. But all I've got to go on is these brochures. I've got to plunk down way too much of my hard-earned cash based on what's inside 48 pages of 80-pound enamel.

When designing a brochure, or any piece of printed communications for that matter, we must have in the forefront of our minds a clear picture of where this brochure is going to be six months from now. Two thousand miles away some poor soul is going to have to make an informed decision based on the efforts put forward in our brochure design. Works, pictures, typestyles, colors, and arrangements will all combine to influence some interested reader somewhere down the line. I know this sounds terribly obvious but sometimes designers caught up in a flurry of considerations lose sight of that. Deadline pressures, budget restrictions, and personal preferences on the part of the designer or the client can have a detrimental influence on our decisions. We forget that we are creating the ultimate surrogate. Like it or not, the brochure is the stand-in for the real thing. This design stuff...it's pretty serious. Design is powerful. What things look like reflect the tangibles as well as the intangibles. And strangely enough, truth has a way of leaking out.

So, when I have a brochure in my hand I look past the obvious; I read between the lines, so to speak. As a designer, I believe I'm conscious of this where many people might not be. Nonetheless all elements are working hard to influence as well as to inform. Design is a reflection of reality. Critics will argue otherwise saying we create illusion. We don't. The truth leaks out. The best product usually has the best brochure. At least I hope that's true. We picked the cruise with the nicest brochure.

—Steve Wedeen
Vaughn Wedeen Creative Inc.
Albuquerque, New Mexico

ADDITIONAL PRODUCT
INFORMATION

HOW TO SEL
RIGHT MORT

ADJUSTABLE
[ARM]
The main advanta
easier to qualify a
amount. You get a
plus a choice of n

An Adjustable-R
If You:
■ Need or want r
afford with a fixe
■ Feel that interes
decrease during
■ Think that your
anging, and pos
plan to own you

XED-RATE
primary advar
is its predicta
st payments

d-Rate Loa
t the certain
t over the
n a fixed c
that interes
term
stay in y

A MO
ive you
th a lo
vide fi
little

PROVIDES AN
OVERVIEW OF
OVER 50 BANK
PRODUCTS AND
SERVICES TO
MEET YOUR
FINANCIAL
DEMANDS

SECURITY PACIFIC BANK
WASHINGTON

INCLUDES
HELPFUL
CHARTS AND
SIMPLIFIED
WORKSHEETS
TO MAKE
BANKING
EASIER

ECURITY PACIFIC BANK
WASHINGTON

BETTER BANKING
FROM SECURITY
PACIFIC BANK
WASHINGTON

INSTITUTIONAL

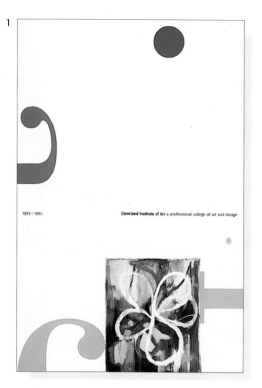

Cleveland Institute of Art a professional college of art and design

1993–1994

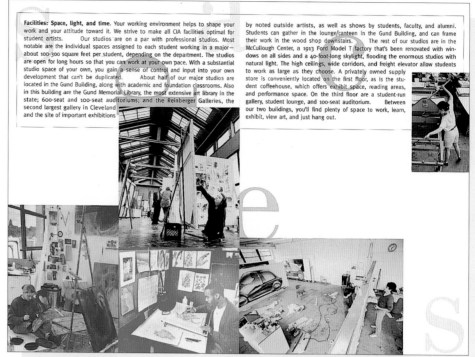

Facilities: Space, light, and time. Your working environment helps to shape your work and your attitude toward it. We strive to make all CIA facilities optimal for student artists. Our studios are on a par with professional studios. Most notable are the individual spaces assigned to each student working in a major— about 100–300 square feet per student, depending on the department. The studios are open for long hours so that you can work at your own pace. With a substantial studio space of your own, you gain a sense of control and input into your own development that can't be duplicated. About half of our major studios are located in the Gund Building, along with academic and foundation classrooms. Also in this building are the Gund Memorial Library, the most extensive art library in the state; 600-seat and 100-seat auditoriums; and the Reinberger Galleries, the second largest gallery in Cleveland and the site of important exhibitions

by noted outside artists, as well as shows by students, faculty, and alumni. Students can gather in the lounge/canteen in the Gund Building, and can frame their work in the wood shop downstairs. The rest of our studios are in the McCullough Center, a 1913 Ford Model T factory that's been renovated with windows on all sides and a 40-foot-long skylight, flooding the enormous studios with natural light. The high ceilings, wide corridors, and freight elevator allow students to work as large as they choose. A privately owned supply store is conveniently located on the first floor, as is the student coffeehouse, which offers exhibit space, reading areas, and performance space. On the third floor are a student-run gallery, student lounge, and 100-seat auditorium. Between our two buildings, you'll find plenty of space to work, learn, exhibit, view art, and just hang out.

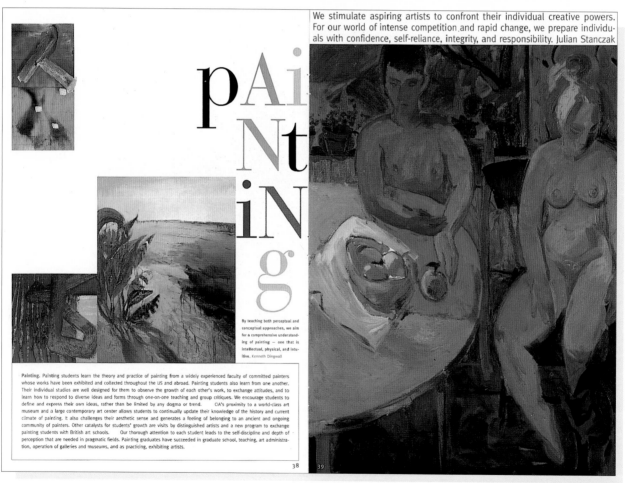

We stimulate aspiring artists to confront their individual creative powers. For our world of intense competition and rapid change, we prepare individuals with confidence, self-reliance, integrity, and responsibility. Julian Stanczak

pAiNtiNg

By teaching both perceptual and conceptual approaches, we aim for a comprehensive understanding of painting — one that is intellectual, physical, and intuitive. Kenneth Dingwall

Painting. Painting students learn the theory and practice of painting from a widely experienced faculty of committed painters whose works have been exhibited and collected throughout the US and abroad. Painting students also learn from one another. Their individual studios are well designed for them to observe the growth of each other's work, to exchange attitudes, and to learn how to respond to diverse ideas and forms through one-on-one teaching and group critiques. We encourage students to define and express their own ideas, rather than be limited by any dogma or trend. CIA's proximity to a world-class art museum and a large contemporary art center allows students to continually update their knowledge of the history and current climate of painting. It also challenges their aesthetic sense and generates a feeling of belonging to an ancient and ongoing community of painters. Other catalysts for students' growth are visits by distinguished artists and a new program to exchange painting students with British art schools. Our thorough attention to each student leads to the self-discipline and depth of perception that are needed in pragmatic fields. Painting graduates have succeeded in graduate school, teaching, art administration, operation of galleries and museums, and as practicing, exhibiting artists.

38 39

1
Design Firm, **Nesnadny & Schwartz**
Art Director, **Joyce Nesnadny/Mark Schwartz**
Designer, **Joyce Nesnadny/Brian Lavy**
Photographer, **Robert Muller/Mark Schwartz**
Copywriter, **Anne Brooks Ranallo**
Client, **Cleveland Institute of Art**
Printing, 6-color, SD Warren Lustro Dull Recycled 100
 lb. (cover), SD Warren Lustro Dull Recycled 80 lb.
 (text), Gilbert Gilclear Medium Vellum (flysheets)

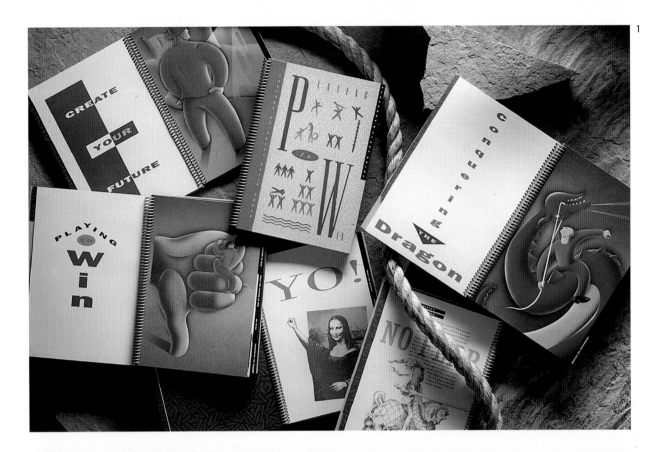

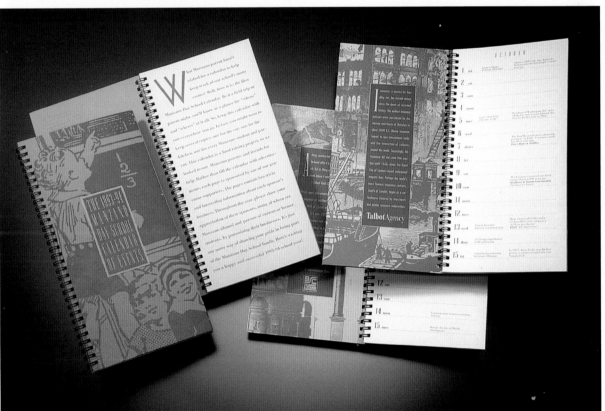

1
Design Firm, **Vaughn Wedeen Creative**
Art Director, **Rick Vaughn**
Designer, **Rick Vaughn**
Illustrators, **Jeff Koegel/Rick Vaughn**
Client, **Pecos River Learning Center**
Printing, Cougar White Vellum (cover), Simpson
 Evergreen Almond (text)

2
Design Firm, **Vaughn Wedeen Creative**
Art Director, **Steve Wedeen**
Designer, **Steve Wedeen**
Illustrators, **Vivian Harder/Stan McCoy**
Copywriter, **Nathan James**
Client, **Manzano Day School**
Printing, 2-color on Fox River Confetti and French
 Durotone Newsprint

1

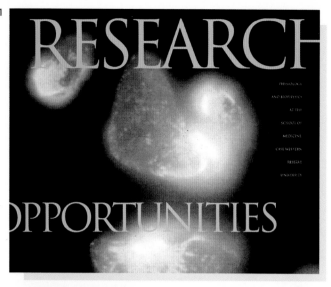

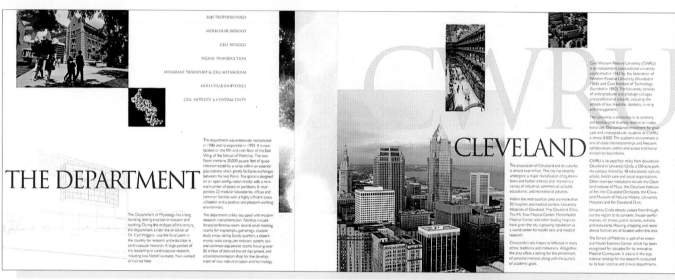

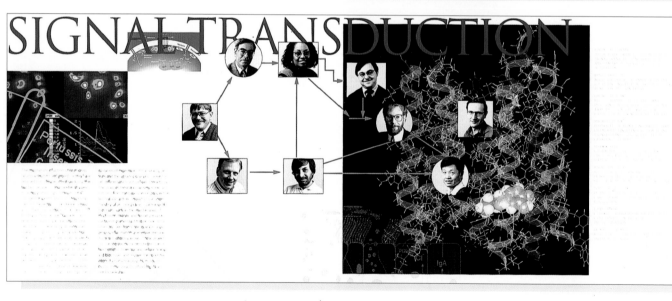

1
Design Firm, **Nesnadny & Schwartz**
Art Director, **Mark Schwartz/Sheila Hart**
Designer, **Sheila Hart/Brian Lavy**
Illustrator, **Sheila Hart**
Photographer, **Mark Schwartz/Stock Photography**
Copywriter, **Case Western Reserve University
 School of Medicine**
Client, **Case Western Reserve University School
 of Medicine**
Printing, 4-color on SD Warren Lustro Dull 100 lb.

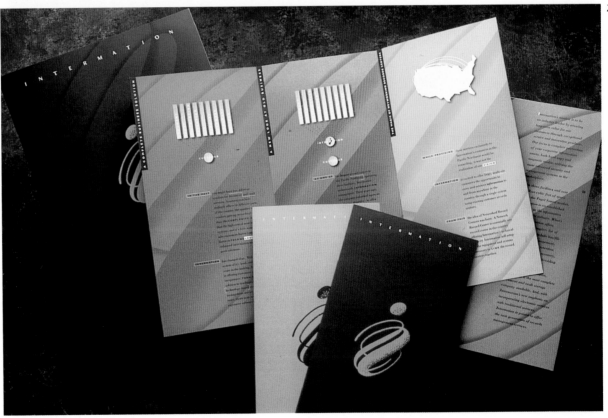

1
Design Firm, **Hornall Anderson Design Works**
Art Director, **Jack Anderson**
Designer, **Jack Anderson/Heidi Hatlestad/Bruce
 Branson-Meyer**
Photographer, **Tom Collicott**
Copywriter, **Pamela Bond**
Client, **Six Sigma**
Printing, 4-color on Quintessence Remarque,
 White Gloss

2
Design Firm, **Hornall Anderson Design Works**
Art Director, **Jack Anderson**
Designers, **Jack Anderson/Leo Raymundo**
Illustrator, **Leo Raymundo**
Copywriter, **Bill Rozier**
Client, **Intermation**
Printing, 2-color plus black outside, 1-color inside
 on Gilbert Esse Smooth White Cover (folder), 6-
 color over 6-color on Monadnoch Smooth
 Bright White Cover (brochure)

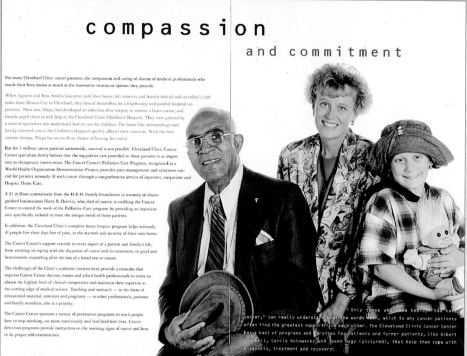

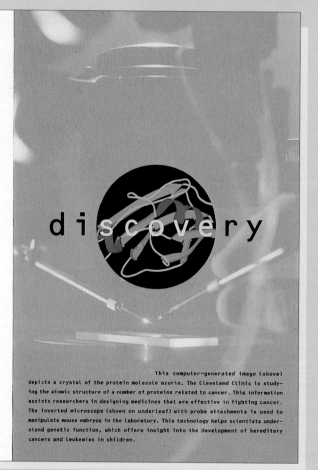

1
Design Firm, **Nesnadny & Schwartz**
Art Director, **Tim Lachina/Michelle Moehler**
Designer, **Tim Lachina/Michelle Moehler**
Photographer, **Tony Festa**
Copywriter, **Sue Omori**
Client, **Cleveland Clinic Foundation**
Printing, 6-color on Loe Dull Recycled, Zanders
 T-2000 Vellum

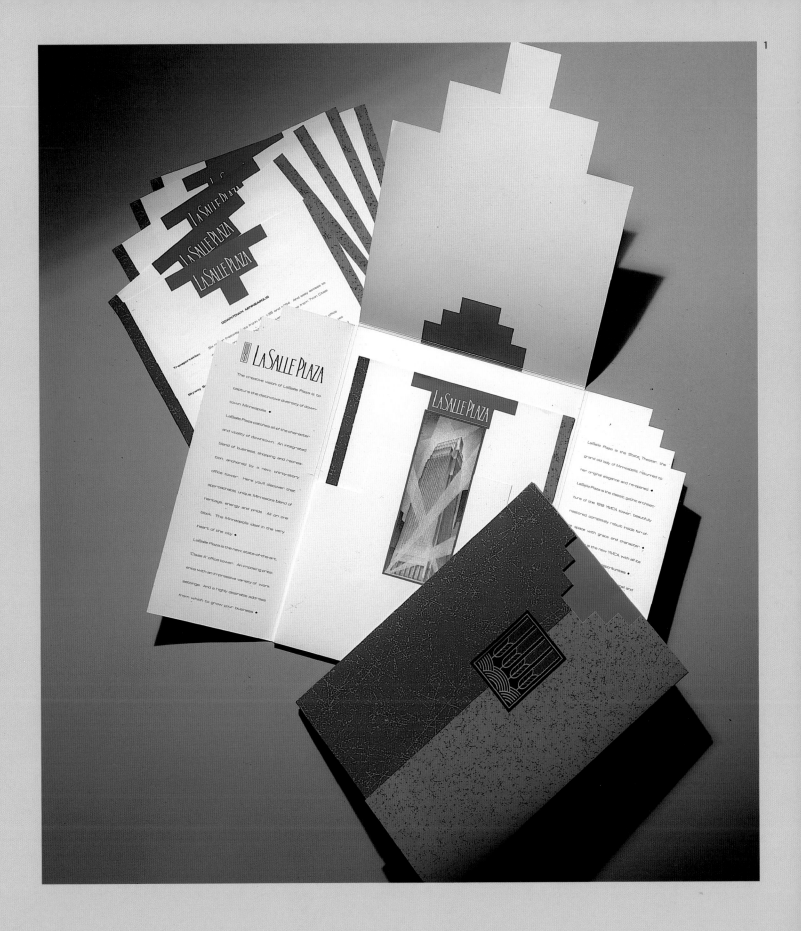

1
Design Firm, **Carmichael Lynch**
Art Director, **Peter Winecke**
Designer, **Peter Winecke**
Illustrator, **Mark Herman**
Copywriter, **John Neumann**
Client, **LaSalle Plaza**
Printing, 4-color

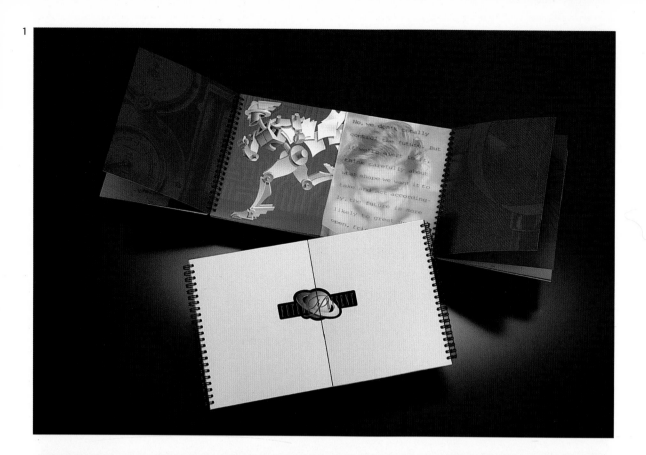

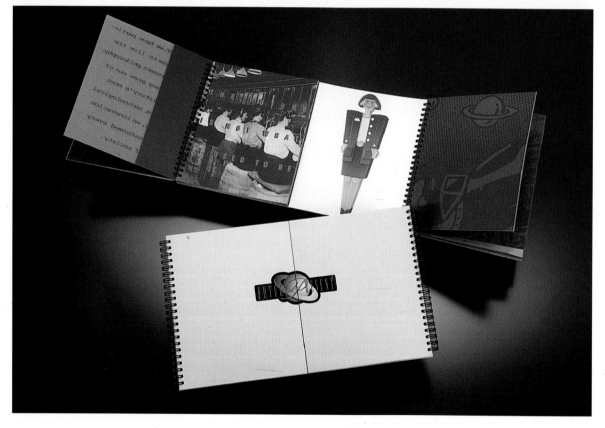

1
Design Firm, **Vaughn Wedeen Creative**
Art Directors, **Steve Wedeen/Rick Vaughn**
Designer, **Steve Wedeen**
Illustrators, **D. Tillinghast/D. Jonason**
Copywriters, **Nathan James/Richard Kuhn/**
 Steve Wedeen
Client, **US West Communications**
Printing, Gilbert Esse White Smooth Cover, Matte
 Calendered Rigid Clear Vinyl

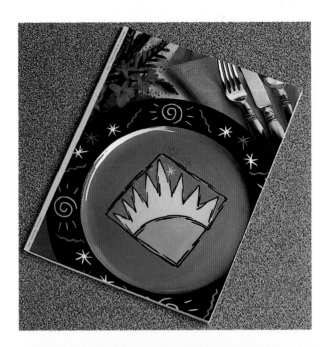

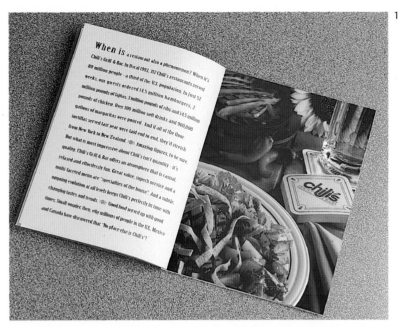

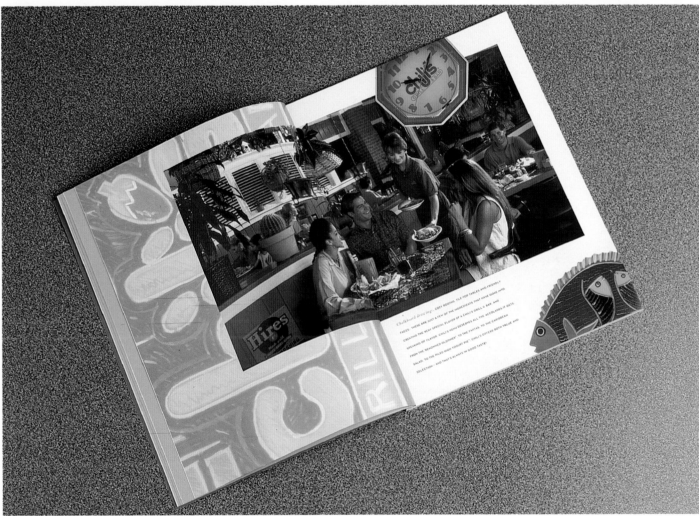

1
Design Firm, **Joseph Rattan Design**
Art Director, **Joe Rattan**
Designer, **Joe Rattan/Greg Morgan**
Photographer, **Stewart Cohen**
Copywriter, **Mary Langridge**
Client, **Brinker International**
Printing, 4-color, 3 PMS consolidated, Reflections
 and Simpson Quest and Equinox

1
Design Firm, **Modern Dog**
Art Director, **Michael Strassburger/Robynne Raye**
Designer, **Michael Strassburger/Robynne Raye**
Illustrator, **Robynne Raye**
Copywriter, **Mark Bocek**
Client, **Seattle Repertory Theatre**
Printing, Chipboard, Simpson Starwhite Vicksburg
 and Gainsborough, hand-glued

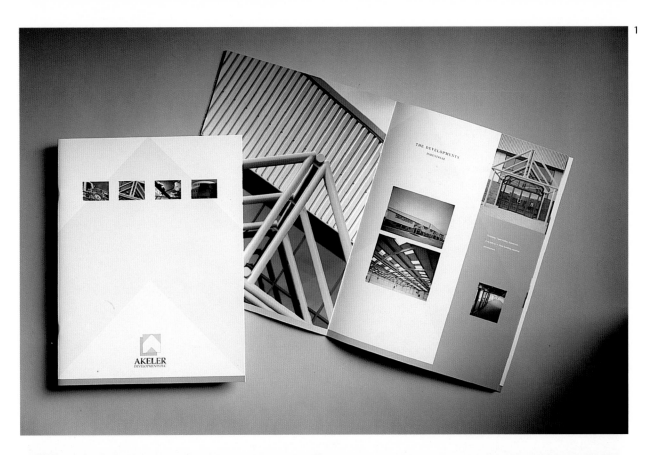

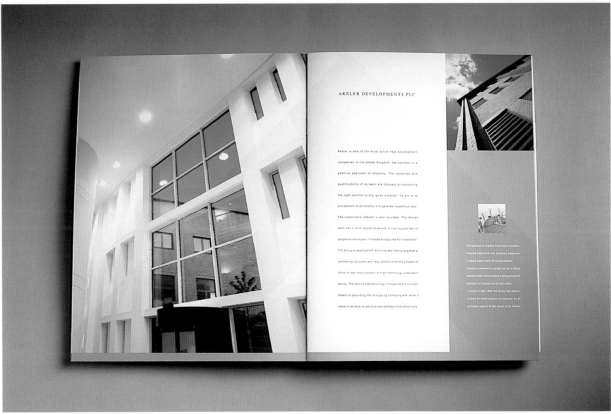

Design Firm, **Yellow M**
Art Director, **Craig Falconer**
Designer, **Craig Falconer**
Photographer, **Eric Murphy**
Client, **Akeler Developments PLC**
Printing, 4-color, spot varnish, Chevron on every page

1
Design Firm, **Lee Reedy Design Associates, Inc.**
Art Director, **Lee Reedy**
Designer, **Lee Reedy**
Illustrators, **Lee Reedy**
Copywriter, **AWWA**
Client, **AWWA**
Printing, 2-color

2
Design Firm, **Yellow M**
Art Director, **Simon Cunningham**
Designer, **Simon Cunningham**
Illustrator, **Ian Millen**
Client, **Newcastle Protection & Indemnity**
Printing, 4-color

All illustrations are Mac-generated.

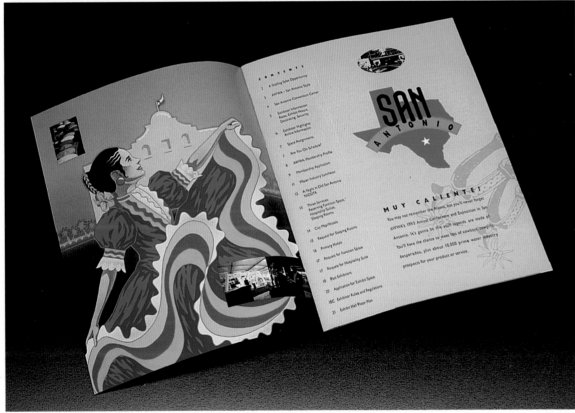

1
Design Firm, **Lee Reedy Design Associates, Inc.**
Art Director, **Lee Reedy**
Designer, **Lee Reedy**
Photographer, **Brad Bartholomew (cover)**
Copywriter, **John Kaiser**
Client, **American Water Works Association**
Printing, 4-color

1

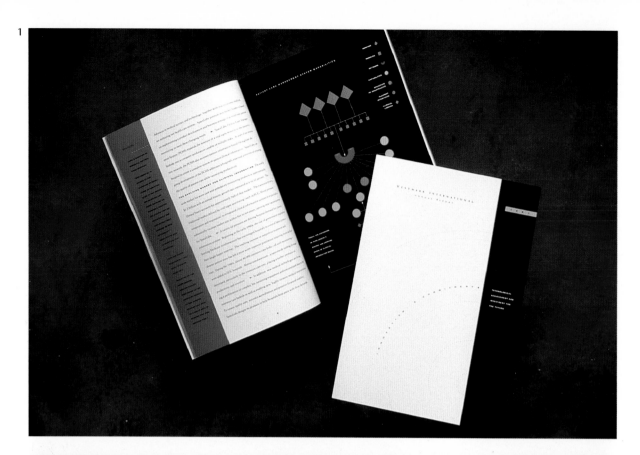

2

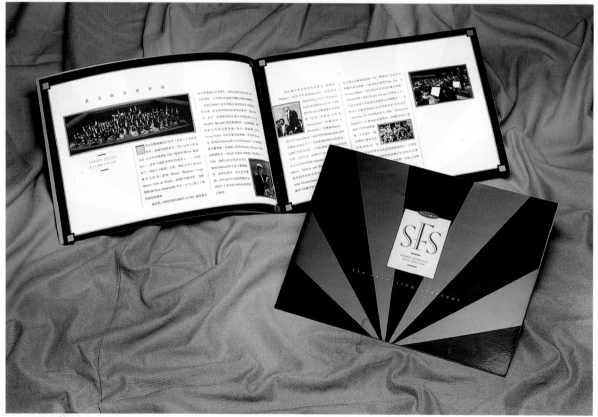

1
Design Firm, **Hornall Anderson Design Works**
Art Director, **John Hornall**
Designer, **John Hornall/Julia LaPine/Mary Hermes/ Brian O'Neill**
Photographer, **Alan Abramowitz**
Copywriter, **Anne Bugge**
Client, **Westmark International**
Printing, 4-color over 4-color on Reflections Gloss Cover White, 6-color over 6-color on Reflections Gloss Text White

2
Design Firm, **Leslie Chan Design Co., Ltd.**
Art Director, **Leslie Chang Wing Kei**
Designer, **Leslie Chan Wing Kei/Tong Song Wei**
Client, **Orient Express Container Group**
Printing, 4-color, foil stamped, two PMS colors on Neenah Artone Paper

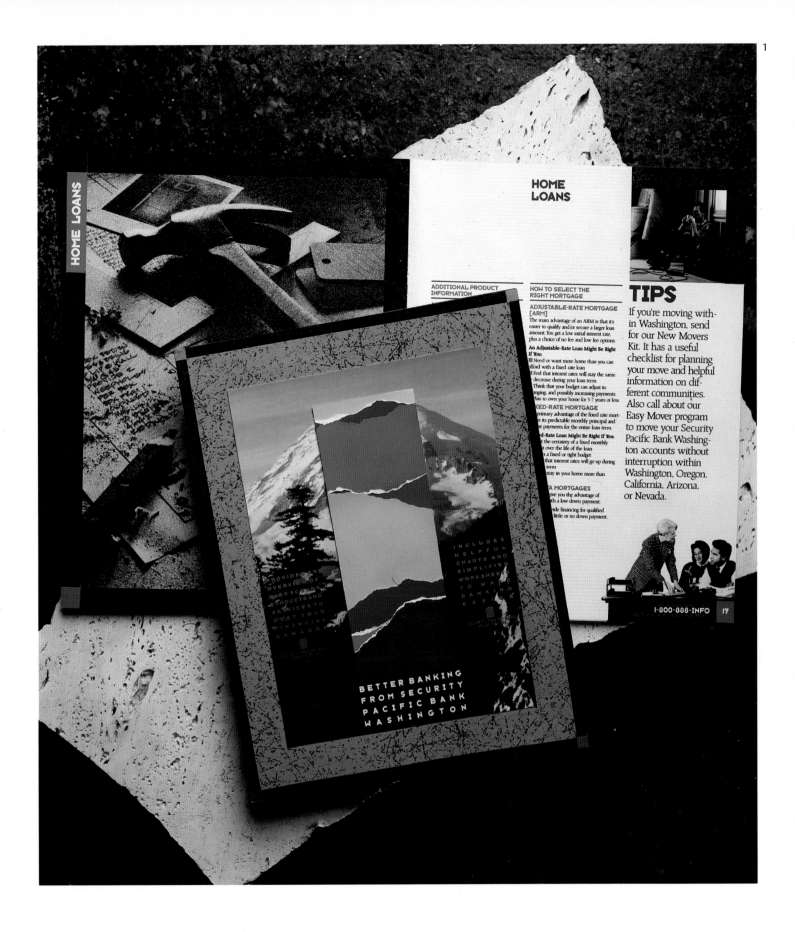

1
Design Firm, **Carmichael Lynch**
Art Director, **Peter Winecke**
Designer, **Peter Winecke**
Photographer, **John Lehn**
Copywriter, **John Neuman**
Client, **Rainier Bank**
Printing, 4-color, 24 pages

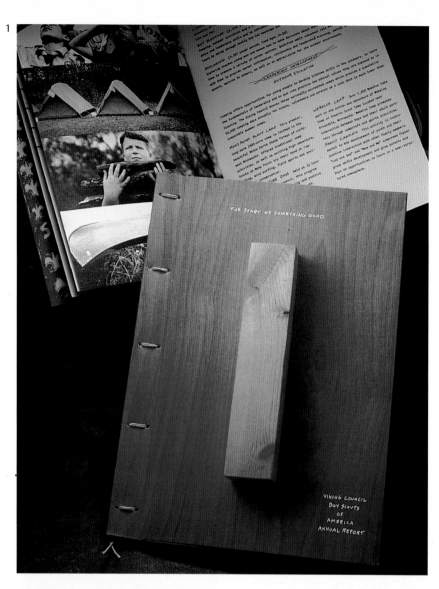

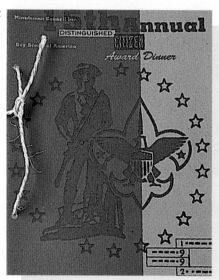

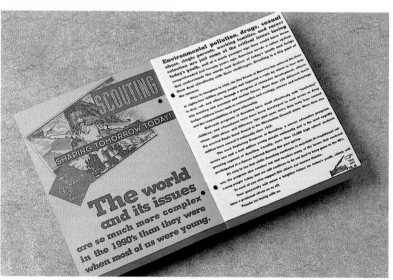

1
Design Firm, **Olson Johnson Design Co.**
Designer, **Dan Olson**
Illustrator, **Haley Johnson**
Photographer, **Paul Irmitek**
Copywriter, **Jon Anderson**
Client, **Boy Scouts of America, Viking Council**
Printing, 6-color on Benefit Soft White hand
 bound by volunteers

2
Design Firm, **Marc English: Design**
Designer, **Marc English**
Copywriter, **David Adams**
Client, **Middlesex Council, Boy Scouts
 of America**
Printing, 2 match colors, Simpson Quest, Bronze,
 Moss, Ivory

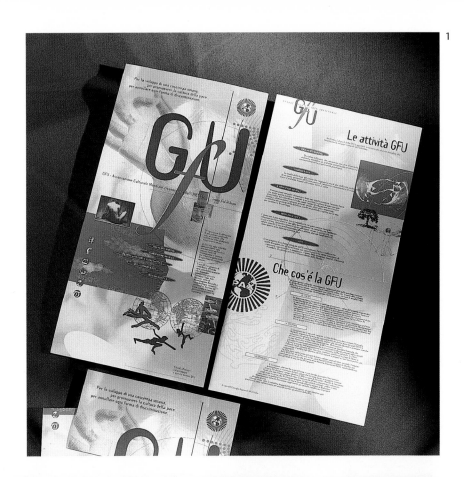

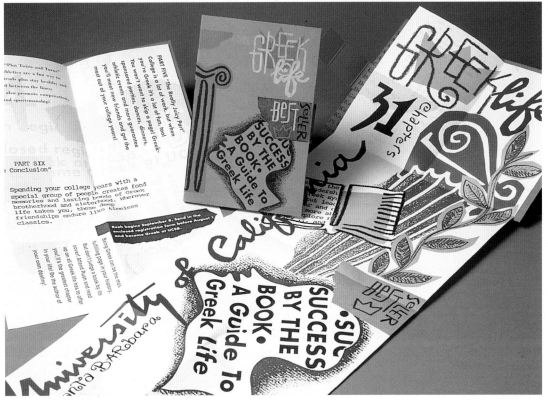

1
Design Firm, **Metalli Lindberg Advertising**
Art Director, **Stefano Dal Tin/Lionello Borean**
Designer, **Stefano Dal Tin/Lionello Borean**
Client, **GFU Italia (cultural association)**
Printing, 2-color on Fedrigoni paper

2
Design Firm, **Sayles Graphic Design**
Art Director, **John Sayles**
Designer, **John Sayles**
Illustrator, **John Sayles**
Copywriter, **Wendy Lyons**
Client, **University of California, Santa Barbara**
Printing 4-color plus varnish on Hopper Cardigan
 (text) Chipboard

*A combination brochure and poster, this multilayered
mailing arrives in a chipboard "book jacket." As the
piece is read, it unfolds to reveal a poster and the
"Success By The Book" name.*

1

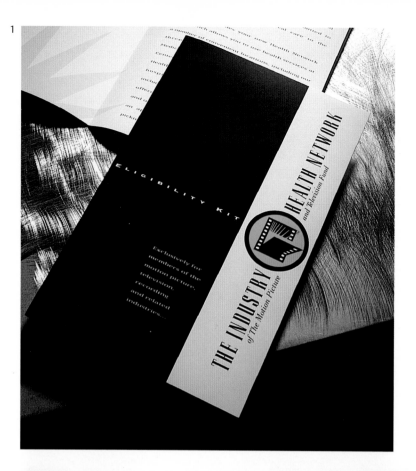

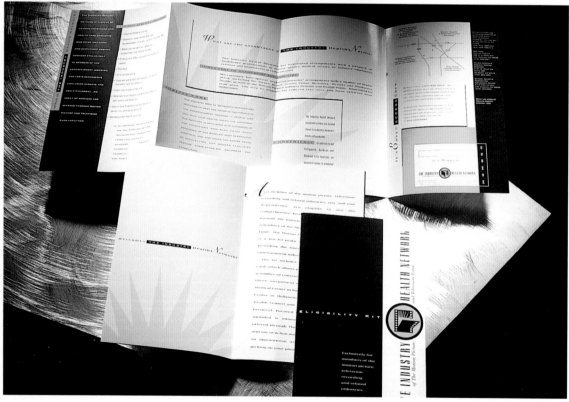

1
Design Firm, **Vrontikis Design Office**
Art Director, **Petrula Vrontikis**
Designer, **Petrula Vrontikis**
Client, **Motion Picture & Television Fund, The**
 Industry Health Network
Printing, 2-color on Vintage Velvet

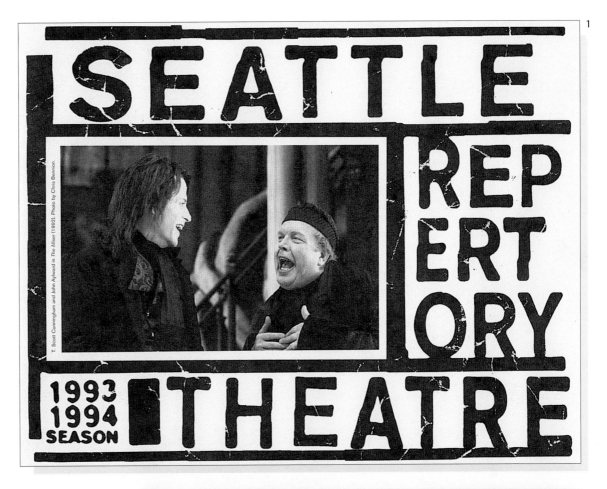

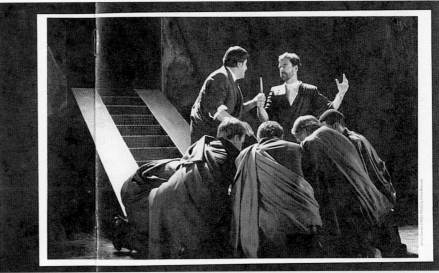

For 30 years now, this remarkable region has vigorously supported a continuous celebration of the human imagination. It's called the Seattle Rep.

At The Rep, we believe that the theatre is one language with an infinite number of dialects. We do work that is diverse and daring. We approach classics with a spirit of discovery normally associated with world premieres. We present new plays with the exciting awareness that each one is a potential classic.

But great theatre is only possible with a great audience, a vital and curious group of people interested in exploring their own lives and the life of the world around them, people eager to be surprised, delighted and challenged by the great plays of our time and of all time.

Take your place in just such a group: the audience of the Seattle Repertory Theatre.

1
Design Firm, **Modern Dog**
Art Director, **Michael Strassburger**
Designer, **Michael Strassburger**
Photographer, **Chris Bennion**
Client, **Seattle Repertory Theatre**
Printing, 4-color on French Durotone Butcher Off-White

1

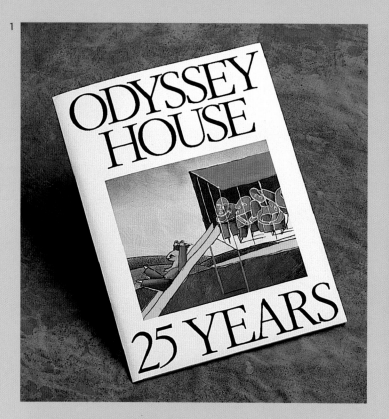

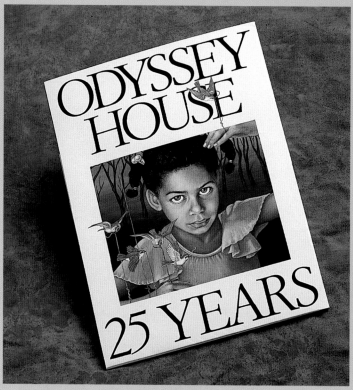

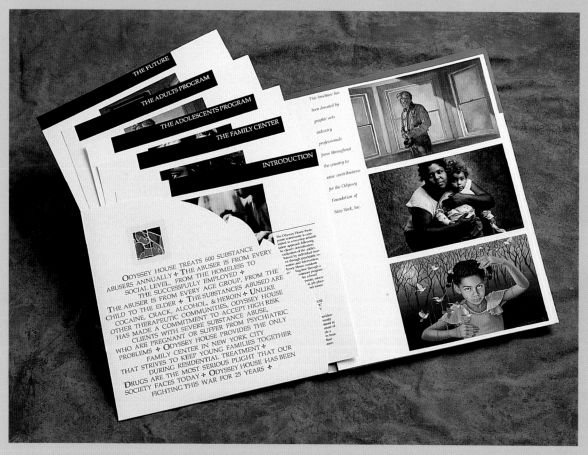

1

Design Firm, **Metroplois Corp.**
Art Director, **Denise Davis Mendelsohn**
Designer, **Peter Christensen**
Copywriter, **Odyssey House**
Client, **Odyssey House**
Printing, 5-color over 5-color and varnish
 on Trophy

Interior artwork is perforated to be used alternatively as postcards. All 12 illustrations and photographs were created as donations and helped to raise $2 million in private corporate funding.

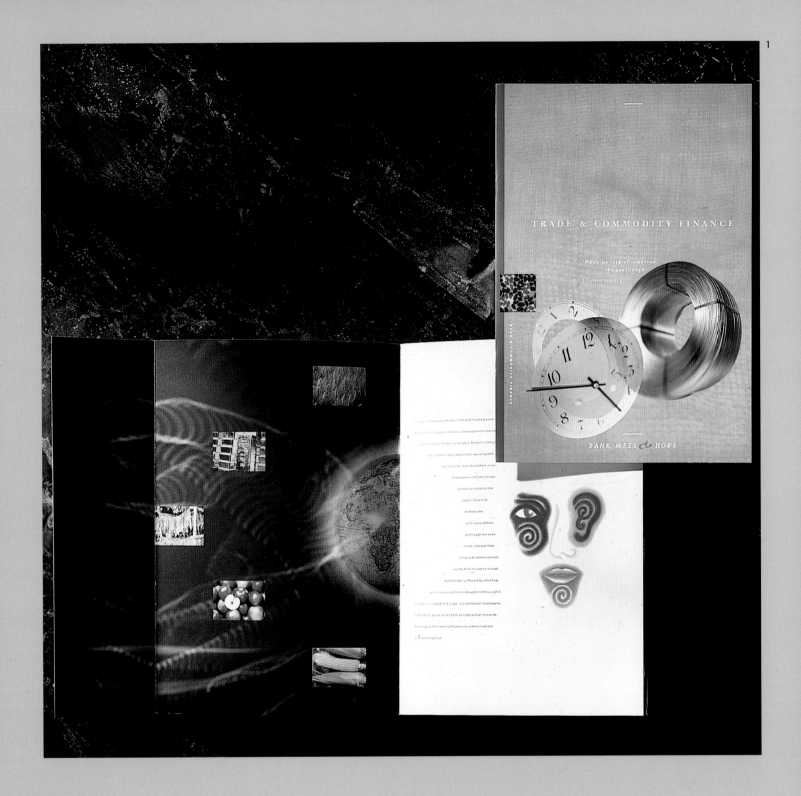

1
Design Firm, **Keja Donia Design**
Art Director, **Eric Nuijten**
Illustrator, **Ron van Roon/Robert Shackelton/**
 Lex van Pieterson
Photographer, **Zentrale Farbbild Agentur GmbH**
Copywriter, **Burson Marsteller/Bank Mees**
 & Hope
Client, **Bank Mees & Hope**
Printing 4-color

1

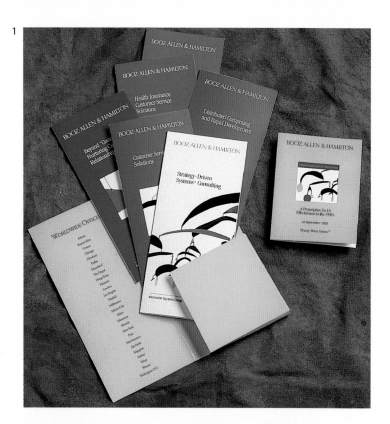

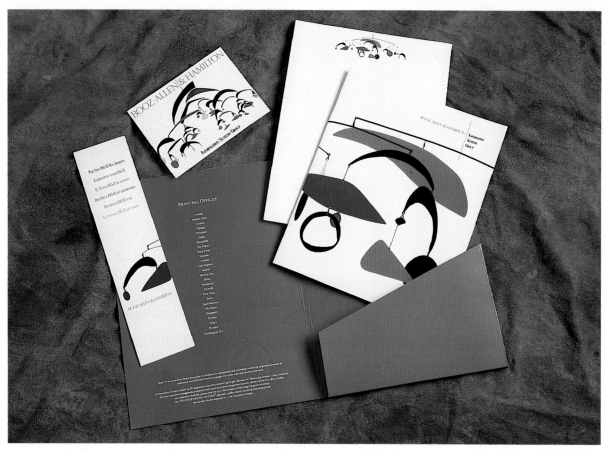

1
Design Firm, **Metroplis Corp.**
Art Director, **Denise Davis Mendelsohn**
Designer, **Denise Davis Mendelsohn**
Copywriter, **Booz, Allen & Hamilton, Inc.**
Client, **Booz, Allen & Hamilton, Inc.**
Printing, 5-color on Zanders Chromolux

Original mobiles (6–10 feet long) were designed, commissioned, constructed, and then photographed for the brochure. The mobiles are now owned and displayed by the client and the project has been further developed to include additional brochures, posters, hats, jackets, t-shirts, and caps.

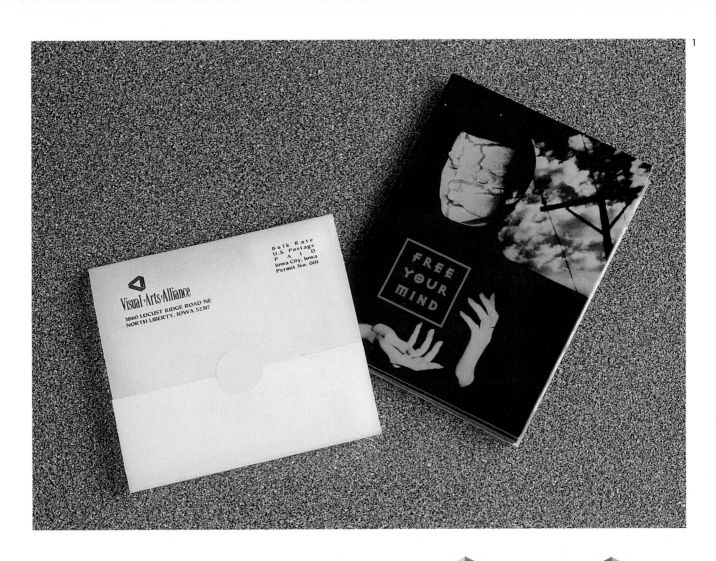

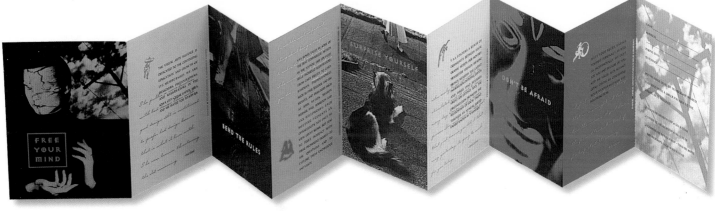

1
Designer, **Renée Kremer and Kimberly Cooke**
Photographer, **Mark C. Hartley/Jon Durant**
Copywriter, **Kimberly Cooke**
Client, **Visual Arts Alliance**
Printing, 5-color PMS, Karma, UV Ultra Wrapper

which represents 22.5 percent of Horizon's total revenues. We plan to signifi-

cantly expand the volume and profit contribution of these services in fiscal

1993, and we anticipate that they will comprise approximately 30 percent of

Horizon's total revenues by the end of this fiscal year.

AN OVERVIEW OF SPECIALTY MEDICAL

SERVICES & PROGRAMS

► ► ► Medical advances have increased life expectancy, which in turn has

brought about an increase in the number of people with disability and chronic

illness. This fact, together with the growing number of elderly citizens, has

created a tremendous need for long-term care and specialized services. For the

foreseeable future, the rising demand for long-term care beds will continue to

significantly outpace the available supply. Horizon is helping to meet this need

by offering services that minimize costs while maintaining the highest stan-

dards of care. I would like to highlight several of our specialty services.

SUBACUTE CARE

► ► ► In an effort to contain hospital and medical costs, health maintenance

organizations, private health insurers and other third-party payors are direct-

ing a growing number of patients from acute care hospitals to subacute care

settings — a quality, cost-effective alternative. Horizon specialty hospitals are

designed and managed to provide optimum care at a cost savings of 33 to 50

Revenues from our specialty services and programs increased 67 percent during fiscal 1992.

percent: daily per patient revenues average $500 instead of the $800 - $1,000

for comparable services at acute care hospitals.

► ► ► We opened our first specialty hospitals in fiscal 1992 in Edmond,

Oklahoma and Las Vegas, Nevada. These two hospitals, operated under "spe-

cialty hospital" licenses, with a total of 70 beds, provide subacute physical

rehabilitation and complex medical care programs such as ventilator care, head

trauma care, and coma stimulation. Three additional subacute units totaling 32

beds — specializing in ventilator care and wound care — opened in June, 1992

at Horizon long-term care centers in Ohio.

► ► ► We plan to open four specialty hospitals during fiscal 1993. The addi-

tional beds will double the operating capacity of Horizon's subacute care pro-

gram. During fiscal 1994, we plan to open four to six additional specialty

hospitals, further emphasizing the importance and success of this efficient,

cost-effective service. Of course, we will be evaluating other expansion oppor-

tunities in specialty care hospitals as they arise.

ALZHEIMER'S LIVING CENTERS

► ► ► Horizon was a pioneer in the field of Alzheimer's care. Our Alzheimer's

Living Centers, which now operate in dedicated wings within 18 of our long-

term care centers, provide specialized care for 464 patients. Our goal is to

maximize each resident's capabilities in a drug-free regimen. We use a team

In fiscal 1992, Horizon developed and opened its first Specialty Hospitals.

1
Design Firm, **Vaughn Wedeen Creative**
Art Director, **Daniel Michael Flynn**
Designer, **Daniel Michael Flynn**
Illustrator, **Curtis Parker**
Photographer, **Valerie Santagto**
Copywriter, **Nathan James/Valerie Santagto**
Client, **Horizon Healthcare Corporation**
Printing, Hopper Proterra Vellum Natural (cover
 and text) on Potlach Vintage Gloss White Book

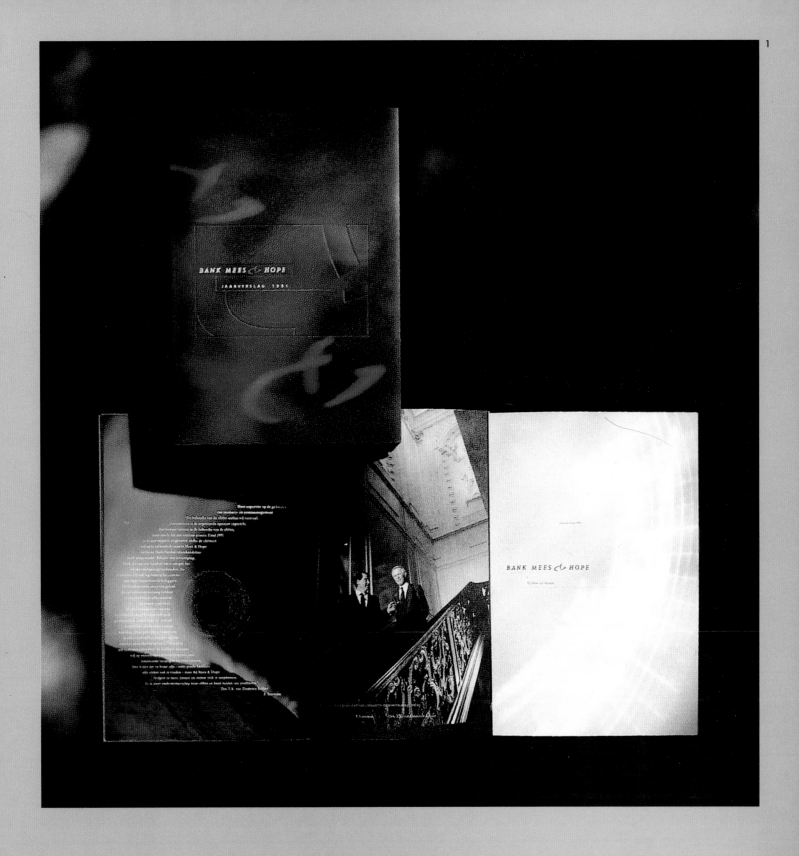

1
Design Firm, **Keja Donia Design**
Art Director, **Eric Nuijten**
Illustrator, **Jos van Uytregt/Artbox/Robert Shackleton/Lex van Pieterson**
Photographer, **Zentrale Farbbild Agentur GmbH**
Copywriter, **Mrs. L. Alijk/Bank Mees & Hope**
Client, **Bank Mees & Hope**
Printing, 5-color

The relationship between dynamics and banking ideas is projected on a background of natural phenomena.

1

2

1
Design Firm, **The Weller Institute for the Cure of Design**
Art Director, **Don Weller**
Designer, **Don Weller**
Photographer, **James Moulin**
Copywriter, **Rose M. Milovich**
Client, **Nora Eccles Harrison Museum of Art**
Printing, 5-color, Lustro Dull (cover and text)

2
Design Firm, **Grafik Communications, Ltd.**
Art Director, **Melanie Bass**
Illustrator, **Alain Levesque**
Copywriter, **Eric Stewart**
Client, **Blue Cross/Blue Shield**

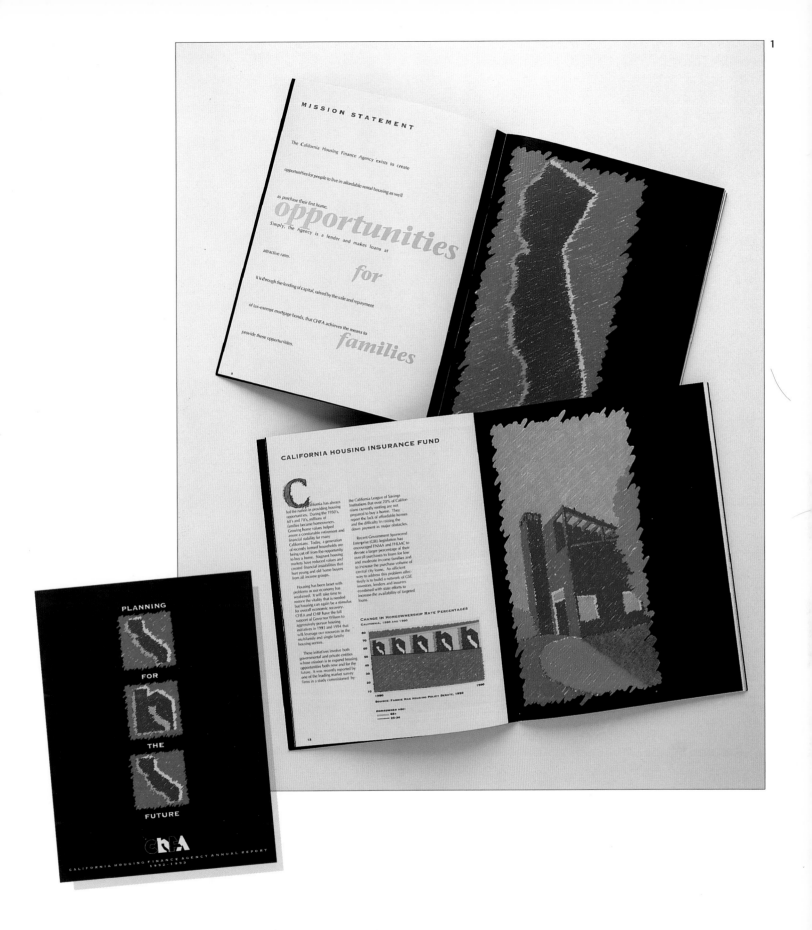

1
Design Firm, **Winter Graphics**
Art Director, **Mary Winter**
Designer, **Mary Winter**
Illustrator, **Simon Olney**
Photographer, **Gordon Lazzaroni**
Copywriter, **CHFA Staff**
Client, **California Housing Finance Agency**
Printing, 5-color plus a dry trap varnish.

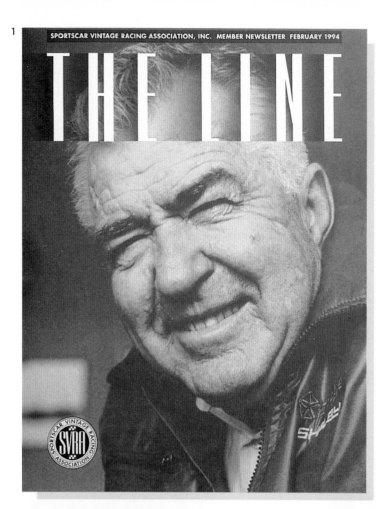

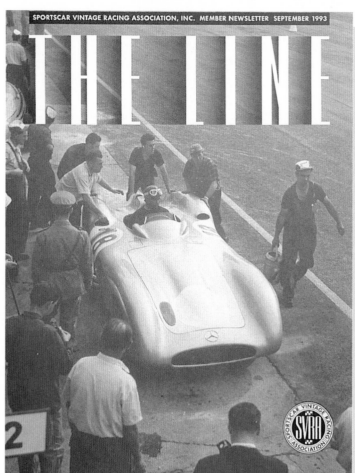

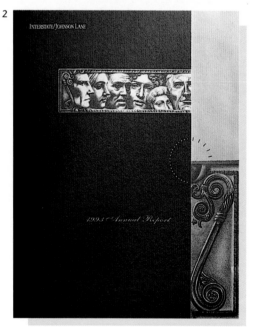

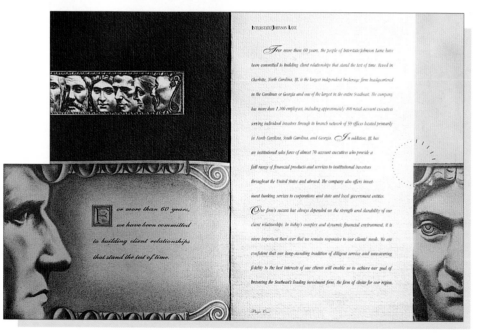

1
Design Firm, **Muller + Company**
Art Director, **John Muller**
Designer, **John Muller**
Photographer, **Jesse Alexander**
Client, **Sportscar Vintage Racing Association**
Printing, 3-color on Hammermill Regalia Lustre

2
Design Firm, **Mervil Paylor Design**
Art Director, **Mervil M. Paylor**
Designer, **Mervil M. Paylor**
Illustrator, **David Wilgus**
Copywriter, **Debora Arnold**
Client, **Interstate Johnson Lane**
Printing, 5-color on Curtis Tweedweave Dazzling
 White (cover), 2-color on Nekoosa Opague
 Offset Smooth, Mustard (text A), Nekoosa
 Opague Offset Smooth Spruce, (text B)

*The biggest challenge was getting the various
elements in the different pages and sections to
register. This was done by careful planning on the
part of the designer, the illustrator, and the printer.*

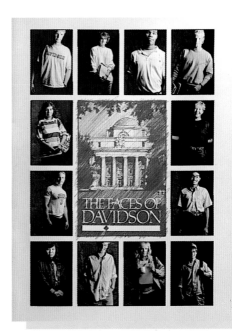

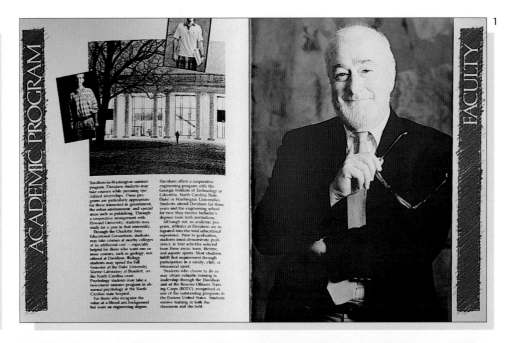

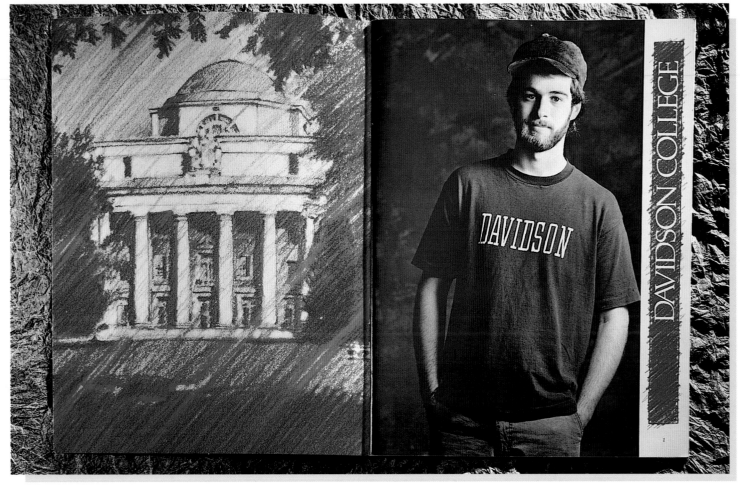

1
Design Firm, **Mervil Paylor Design**
Art Director, **Mervil M. Paylor**
Designer, **Mervil M. Paylor**
Illustrator, **Gary Palmer**
Photographer, **Ron Chapple**
Copywriter, **Sheryl Aikman**
Client, **Davidson College**
Printing, 4-color on Lustro Offset Enamel Dull Cream
(cover), Lustro Offset Enamel Dull Cream (text A),
Simpson Gainsborough Felt Spice Ivory (text B)

The portrait photography began as a personal project for the photographer, a Davidson alumni. He later allowed the college to use the photos for recruiting materials.

1

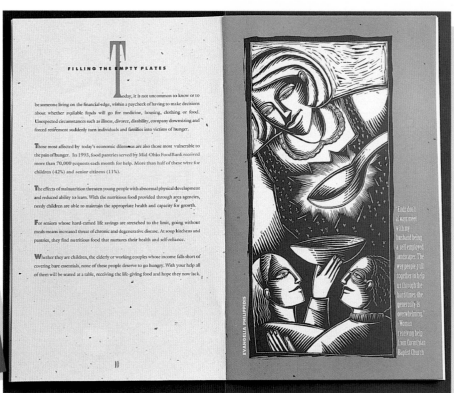

2

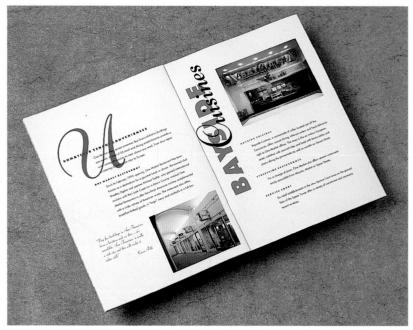

1
Design Firm, **Rickabaugh Graphics**
Art Director, **Eric Rickabaugh**
Designer, **Tina Zientarski**
Illustrator, **Evangelia Philippidis/Ted Pitt/Clint
 Hansen/Mark Braught**
Copywriter, **Lauren Smith**
Client, **Mid-Ohio Food Bank**
Printing, 2-color on Fox River Confetti

2
Design Firm, **Debra Nichols Design**
Art Director, **Debra Nichols**
Designer, **Debra Nichols/Lori Powell/
 Michael Sechman (computer rendering)**
Photographer, **Wes Thompson**
Client, **CB Commercial Real Estate Group**
Printing, 6-color, varnish, 10 pt. Kromekote C1S
 White (cover), Lustro Gloss Book, 100 lb. (text)

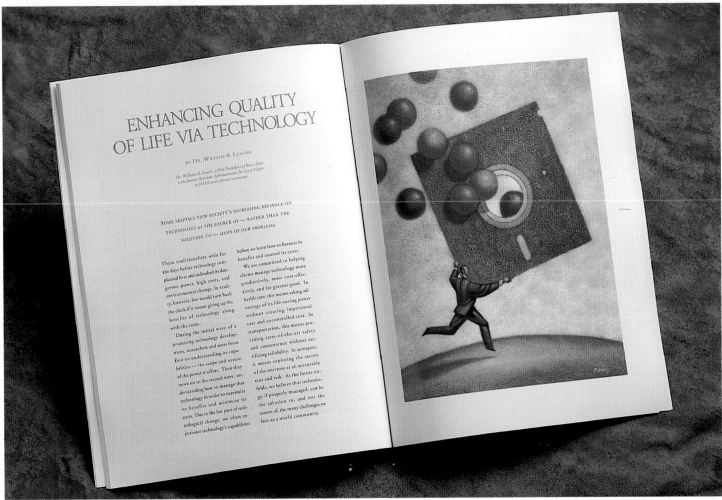

1
Design Firm, **Metroplois Corp.**
Art Director, **Denise Davis Mendelsohn**
Designer, **Lisa DeSeno/Richard Uccello/
 Trina Riso**
Copywriter, **Karen Abarbanal/Editor**
Client, **Booz, Allen & Hamilton, Inc.**
Printing, 5-color on 5-color and varnish on
 Eloquence

*Five writers and 12 photographers were used for this
project which includes eight stories of client projects
from around the world. The theme chapters contain
writings by great thinkers such as Kissinger.*

1

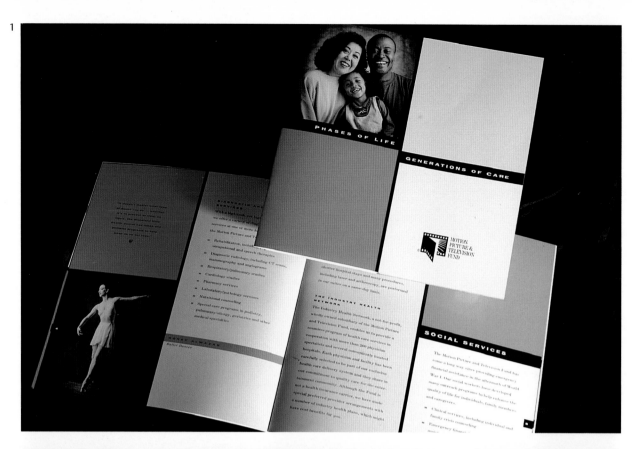

2

1
Design Firm, **Vrontikis Design Office**
Art Director, **Petrula Vrontikis**
Designer, **Petrula Vrontikis**
Photographer, **Jeff Sedlik**
Copywriter, **Louella Benson**
Client, **Motion Picture & Television Fund**
Printing, 3-color plus varnish on Potlach
 Quintessence

2
Design Firm, **Vrontikis Design Office**
Art Director, **Petrula Vrontikis**
Designer, **Kim Sage**
Photographer, **Jeff Sedlik**
Client, **Motion Picture & Television Fund**
Printing, 4-color on Simpson Quest

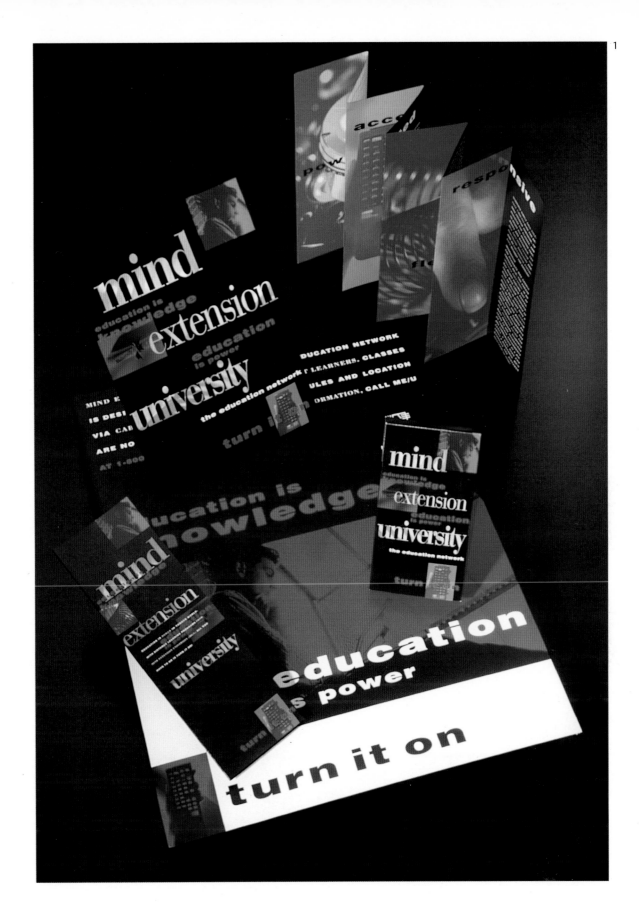

1
Design Firm, **Vaughn Wedeen Creative**
Art Director, **Steve Wedeen**
Designer, **Steve Wedeen**
Photographer, **Michael Barley/Stock
 Photography**
Copywriter, **Steve Wedeen/Nathan James**
Computer Manipulation/Production, **Chip Wyly**
Client, **Mind Extension University**
Printing, 4-color in Vintage Gloss Book

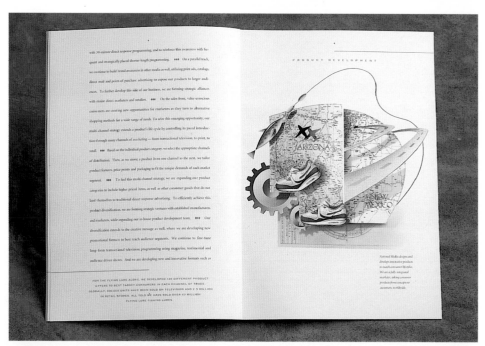

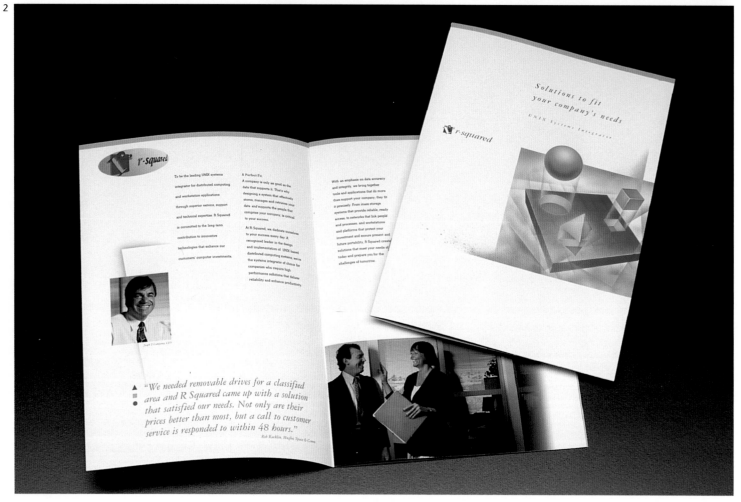

1
Design Firm, **Bernhardt Fudyma Design Group**
Art Director, **Craig Bernhardt/Iris Brown**
Designer, **Iris Brown**
Illustrator, **Valerie Sinclair**
Copywriter, **Cathy Barkey**
Client, **National Media Corporation**
Printing, 6-color

2
Design Firm, **Lee Reedy Design Associates, Inc.**
Art Director, **Lee Reedy**
Designer, **Heather Bartlett**
Illustrator, **Gary Molzan**
Photographer, **Frank Cruz**
Copywriter, **Bonnie Carmus**
Client, **R-Squared**
Printing, 5-color

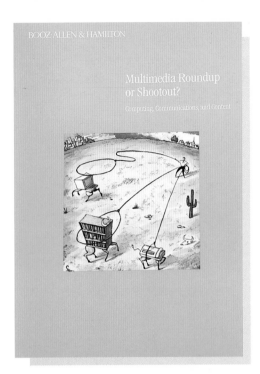

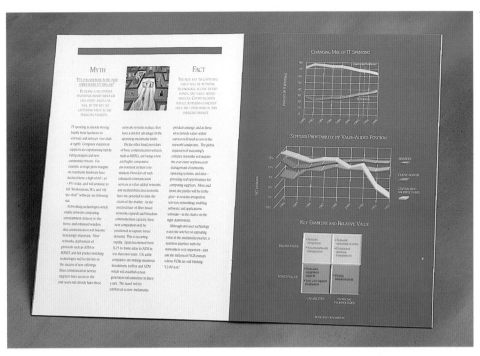

1

2

1
Design Firm, **Metropolis Corp.**
Art Director, **Denise Davis Mendelsohn**
Designer, **Richard Uccello**
Illustrator, **Paul Schullenberg**
Copywriter, **Booz, Allen & Hamilton, Inc.**
Client, **Booz, Allen & Hamilton, Inc.**
Printing, 5-color over 5-color and varnish
on Reflections

2
Design Firm, **Stawicki Werbeagentur**
Art Director, **Markus Schmidt**
Designer, **Markus Schmidt**
Illustrator, **Markus Schmidt**
Copywriter, **Martin Wider**
Client, **Wyse Technology**
Printing, 5-color on Handmade Paper
(Gmund Butten)

1

2

1
Design Firm, **Julia Tam Design**
Art Director, **Julia Chong Tam**
Designer, **Julia Chong Tam**
Illustrator, **Sandra Spidel**
Copywriter, **Jan Gonzales**
Client, **UCLA Tiverton House**
Printing, 6-color on Lustro Natural

2
Design Firm, **Julia Tam Design**
Art Director, **Julia Chong Tam**
Designer, **Julia Chong Tam**
Illustrator, **Julia Chong Tam**
Copywriter, **Laura Schultz Stiman**
Client, **UCLA Housing**
Printing, 2-color on Recycled Paper

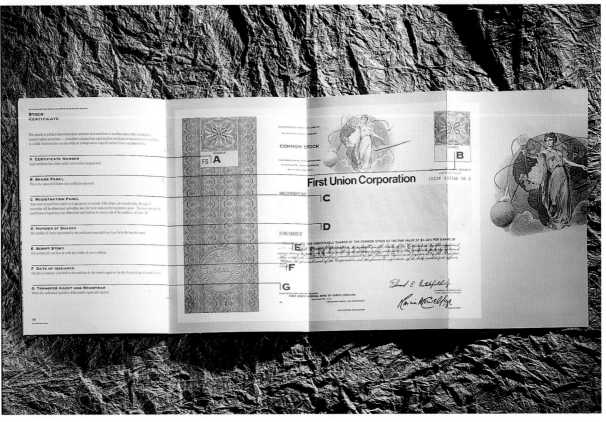

1
Design Firm, **Stawicki Werbeagentur**
Art Director, **Markus Schmidt**
Designer, **Markus Schmidt**
Copywriter, **Silke Neumayer**
Client, **Globus Warenhäuser**
Printing, 4-color on Recycled Paper (Steinbeis
Temming), bound with wooden ledges and
metal screws

2
Design Firm, **Mervil Paylor Design**
Art Director, **Mervil M. Paylor**
Designer, **Mervil M. Paylor**
Copywriter, **Maggie Norris**
Client, **First Union Corporation**
Printing, 4-color on Hopper Proterra Felt Coastal
White (cover), Simpson Evergreen Almond (text
A), Ikonofix Dull White (text B)

1
Design Firm, **RBMM/The Richards Group**
Art Director, **Brian Boyd**
Designer, **Brian Boyd**
Photographer, **Greg Watermann**
Copywriter, **Paul Brandenburger**
Client, **Episcopal School of Dallas**
Printing, 4-color on Pre-eminence (cover and text)

Used to celebrate the third decade of the school, this brochure helped to raise funds to build math and science building.

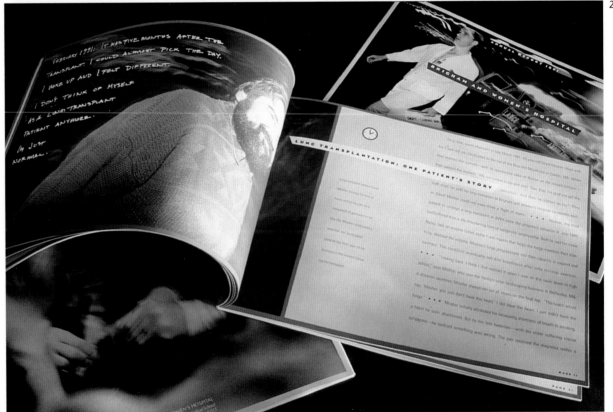

1
Design Firm, **Olson Johnson Design Co.**
Designer, **Dan Olson/Haley Johnson**
Client, **Goldsmith, Agio, Helms & Co.**
Printing, 3-color on Gilbert Esse French Parchtone

2
Design Firm, **Clifford Selbert Design**
Design Team, **Clifford Selbert/Melanie Love**
Photographer, **Jerry Berndt**
Copywriter, **Susan Reed**
Client, **Brigham and Women's Hospital**
Printing, Starwhite Vicksburg (pages), Golden
 Cask Dull (cover)

*Design team was on call to observe an actual trans-
plantation. We wanted to achieve the same "imme-
diacy" in our brochure design.*

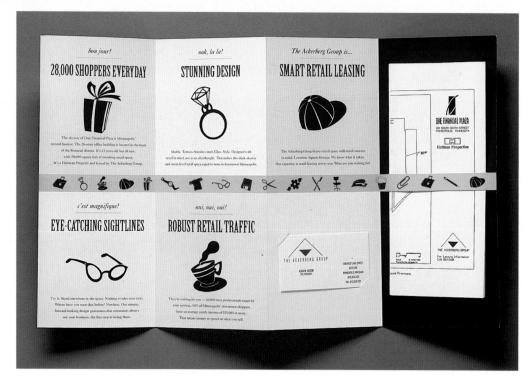

1
Design Firm, **Hunt Weber Clark Design**
Art Director, **Nancy Hunt-Weber**
Designer, **Nancy Hunt-Weber**
Client, **Nancy Hunt-Weber**
Printing, 4-color, 10 pt. Krome

2
Design Firm, **Tilka Design**
Art Director, **Jane Tilka**
Designer, **Brad Hartman**
Illustrator, **Mike Reed**
Copywriter, **Jane Caplan**
Client, **The Ackerberg Group**
Printing, 2-color on Simpson Evergreen

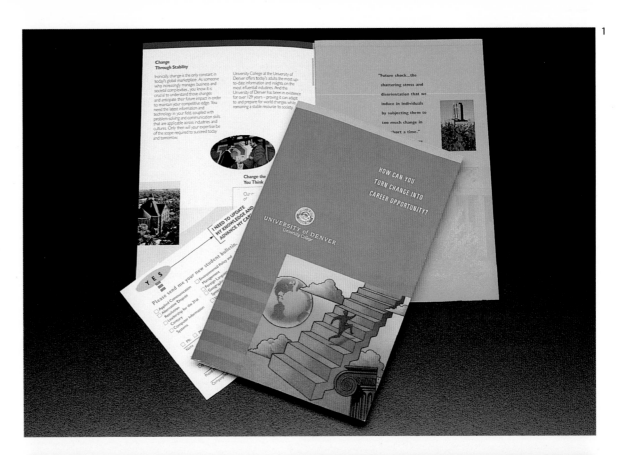

1
Design Firm, **Lee Reedy Design Associates, Inc.**
Art Directors, **Lee Reedy/Heather Bartlett**
Designer, **Heather Bartlett/Jon Wretlind**
Illustrator, **Patrick Merewether**
Copywriter, **University College**
Client, **University College**
Printing, 4-color, UV coating

2
Design Firm, **Lee Reedy Design Associates, Inc.**
Art Director, **Lee Reedy**
Designer, **Heather Bartlett**
Illustrator, **Patrick Merewether**
Client, **University of Denver, University College**
Printing, 5-color

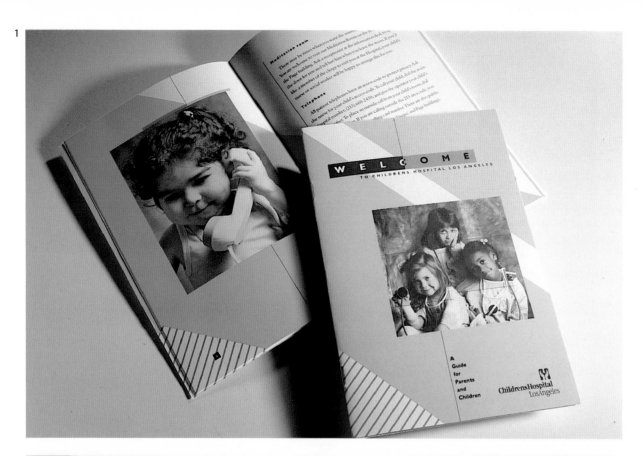

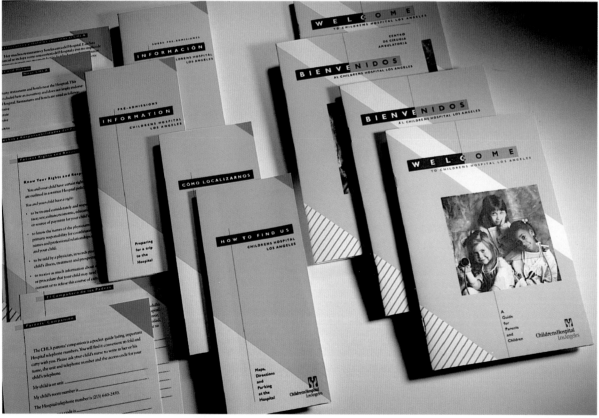

1
Design Firm, **Vrontikis Design Office**
Art Director, **Petrula Vrontikis**
Designer, **Petrula Vrontikis**
Photographer, **Jeff Corwin**
Copywriter, **Anita Bennett**
Client, **Children's Hospital, Los Angeles**
Printing, 4-color on Hopper Kiana

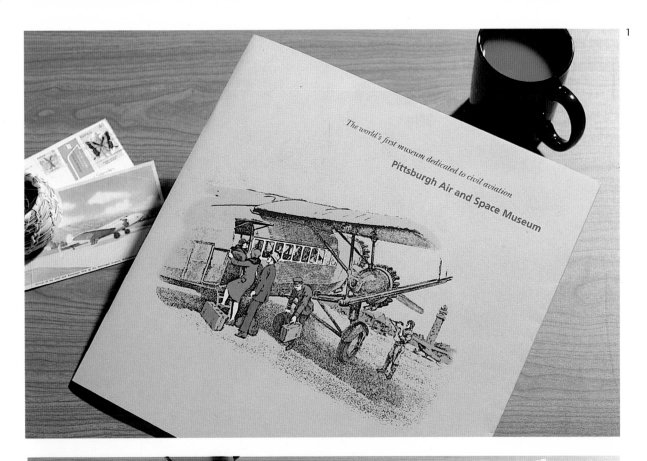

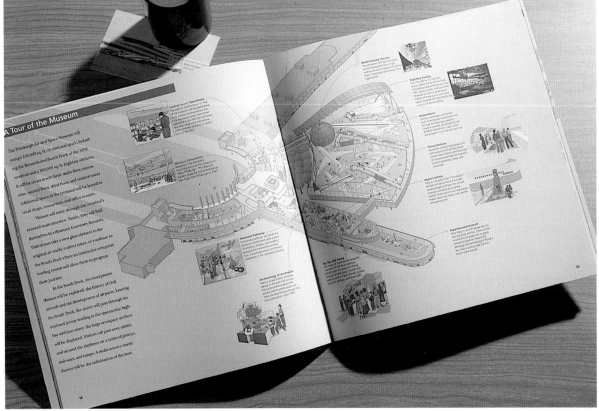

1
Design Firm, **Agnew Moyer Smith Inc.**
Art Director, **C. Reed Agnew**
Designer, **Norm Goldberg**
Illustrator, **Kurt Hess/Rick Henkel**
Copywriter, **Neil Fisher**
Client, **Commissioners of Allegheny County**
Printing, 5-color

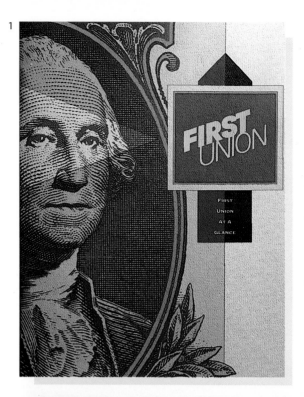

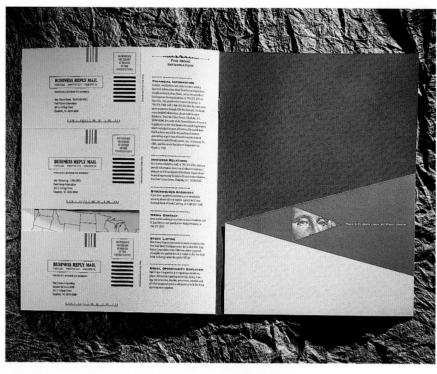

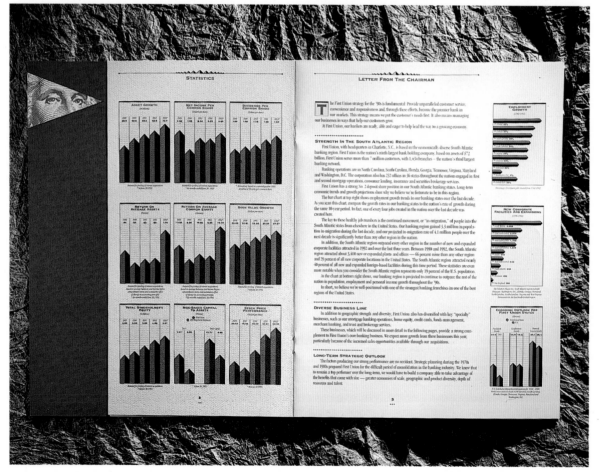

1
Design Firm, **Mervil Paylor Design**
Art Director, **Mervil M. Paylor**
Designer, **Mervil M. Paylor**
Photographer, **Wes Bobbitt**
Copywriter, **Kate Duncan**
Client, **First Union Corporation**
Printing, 6-color on Hopper Proterra Felt Coastal
 White (cover), Hopper Proterra Felt Sandstone
 (text A), Ilonofix Dull White (text B)

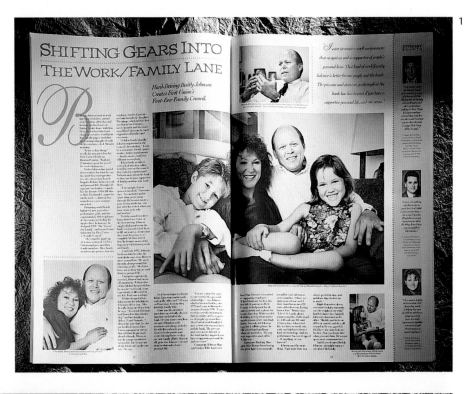

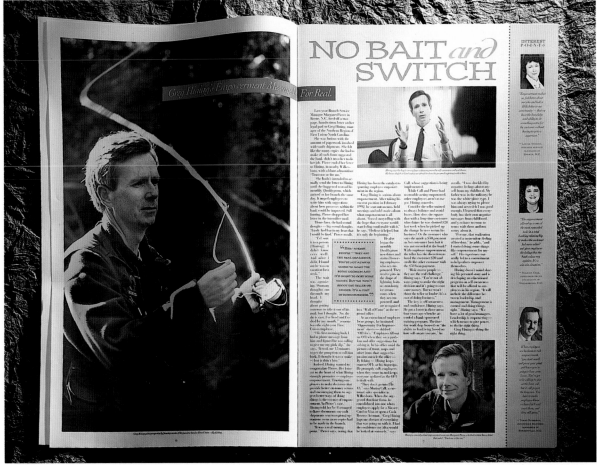

1
Design Firm, **Mervil Paylor Design**
Art Director, **Mervil M. Paylor**
Designer, **Mervil M. Paylor**
Photographer, **Candace Freeland**
Copywriter, **Sysan Shackleford**
Client, **First Union Corporation**
Printing, 6-color on Simpson Evergreen Birch

T O M

TIOGA

RALEIGH

RALEIGH

DESIGN
...end and a resilient rear
...handling. That's the
...Point
...by
...ride.

TUBE
...Raleigh takes
...be. This gives
...al butting at
...and ovalizing
...ving you
...strength
...rigidity
...weight.

John Tomac is the artist. His work is framed by Raleigh. Since 1988, his first year as World Mountain Bike Champion, John has been the most dominant rider. Over the years, John and our engineers have learned enough about racing to write a

book. But we're bike designers not writers, so we decided to pass along our knowledge by building it into some

top tube, ...
can bet the ...
John's name ...
any bike ...
soul goes into

PRODUCT BOOKLETS

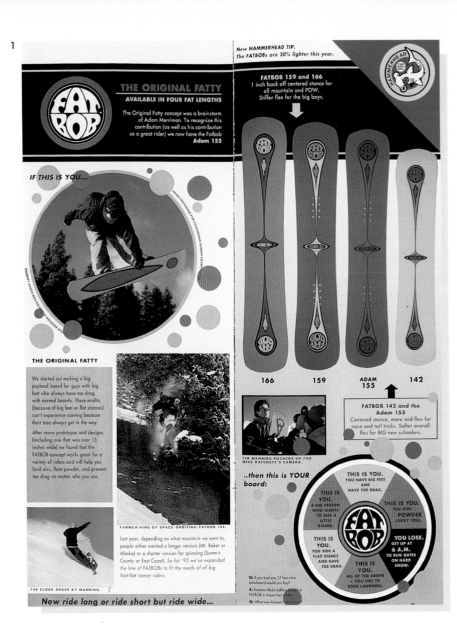

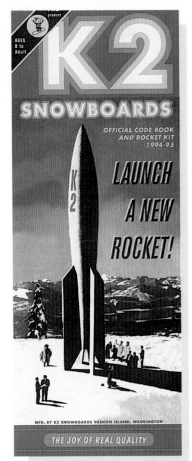

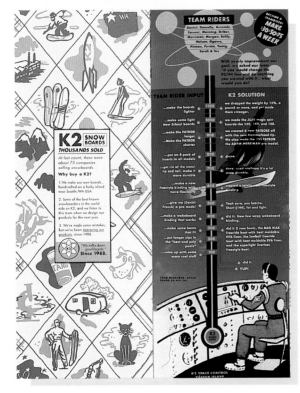

1
Design Firm, **Modern Dog**
Art Director, **Vittorio Costarella/Brent Turner**
Designer, **Vittorio Costarella/Michael Strassburger**
Illustrator, **Vittorio Costarella**
Photographers, **Jeff Curtes/Eric Berger/Jules Frazier**
Copywriter, **Brent & Luke**
Client, **K2 Snowboards**
Printing, 4-color on Carnival Grove (cover),Vintage
 Remarque Dull (text)

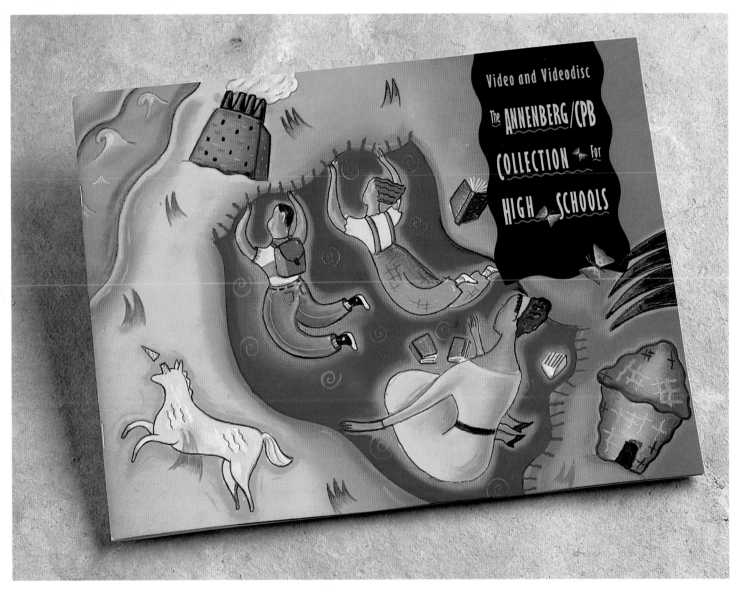

1
Design Firm, **Grafix Communications, Ltd.**
Design Team, **Gregg Glaviano/Susan English**
Illustrator, **Mercedes McDonald**
Client, **Corporation for Public Broadcasting**

The Multimedia Market is Growing at an Incredible Rate! In 1990, the multimedia market was in an early growth stage, accounting for approximately $4 billion in sales. By 1995, it's expected to increase to almost $25 billion* – a growth of over 600% in five years! This represents huge profit potential for value-added resellers. And NOW is the time to take full advantage of this opportunity. How can you get a piece of the action?

IBM is a recognized leader in multimedia technology, the only full-service provider of multimedia and creative graphics products and services in the country. From training and support to full multimedia systems integration such as video servers and software, IBM understands your customers' needs. Supplemented by an aggressive industry wide marketing, advertising and public relations program, IBM creates the marketing presence to bring your customers back — and your profits soaring.

Source: FROST & SULLIVAN

IBM's expanding Ultimedia Tools Series offers your customers easy entry into the creative graphics arena by providing one common, open architecture for all participating software manufacturers — ensuring that any and all tools will work together with ease. This architecture is unique as it was created by participating Ultimedia Tools Series developers, and not a third party. Whenever possible this ever evolving architecture adheres to existing industry standards. The architecture gives end-users limitless computer graphics capabilities to enhance business communications using the OS/2™, Windows™ and DOS systems they already have. You can also integrate entire systems for your customers to create a complete creative graphics solution!

The Profit Opportunity – Access Graphics and Ultimedia Tools Series

Let Access Graphics show you how the Ultimedia Tools Series can increase your bottom line by offering your customers a full spectrum of unique, easy-to-use products, by expanding your markets, and by providing all the support you need!

Increase Sales with Products that are Faster and Easier

With the Ultimedia Tools Series, you can offer all of your customers interested in multimedia an easy, efficient way of satisfying all their creative graphics needs. As a result of the Ultimedia Tools Series' common architecture, casual to professional users can introduce, demonstrate and sell their products and services; train personnel; hold impromptu video conferences and two-way meetings; improve everything from memos to major presentations; increase productivity and lower communications costs plus much more . . . all faster and easier than they've ever imagined!

Expand Your Markets

Expand your markets with the Ultimedia Tools Series by entering some of the most exciting areas in the creative graphics industry today, including desktop video, authoring, graphic design, audio and animation. Increase your profits by increasing your customer base!

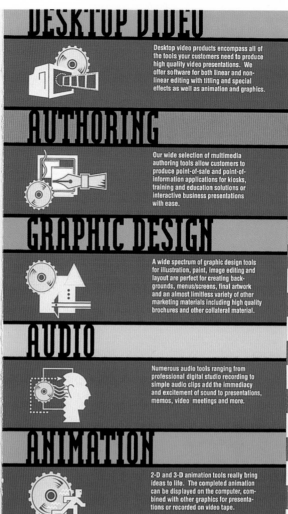

DESKTOP VIDEO

Desktop video products encompass all of the tools your customers need to produce high quality video presentations. We offer software for both linear and non-linear editing with titling and special effects as well as animation and graphics.

AUTHORING

Our wide selection of multimedia authoring tools allow customers to produce point-of-sale and point-of-information applications for kiosks, training and education solutions or interactive business presentations with ease.

GRAPHIC DESIGN

A wide spectrum of graphic design tools for illustration, paint, image editing and layout are perfect for creating backgrounds, menus/screens, final artwork and an almost limitless variety of other marketing materials including high quality brochures and other collateral material.

AUDIO

Numerous audio tools ranging from professional digital studio recording to simple audio clips add the immediacy and excitement of sound to presentations, memos, video meetings and more.

ANIMATION

2-D and 3-D animation tools really bring ideas to life. The completed animation can be displayed on the computer, combined with other graphics for presentations or recorded on video tape.

Ultimedia Tools Series products are distributed through Access Graphics, and right now you can become authorized to sell these products and participate in the greatest growth potential in the industry today. Access Graphics offers a host of complementary peripherals to complete an Ultimedia Tools Series solution, including products from top-name manufacturers such as IBM, Sony, Mitsubishi, Truevision and Hewlett-Packard.

What's more, we'll help you. When you sign up with Access Graphics to sell the products of the Ultimedia Tools Series, we'll provide you with all the support you need. Like an expert sales staff. Technical support and training. Complementary solution products. Marketing tools. And more. Access provides all this support free of charge, allowing more revenue to flow to your bottom line.

In addition, when you request authorization materials, we'll send you our free authorization kit, complete with a multimedia Sampler CD of the Ultimedia Tools Series products, configuration guide, product matrix and our Creative Graphics application form.

FAX FORM

COMPANY

NAME

PHONE

FAX

Don't wait... the multimedia market is exploding and NOW is the time to realize its profit potential!

Call your Access Graphics account manager for more information at

1-800-733-9333

or Fax the above form to
(303) 440-1681.

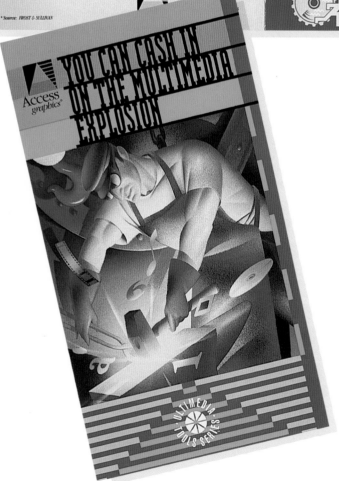

1
Design Firm, **Lee Reedy Design**
Art Director, **Lee Reedy**
Designer, **Lee Reedy**
Copywriter, **Access Graphics**
Client, **Access Graphics**
Printing, 4-color

1
Design Firm, **John Kneapler Design**
Art Director, **John Kneapler**
Designer, **John Kneapler/Kristen Loipe**
Illustrator, **Carl Mazur**
Copywriter, **Andi Hughes/Mark Malinowski**
Client, **Ketchum Communications**
Printing, 4-color on Recycled Paper

1

New Directions...

...New Choices.

Make a Choice and Benefit!

1
Design Firm, **Corey McPherson Nash**
Art Director, **Phyllis Kido**
Designer, **Phyllis Kido**
Photographer, **Stock Photography**
Copywriter, **Hewitt & Associates**
Client, **Blue Cross/Blue Shield**
Printing, 5-color

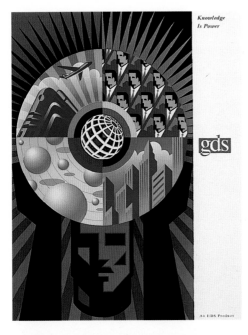

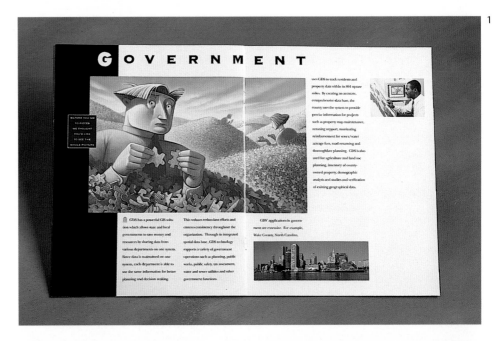

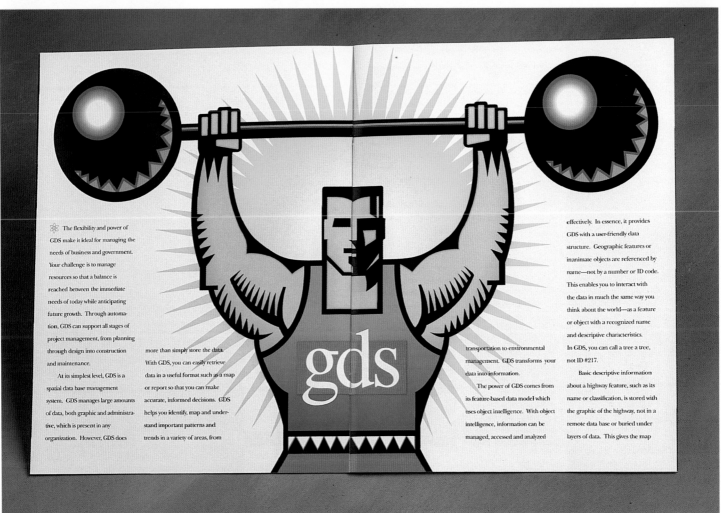

1
Design Firm, **Bartels & Company, Inc.**
Art Director, **David Bartels/Brian Barclay**
Designer, **Brian Barclay**
Illustrator, **Brian Barclay/Mark Ryden/**
 Mary Grandpre/Rafael Obinski
Photogrpaher, **Stock Photography**
Copywriter, **Donn Carstens/Scott Michelson**
Client, **EDS/GDS**
Printing, 4-color on Chromecoat

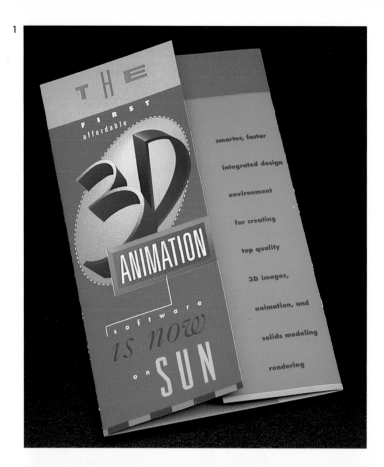

1
Design Firm, **Lee Reedy Design Associates, Inc.**
Art Director, **Lee Reedy**
Designer, **Heather Bartlett**
Illustrator, **Jon Wretlind**
Copywriter, **Steve Herrmann**
Client, **Access Graphics, Studio Group**
Printing 4-color

2
Design Firm, **Studio MD**
Art Director, **Carol Phillips, Maritz Performance**
 Improvement Co.
Designer, **Jesse Doquilo**
Illustrator, **Jesse Doquilo**
Copywriter, **Tom Picard, Maritz Performance**
 Improvement Co.
Client, **Nissan**
Printing, 6-color, pop ups, die cuts, moving
 pieces, plane on spring

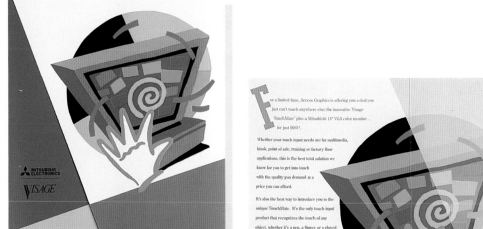

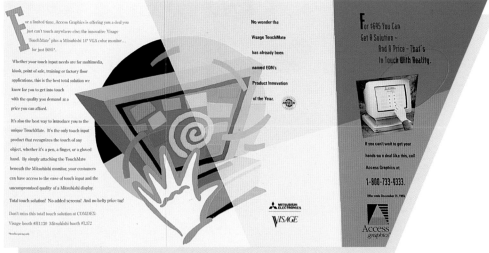

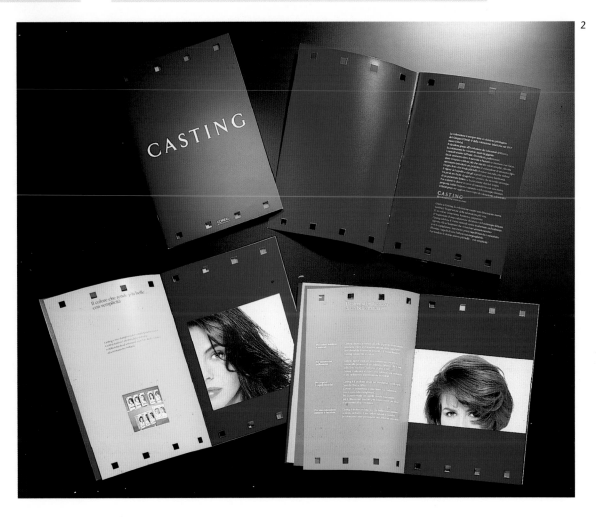

1
Design Firm, **Lee Reedy Design**
Art Director, **Lee Reedy**
Designer, **Lee Reedy**
Illustrator, **Heather Bartlett/Tom Strang**
Copywriter, **Access Graphics Studio Group**
Client, **Access Graphics Studio Group**
Printing, 4-color

2
Design Firm, **Giorgio Rocco Communications**
Art Director, **Giorgio Rocco**
Designer, **Giorgio Rocco**
Photographer, **Archives L'Óreal**
Copywriter, **Anna Andreuzzi**
Client, **L'Óreal**
Printing, 8-color on Ikonofix Zanders Paper, 300g

Playing on the double meaning of "casting," all the pages are die-cut like a film.

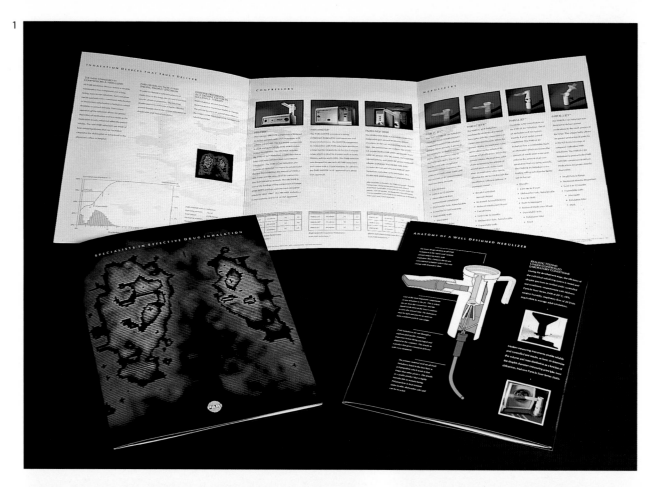

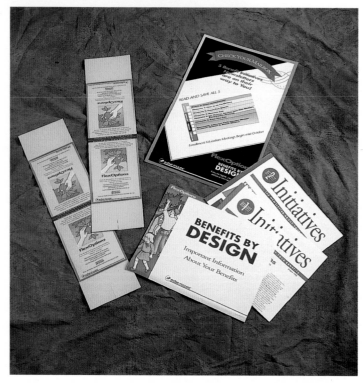

1
Design Firm, **Beauchamp Design**
Art Director, **Michele Beauchamp**
Designer, **Michele Beauchamp**
Illustrator, **Fred Powers**
Photographer, **Kim Brun**
Copywriter, **Geoff Hunziker**
Client, **Pari Respiratory Equipment, Inc.**
Printing, 4-color Topkote

2
Design Firm, **Metropolis Corp.**
Art Director, **Denise Davis Mendelsohn**
Designer, **Lisa DeSeno/Richard Uccello**
Illustrator, **Lisa DeSeno/Richard Uccello**
Client, **Rhone-Poulenc**
Printing, 5-color over 5-color on Sundance Felt

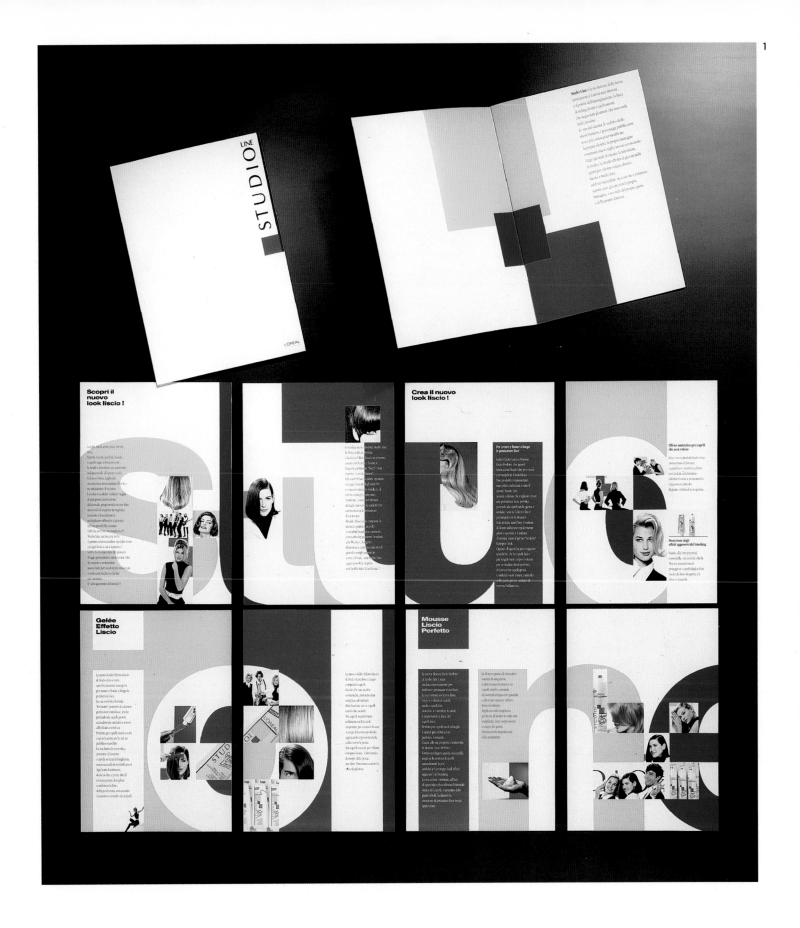

1
Design Firm, **Giorgio Rocco Communications**
Art Director, **Giorgio Rocco**
Designer, **Giorgio Rocco**
Photographer, **Archives L'Óreal**
Copywriter, **Anna Andreuzzi**
Client, **L'Óreal**
Printing, 8-color on Ikonofix Zanders Paper, 300g

1

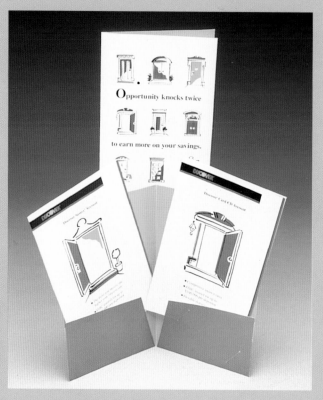

2

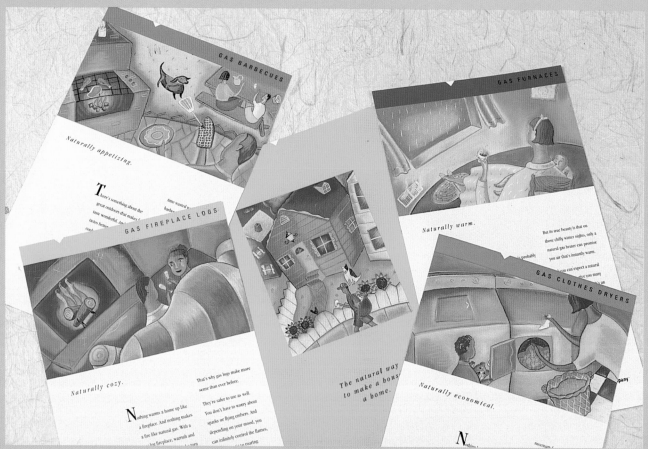

1
Design Firm, **Mike Quon Design Office**
Illustrator, **Mike Quon**
Client, **Discover Card**

2
Design Firm, **Julia Tam Design**
Art Director, **Julia Chong Tam**
Designer, **Julia Chong Tam**
Illustrator, **Mercedes McDonald**
Copywriter, **Peter Brown**
Client, **Southern California Gas Company**
Printing, 6-color on Lustro Recycled, die-cut folder
 with stair-step inserts

Beratung, Planung und Beschaffung.
Von der ersten Idee bis zur Realisierung.

Generalübernahme von Projekten
Renovierung und Erweiterungen
Handel mit Einrichtung und Equipment

Innenarchitektur
Planung, Entwurf, Ausschreibung
Kostenermittlung
Präsentationen und Bemusterungen
Abwicklung und Koordination
Nachbeschaffung

Mit der Realisierung einer guten Idee
sollten alle Beteiligten so früh wie möglich
mit uns beginnen.
Eine gemeinsame Projektplanung mit
Hoteliers, Consulting-Unternehmen, Architekten
und Innenarchitekten verspricht nicht nur eine
höhere Qualität, sondern auch eine
weitaus raschere Durchführung und damit
ein schnelleres Return on investment.

1
Design Firm, **Hartmann & Mehler Designers**
Art Director, **Alf Mattner**
Designer, **Eva Müller**
Photographer, **Frank Weinert**
Copywriter, **Burkhard Birkholz**
Client, **Intercity Hotel GmbH**
Printing, 4-color

*Image brochure with hotel directory to intercity
hotels. Directory has helpful hints on where to dine,
shop, etc. when in a city with an intercity hotel.*

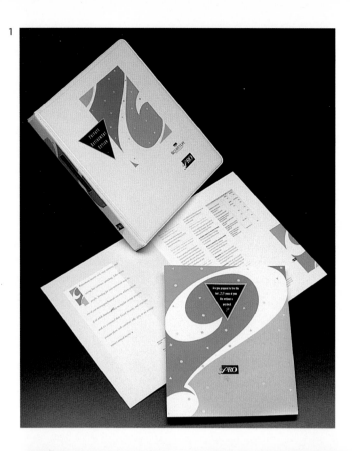

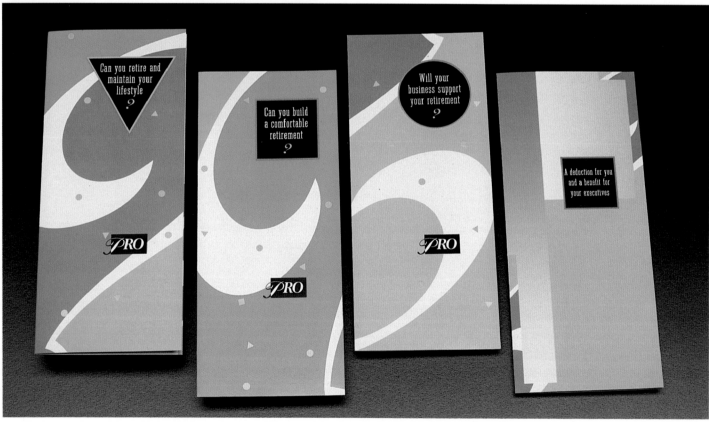

1
Design Firm, **Lee Reedy Design Associates, Inc.**
Art Director, **Lee Reedy**
Designer, **Jon Wretlind**
Illustrator, **Jon Wretlind**
Copywriter, **Cindy Quinn**
Client, **Security Life of Denver**
Printing, 2-color, 4-color on Prodactoith

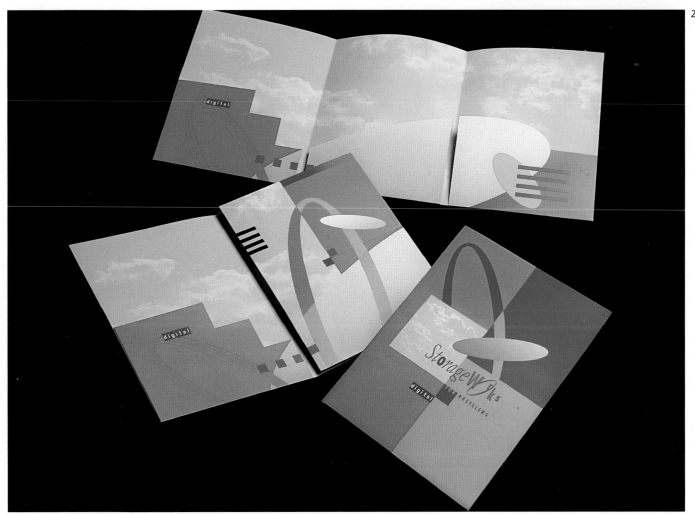

1
Design Firm, **SullivanPerkins**
Art Director, **Ron Sullivan**
Designer, **Ron Sullivan**
Illustrator, **Jon Flaming/Linda Helton/Clark Richardson/Michael Sprong/Ron Sullivan**
Photographer, **Gerry Kano**
Copywriter, **Mark Perkins**
Client, **Neenah Paper**
Printing, 18-colors on Neenah Classic, foil stamping, embossing, die-cuts, thermography, and debossing

2
Design Firm, **Stoltze Design**
Art Director, **Clifford Stoltze/Billie Best**
Designer, **Peter Farrell/Clifford Stoltze**
Client, **Digital Equipment Corp, Quantic Comm.**
Printing, 6-color on Vintage Velvet

1

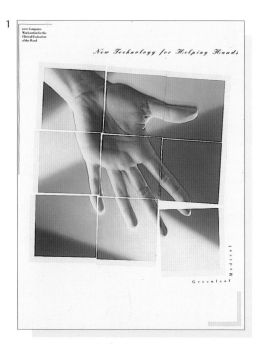

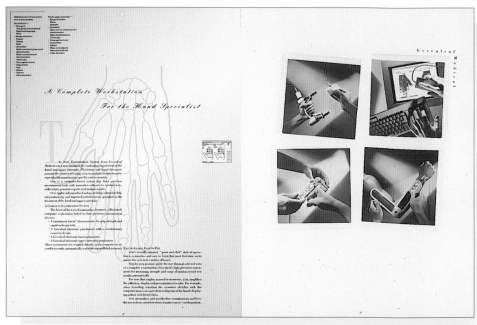

2

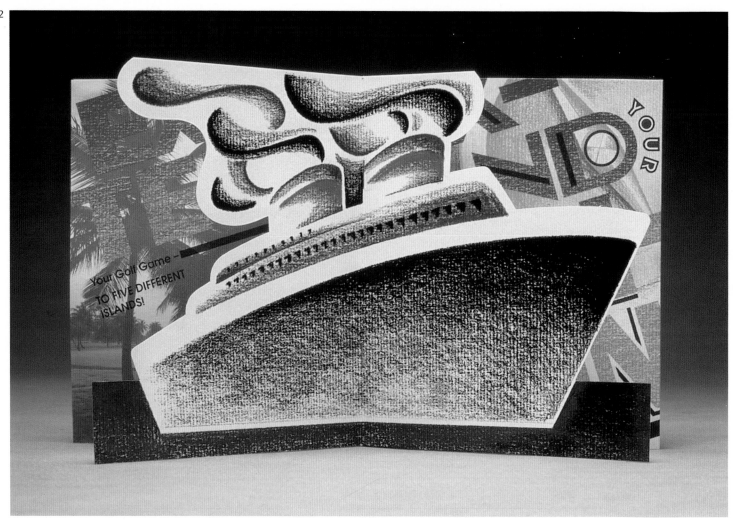

1
Design Firm, **Earl Gee Design**
Art Director, **Earl Gee**
Designer, **Earl Gee**
Photographer, **Geoffrey Nelson**
Copywriter, **Morgan Thomas**
Client, **Greenleaf Medical**
Printing, 4-color, 4 PMS, Simpson Kashmir Natural
 100 lb. (text)

2
Design Firm, **Sayles Graphic Design**
Art Director, **John Sayles**
Designer, **John Sayles**
Illustrator, **John Sayles**
Copywriter, **Wendy Lyons**
Client, **Fort Dearborn Life Insurance Company**
Printing, 4-color on James River Graphika Vellum
 Cream (cover), James River Graphika Vellum
 Cream (text)

Original illustrations and stock photography combine for a unique effect. The cover is a die-cut ship's hull.

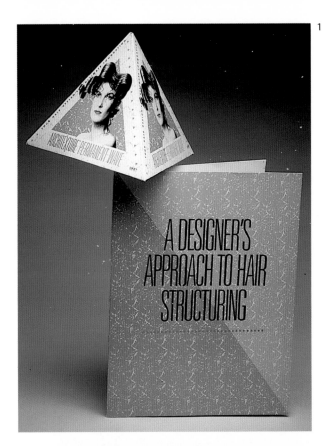

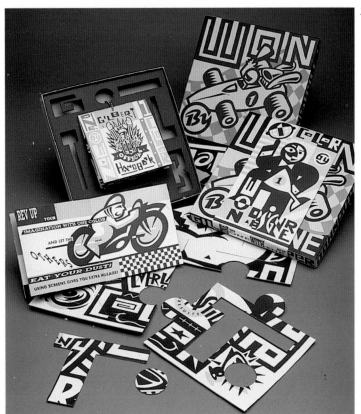

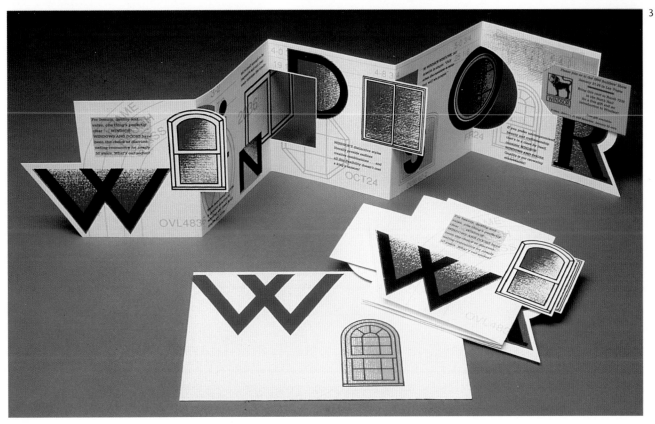

1
Design Firm, **Mike Quon Design Office**
Art Director, **Scott Fishoff**
Designer, **Mike Quon/E. Kinneary**
Illustrator, **Mike Quon**
Client, **Clairol**
Printing, 4-color

2
Design Firm, **Sayles Graphic Design**
Art Director, **John Sayles**
Designer, **John Sayles**
Illustrator, **John Sayles**
Copywriter, **Wendy Lyons**
Client, **Gilbert Paper**
Printing, 1-color on Gilbert Oxford (cover
 and text)

3
Design Firm, **Sayles Graphic Design**
Art Director, **John Sayles**
Designer, **John Sayles**
Illustrator, **John Sayles**
Copywriter, **Wendy Lyons**
Client, **Windsor Windows & Doors**
Printing, 3-color on James River Graphika Vellum
 White (cover)

1

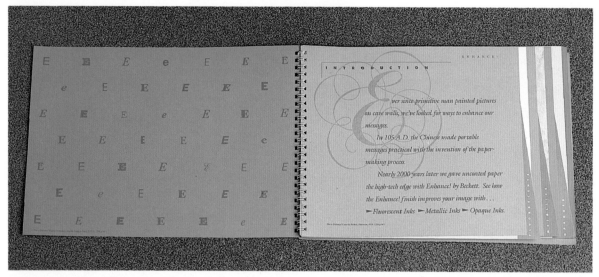

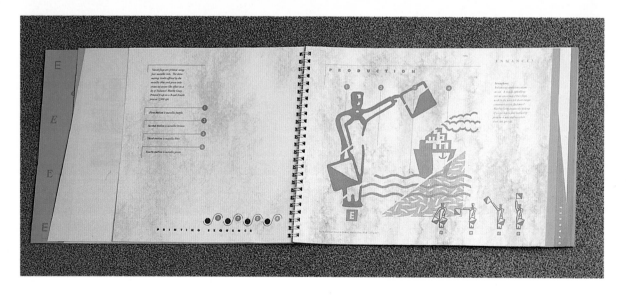

1
Design Firm, **Rickabaugh Graphics**
Art Director, **Eric Rickabaugh**
Designer, **Eric Rickabaugh**
Illustrator, **Michael Linley**
Photographer, **Paul Poplis**
Copywriter, **Daryl Knauer**
Client, **Beckett Paper Co.**
Printing, 50 inks, Beckett Enhance

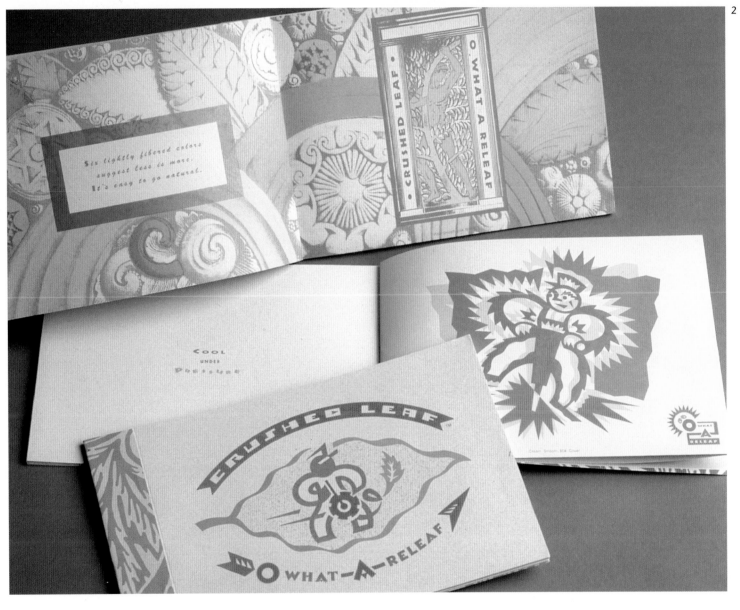

1
Design Firm, **Metalli Lindberg Advertising**
Art Director, **Stefano Dal Tin**
Designer, **Lionello Borean**
Client, **Felis Felix srl**
Printing, Recycled Paper

2
Design Firm, **Sayles Graphic Design**
Art Director, **John Sayles**
Designer, **John Sayles**
Illustrator, **John Sayles**
Client, **Howard Paper**
Printing, 5-color on Howard Paper Crushed Leaf
 (cover and text)

1

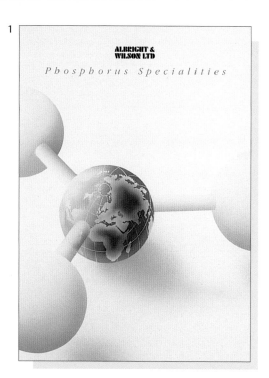

2

1
Design Firm, **Michael Davighi Associates Ltd.**
Art Director, **Michael Davighi**
Designer, **Pushpinder Ropra**
Copywriter, **Albright & Wilson**
Client, **Albright & Wilson**
Printing, 4-color on Huntsman Silk, spot UV varnish
 (cover), inside pictures machine varnished

2
Design Firm, **Rickabaugh Graphics**
Art Director, **Mark Krumel**
Designer, **Mark Krumel**
Photographer, **Tom Watson**
Copywriter, **Hillary Jeffers**
Client, **Huntington Banks**
Printing, 5-color and varnish, Champion Groove,
 (cover), Kromekote Simpson Evergreen (text)
 IRA Brochure

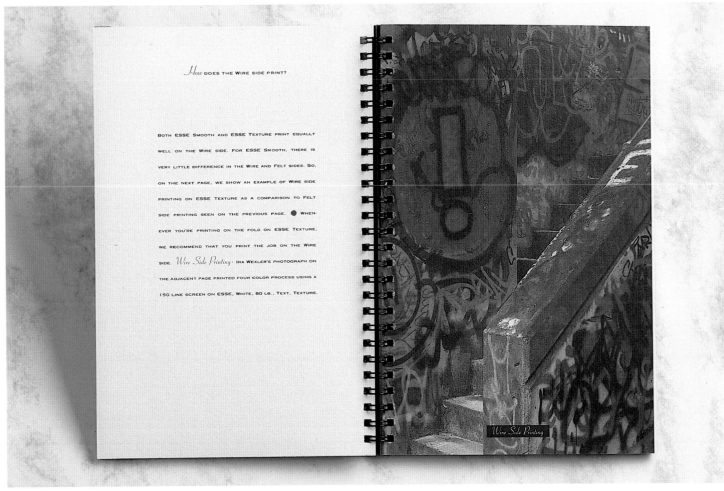

1
Design Firm, **Grafik Communications, Ltd.**
Design Team, **Melanie Bass/Judy F. Kirpich/**
 Gregg Glaviano
Copywriter, **Jake Pollard**
Client, **Gilbert Paper**

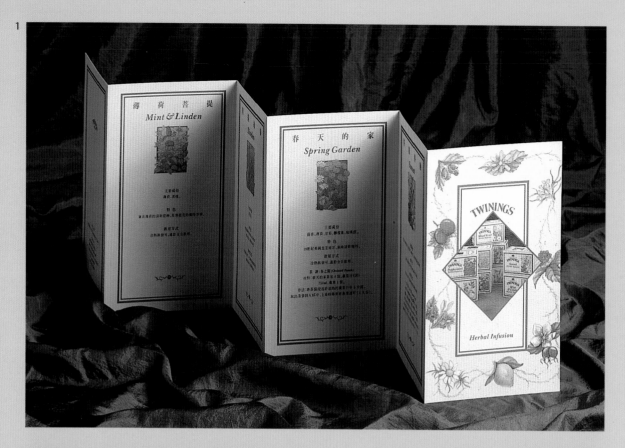

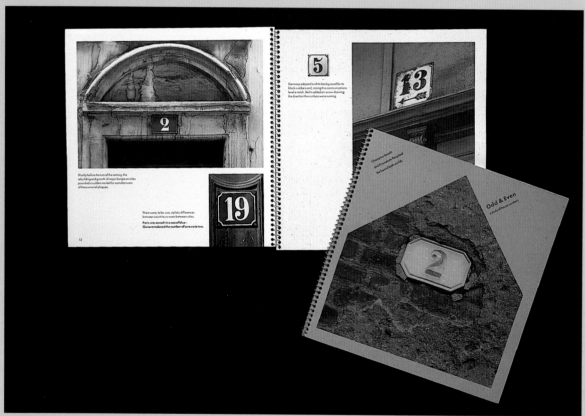

1
Design Firm, **Leslie Chan Design Co., Ltd.**
Art Director, **Leslie Chang Wing Kei**
Designer, **Leslie Chang Wing Kei**
Illustrator, **Tong Song Wei**
Photographer, **Eric Yu**
Client, **Tait Marketing & Distribution Co., Ltd.**
Printing, 4-color, PMS color on Neenah
 Artone Paper

2
Design Firm, **George Tscherny, Inc.**
Art Director, **George Tscherny**
Designer, **George Tscherny**
Assistant Designer, **Michelle Novak/Steve
 Tomkiewicz**
Photographer, **George Tscherny**
Client, **Champion International**
Printing, Champion Kromekote Recycled and
 Champion Benefit

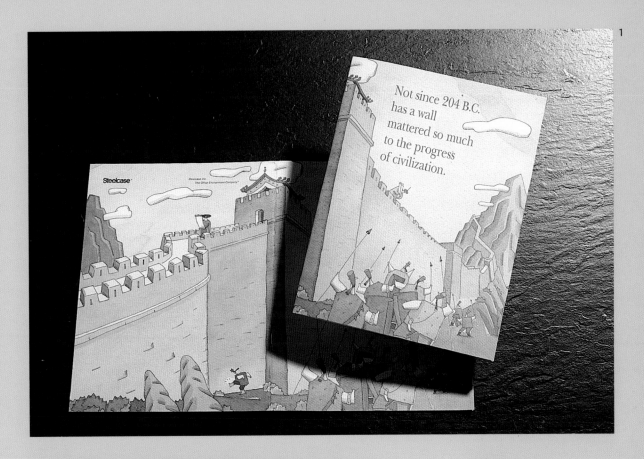

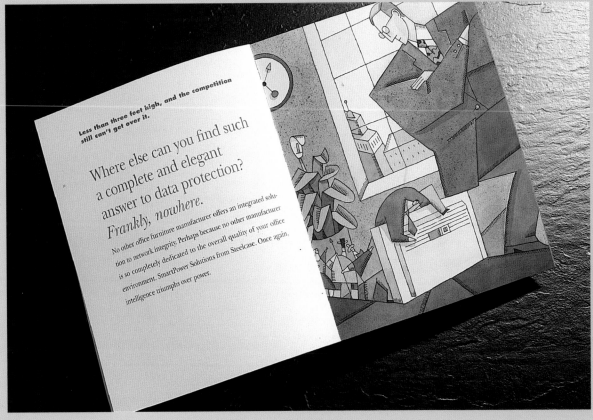

1
Design Firm, **Agnew Moyer Smith Inc.**
Art Director, **Don Moyer**
Designer, **John Sotirakis**
Illustrator, **Robin Jareaux**
Copywriter, **Rodger Morrow**
Client, **Steelcase Inc.**
Printing, 4-color plus 5th PMS match plus spot
 varnish on RSVP Royal Ivory (cover), Evergreen
 Matte Natural Book (text)

1

2

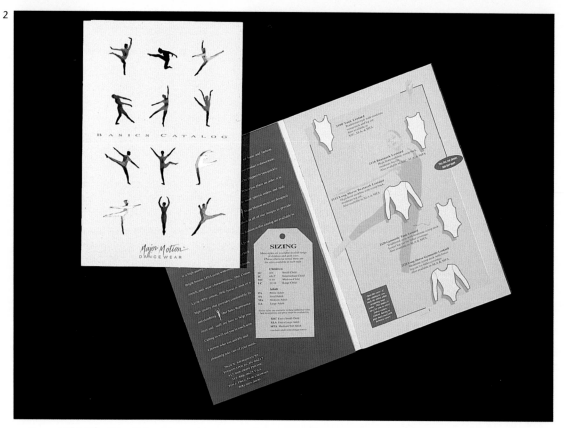

1
Design Firm, **Held & Diedrich**
Art Director, **Dick Held**
Designer, **Dick Held**
Illustrator, **Mario Noche**
Copywriter, **Mary Dugger**
Client, **Benchmark Products Inc.**

2
Design Firm, **Held & Diedrich**
Art Director, **Doug Diedrich**
Designer, **Doug Diedrich**
Illustrator, **Emily Wilson/Rod Geno**
Photographer, **Bob Wilson**
Copywriter, **Tom Wilson**
Client, **Major Motion Dancewear**

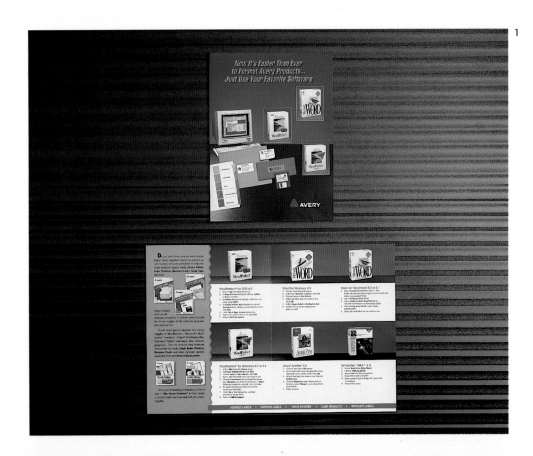

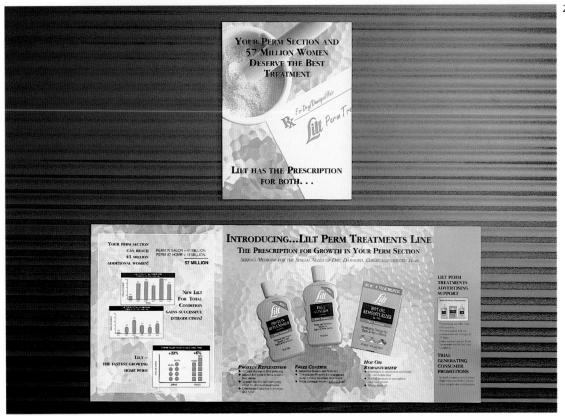

Design Firm, **David Slavin Design**
Art Director, **David Salvin**
Designer, **Suleman Poonja/Alfred Tenazas**
Photographer, **Wynn Miller**
Client, **Avery Alliance Program**
Printing, 5-color

Design Firm, **David Slavin Design**
Art Director, **David Slavin**
Designer, **Julie Welch**
Photographer, **Wynn Miller**
Client, **Lilt For Total Condition Perm Treatment**
Printing, 5-color

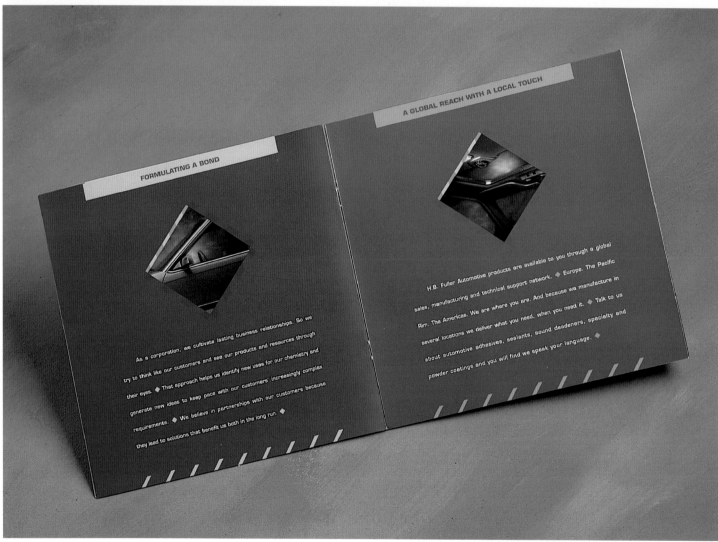

1
Design Firm, **Carmichael Lynch**
Art Director, **Peter Winecke**
Designer, **Peter Winecke/Bruce Mueller**
Photographer, **Steve McHugh**
Copywriter, **John Neumann**
Client, **H.B. Fuller**
Printing, 4-color, 16 pages

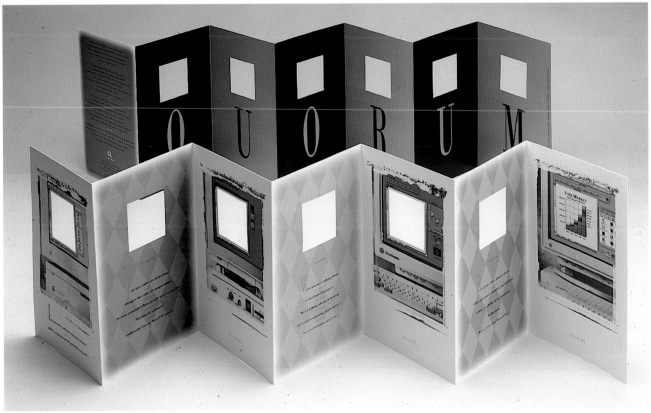

1
Design Firm, **GrandPré & Whaley Ltd.**
Art Director, **Kevin Whaley**
Designer, **Kevin Whaley**
Illustrator, **Kevin Whaley**
Photographer, **Mike Woodside**
Copywriter, **Tom Gibbons**
Client, **Interactive Technologies, Inc.**
Printing, 4-color process and Varnish 80 lb.
Productolith Cover

*The dollar sign on the cover is a 3-D sculpture with
hands scitexed to it.*

2
Design Firm, **Earl Gee Design**
Art Director, **Earl Gee**
Designer, **Earl Gee**
Photographer, **Joshua Ets-Hokin**
Copywriter, **Anne-Christine Strugnell**
Client, **Quorum Software Systems, Inc.**
Printing, 4-color process, 1 PMS, spot dull varnish,
 Simpson Kashmir Natural 65 lb. (cover)

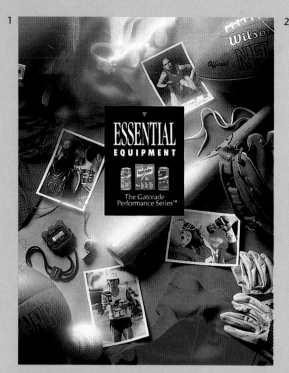

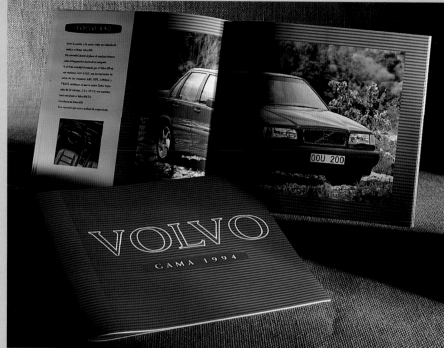

1
Design Firm, **McGuire Associates**
Art Director, **Jim McGuire**
Designer, **Julie Gleason**
Photographer, **Lorne Bidak**
Copywriter, **Walter Goldstein**
Client, **Frommer & Goldstein/Gatorade**
Printing, 4-color on Producto Lith/Gloss Text

2
Design Firm, **Eureka Advertising**
Art Director, **Javier Arcos Pitarque**
Designer, **Eureka Advertising, Madrid, Spain**
Photographer, **Eureka Advertising**
Copywriter, **José Vivanco**
Client, **Volvo Spain**

3
Design Firm, **Riley Design Associates**
Art Director, **Daniel Riley**
Designer, **Daniel Riley**
Illustrator, **Daniel Riley**
Client, **Kaiser Bakeware Company, Germany**
Printing, 5-color and spot varnish, duotone
 photographs

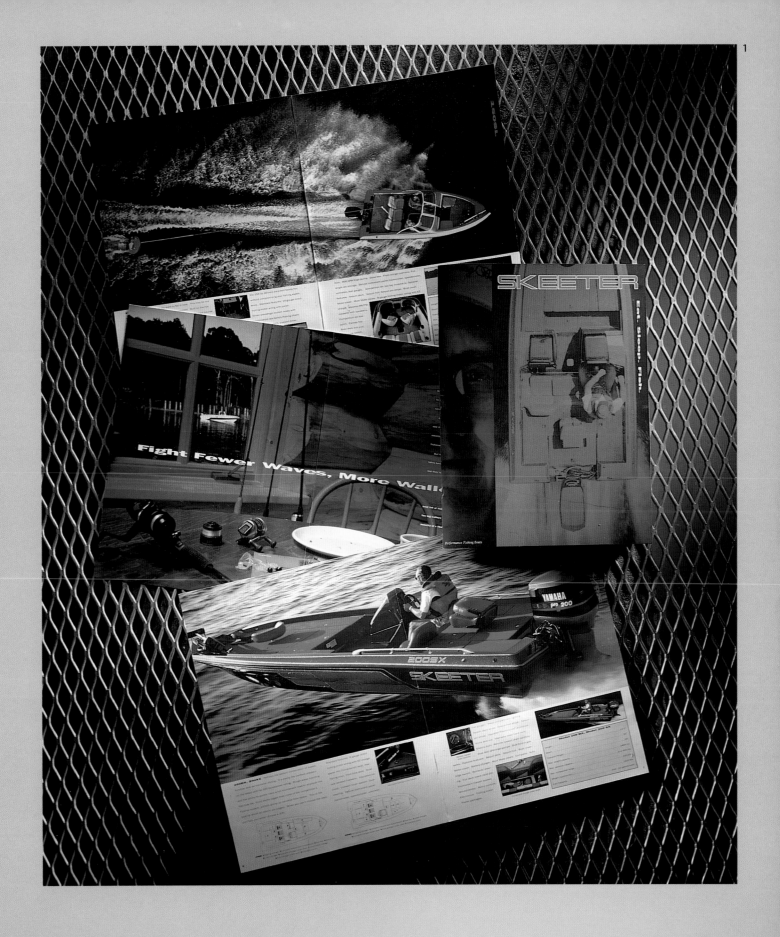

1
Design Firm, **Carmichael Lynch**
Art Director, **Peter Winecke**
Designer, **Peter Winecke**
Photographer, **Steve McHugh**
Copywriter, **John Neumann**
Client, **Skeeter**
Printing, 4-color, 32 pages

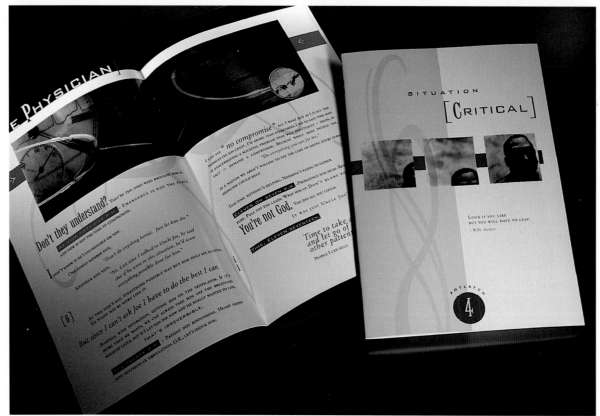

1
Design Firm, **Vrontikis Design Office**
Art Director, **Petrula Vrontikis**
Designer, **Petrula Vrontikis**
Photographer, **Tim Jones/Everard Williams Jr./
 Paul Ottengheime, Abrams/Lacagnina**
Copywriter, **Victoria Branch**
Client, **Potlatch Corporation**
Printing, 5-color plus dull varnish on Potlatch
 Eloquence

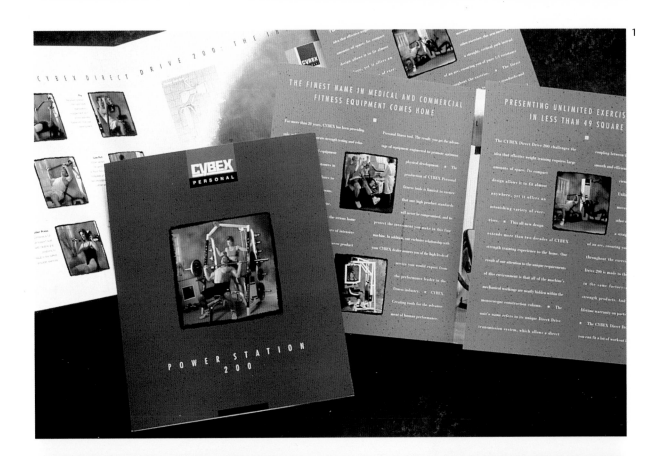

1
Design Firm, **Hornall Anderson Design Works**
Art Director, **Jack Anderson**
Designer, **Jack Anderson/David Bates/
 Julie Keenan/Jeff McClard**
Photographer, **Darrell Peterson**
Copywriter, **Cybex**
Client, **Cybex**
Printing, 6-color over 5-color on Lustro Dull Cover

2
Design Firm, **Riley Design Associates**
Art Director, **Daniel Riley**
Designer, **Daniel Riley**
Photographer, **Michael Collopy**
Client, **Jingirian Company**
Printing, 4-color and varnish, gold foil cover

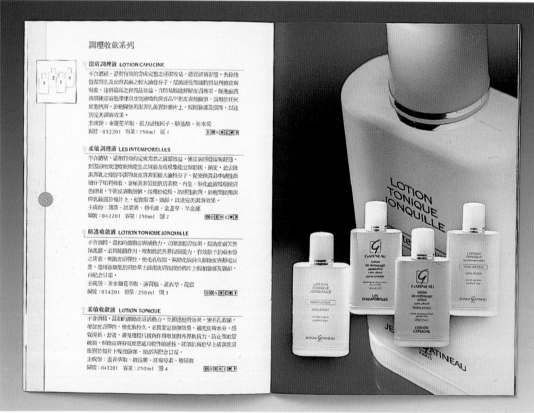

1
Design Firm, **Artailor Design House**
Art Director, **Raymond Lam**
Designer, **Stephen Lau/Vivian Yao**
Photographer, **Dynasty Photography**
Client, **Cosactive & Jeffrey Co., Ltd.**
Printing, 6-color and 6-color Zanders Chromlux

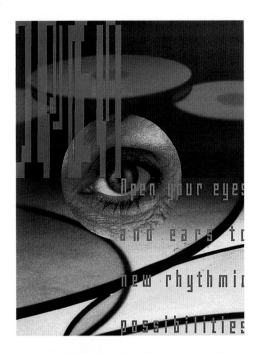

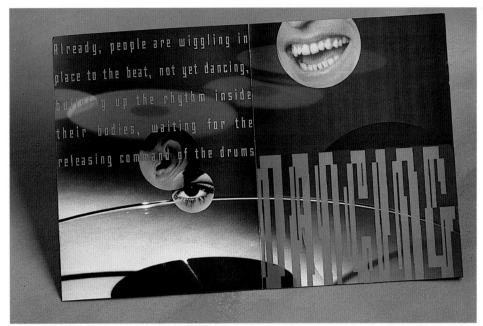

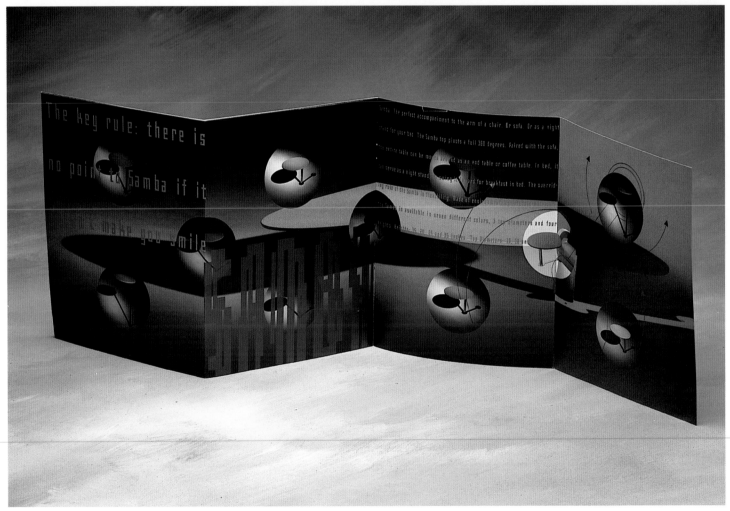

1
Design Firm, **Margo Chase Design**
Art Director, **Margo Chase**
Designer, **Margo Chase**
Photographer, **Doug Slone**
Copywriter, **Kotaro Shimogori/Julie Prenderville**
Client, **Kotaro Shimogori**
Printing, 4-color plus integrated metallic

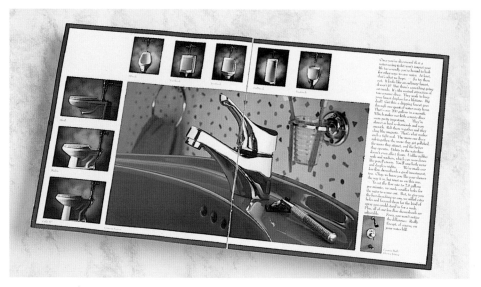

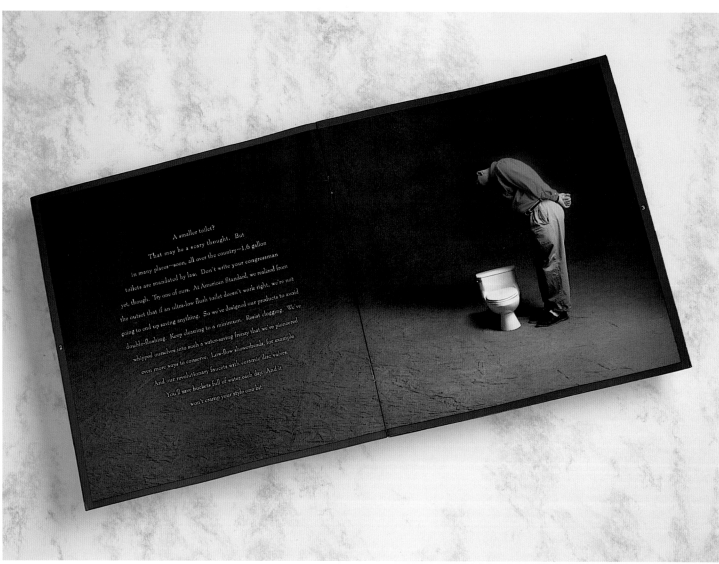

1
Design Firm, **Carmichael Lynch**
Art Director, **Peter Winecke**
Designer, **Peter Winecke**
Photographer, **Lars Hanson**
Copywriter, **John Neumann**
Client, **American Standard**
Printing, 4-color, 8 pages

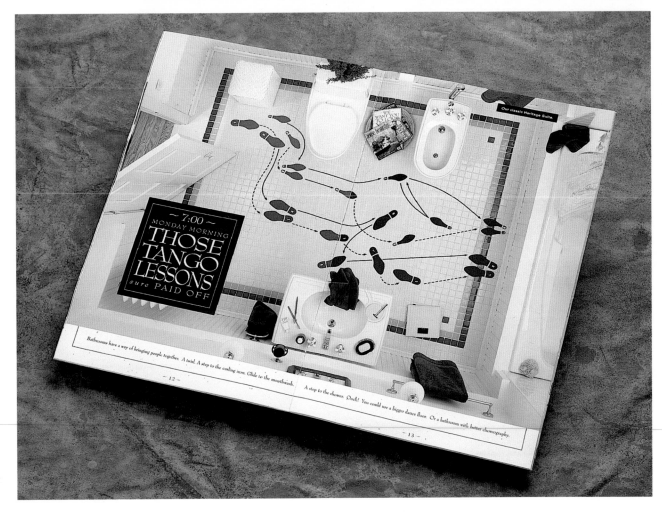

1
Design Firm, **Carmichael Lynch**
Art Director, **Peter Winecke**
Designer, **Peter Winecke**
Photographer, **Lars Hanson/Steve McHugh**
Copywriter, **John Neumann**
Client, **American Standard**
Printing, 4-color, 32 pages

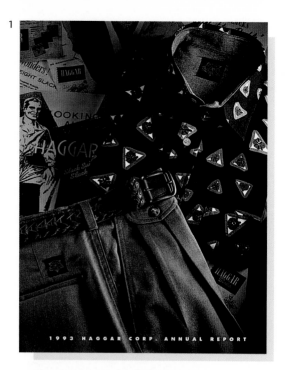

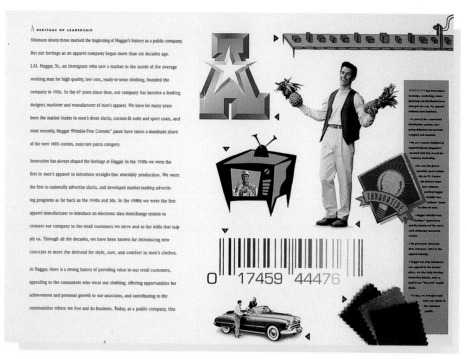

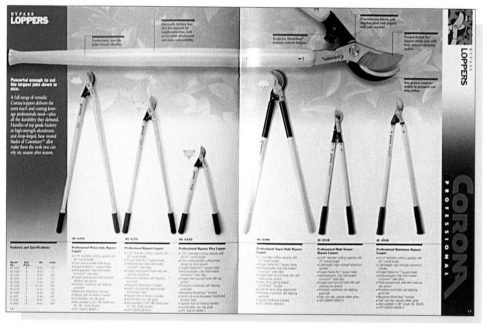

1
Design Firm, **SullivanPerkins**
Art Director, **Ron Sullivan**
Designer, **Rob Wilson/Art Garcia**
Illustrator, **Rob Wilson/Shaun Marshall/
 Randy Sheya/Dan Richards**
Photographer, **Gerry Kano/Robb Debenport**
Copywriter, **Mark Perkins/Hilary Kennard**
Client, **Haggar Apparel Company**
Printing, 8-color on Ikonofix Dull

2
Design Firm, **The Van Noy Group**
Art Director, **Jim Van Noy**
Designer, **Dave Sapp**
Illustrator, **Joe Muizar**
Photographer, **Mercier/Wimberg**
Client, **Corona Clipper Corporation**
Printing, 8-color Vintage Dull Paper

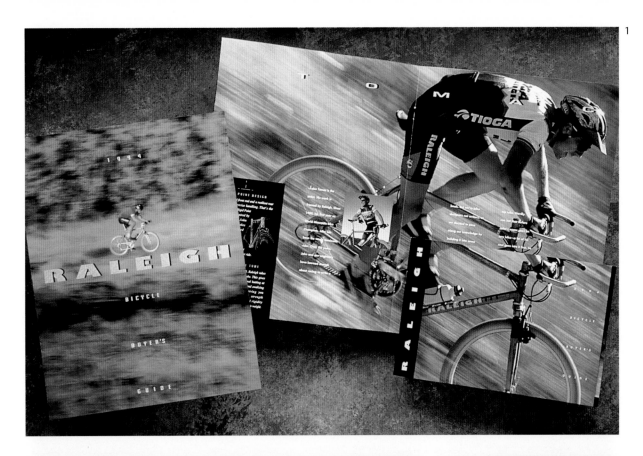

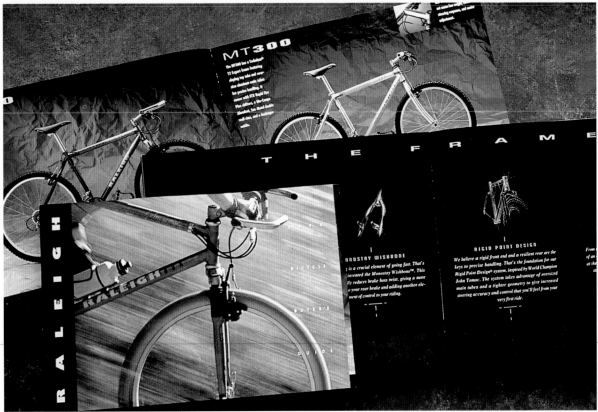

1
Design Firm, **Hornall Anderson Design Works**
Art Director, **Jack Anderson**
Designer, **Jack Anderson/David Bates/Julie
Keenan, John Anicker/Mary Chin Hutchison**
Illustrator, **Bruce Morser**
Photographer, **Steve Bonini**
Client, **Raleigh Cycle Company of America**
Printing, *6-color over 5-color on American Eagle
Gloss Book*

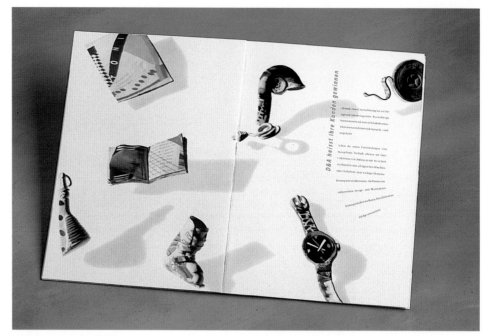

1
Design Firm, **D&A Diego Bally AG**
Art Director, **Felix Dammann**
Designer, **Diego Bally**
Illustrator, **Urs Roos**
Photographer, **Roland Kniel**
Copywriter, **Christoph Fuchs**
Client, **D&A Diego Bally AG**

2
Design Firm, **Hannum Graphics**
Art Director, **Neil Hannum**
Designer, **Neil Hannum**
Photographer, **Gunnar Conrad**
Copywriter, **Brett Hahn**
Client, **Yeti Cycles**
Printing, 4-color, Cross Pointe, Genesis Milkweed
 100 lb. (text)

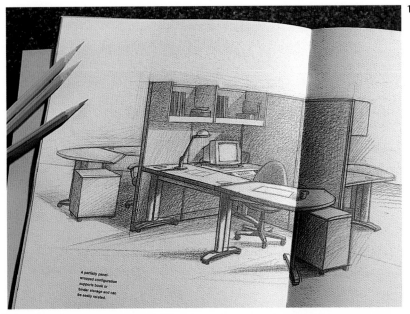

Design Firm, **Agnew Moyer Smith Inc.**
Art Director, **Don Moyer**
Designer, **Gina Kennedy**
Illustrator, **Mark Mentzer/Rick Henkel**
Typographer, **Christina Papp**
Copywriter, **Christine Hollinger**
Client, **Steelcase Inc.**
Printing, 4-color plus 1 PMS plus 1 varnish on
 Quintessence Remarque Dull

*Proterra Felt Canyon Gray, also features two 16-
page signatures each saddle stitched independently
then stitched into a 4-page cover.*

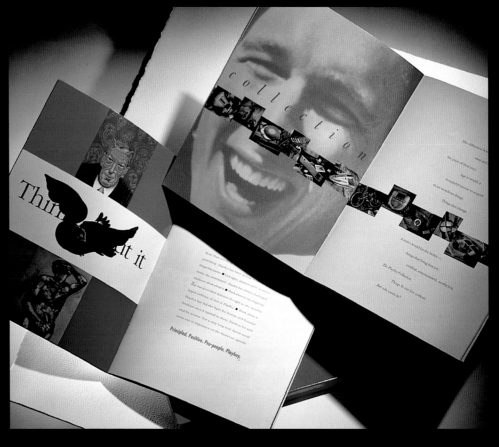

1
Design Firm, **Playboy**
Art Director, **Maria Volpe**
Designer, **Marise Mizrahi**
Illustrator, **Marise Mizrahi**
Copywriter, **Irv Kornblau**
Client, **Playboy**
Printing, 3-color, Zanders T-2000, Elephant Hide
 and Vellum, 2 metallic on Elephant Hide Paper

2
Design Firm, **Playboy**
Art Director, **Maria Volpe**
Designer, **Marise Mizrahi/Sonal Shah**
Copywriter, **Irv Kornbau**
Client, **Playboy Media Kit**
Printing, 6-color on Gilbert Esse Reflections

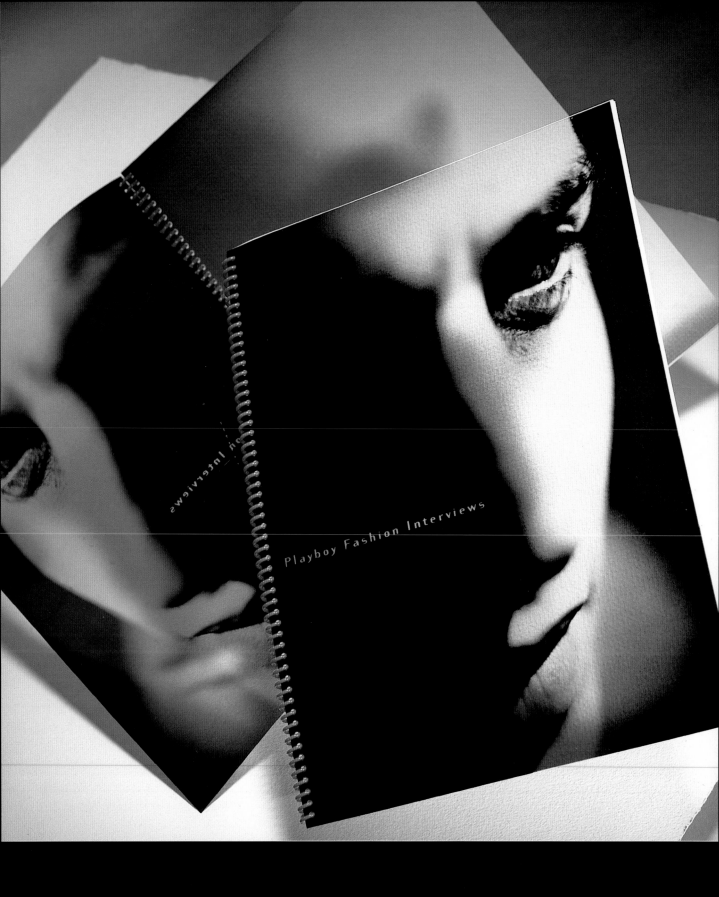

Playboy Fashion Interviews

1
Design Firm, **Playboy**
Art Director, **Marise Mizrahi**
Designer, **Marise Mizrahi**
Photographer, **Greg Weiner**
Client, **Playboy**
Printing, 4-color on Strathmore Grandee
and Acetate

1

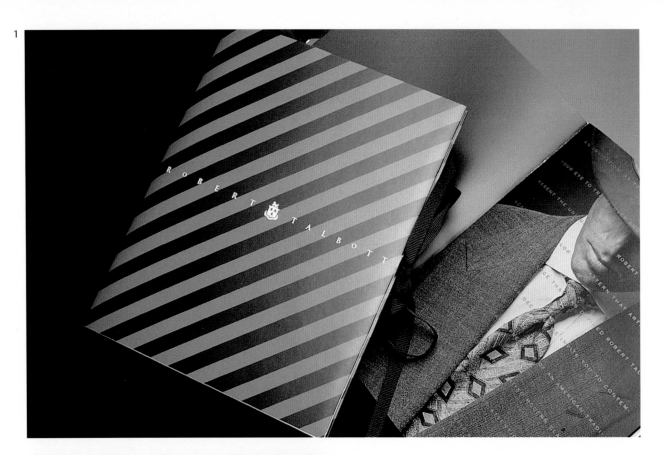

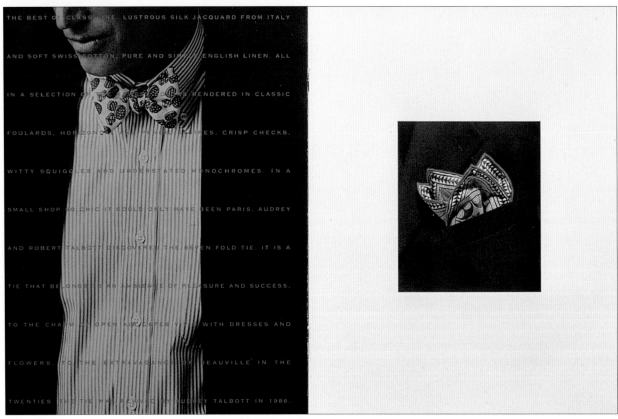

1
Design Firm, **Vanderbyl Design**
Art Director, **Michael Vanderbyl**
Designer, **Michael Vanderbyl**
Photographer, **David Peterson**
Copywriter, **Penny Benda**
Client, **Robert Talbott, Inc.**
Printing, 6-color on Magnoprint

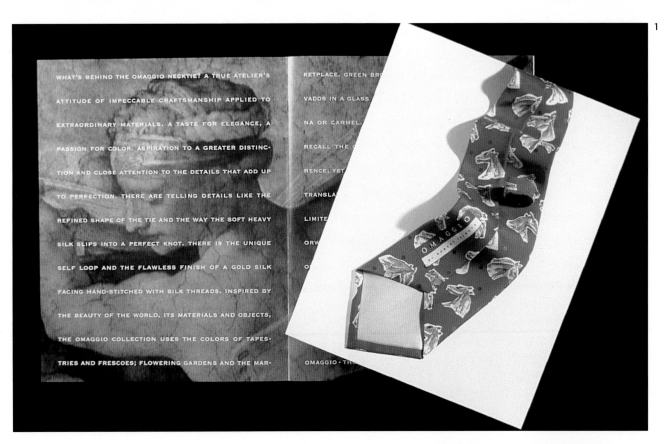

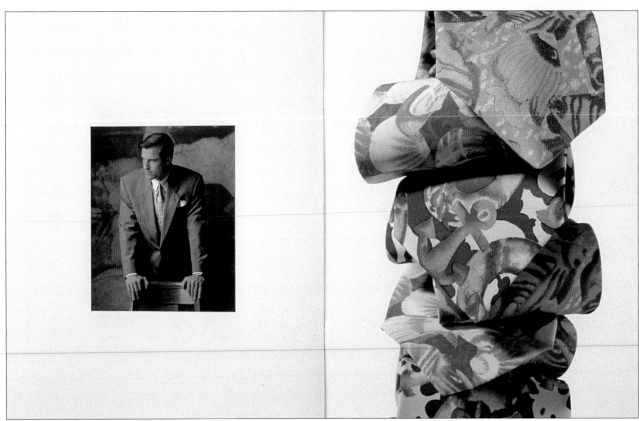

Design Firm, **Vanderbyl Design**
Art Director, **Michael Vanderbyl**
Designer, **Michael Vanderbyl**
Photographer, **David Peterson**
Copywriter, **Penny Benda**
Client, **Robert Talbott, Inc.**
Printing, 4-color on Parilux

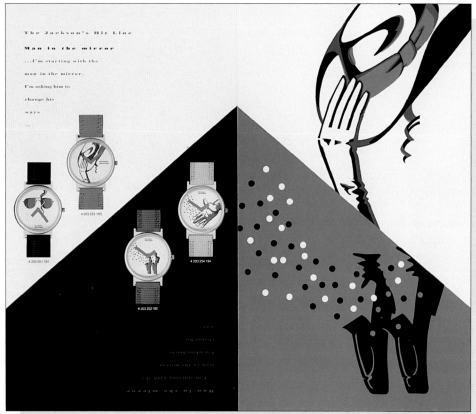

1
Design Firm, **Camellia Cho Design**
Art Director, **Camellia Cho/Annie Lee**
Designer, **Camellia Cho**
Illustrator, **Annie Lee**
Photographer, **Wayne Lam**
Client, **GMK Marketing Ltd.**

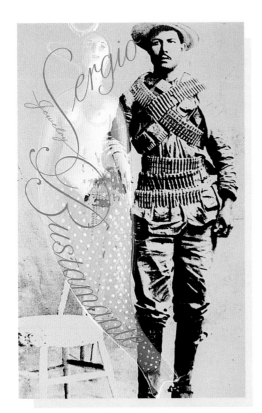

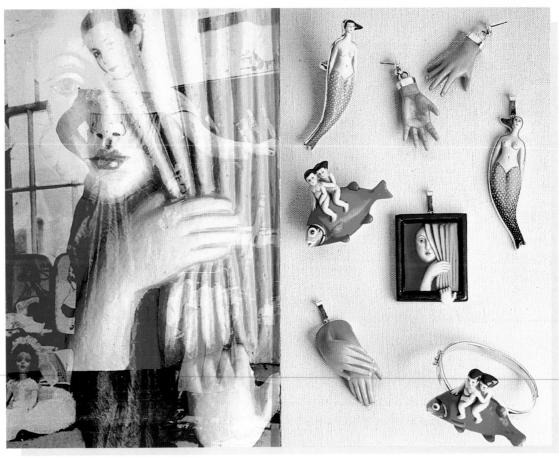

1
Design Firm, **Tyler Smith**
Art Director, **Tyler Smith**
Designer, **Tyler Smith**
Collages, **Tyler Smith**
Photographer, **Dave Gilstein**
Client, **Sergio Bustamante**
Printing, 4-color on Mead Signature Vintage
 Mexican Paper

1

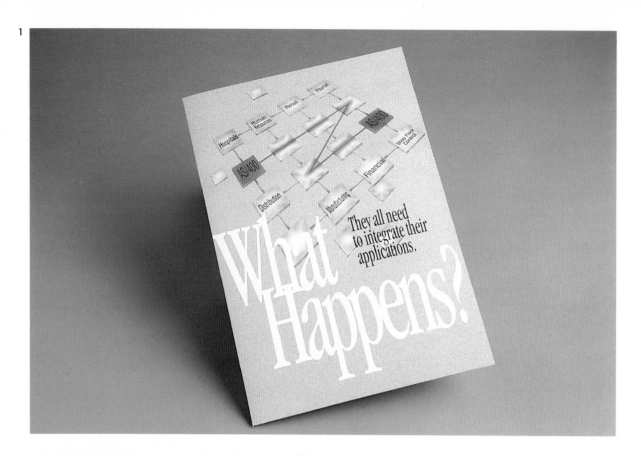

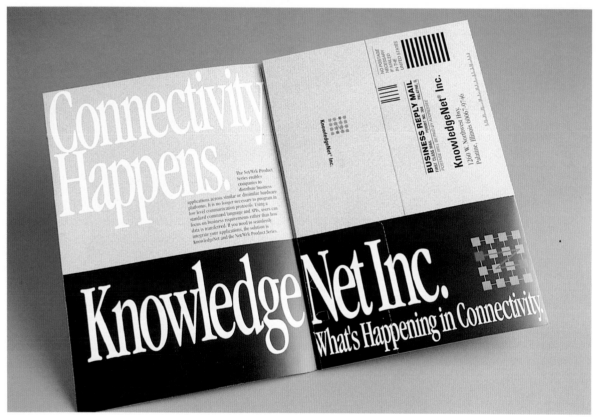

1
Design Firm, **PGM, Inc.**
Art Director, **Francis E. Shimandle**
Designer, **Francis E. Shimandle**
Illustrator, **Arlene Lowe/PGM, Inc.**
Photographer, **Gary Steadman/PGM, Inc.**
Copywriter, **Robert Stein**
Client, **KnowledgeNet, Inc.**
Printing, 4-color over 2-color on Cover Stock, die-
 cut postcard and rolodex card

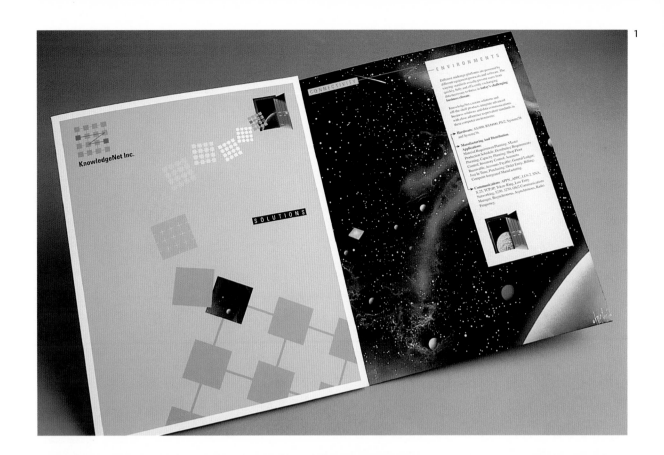

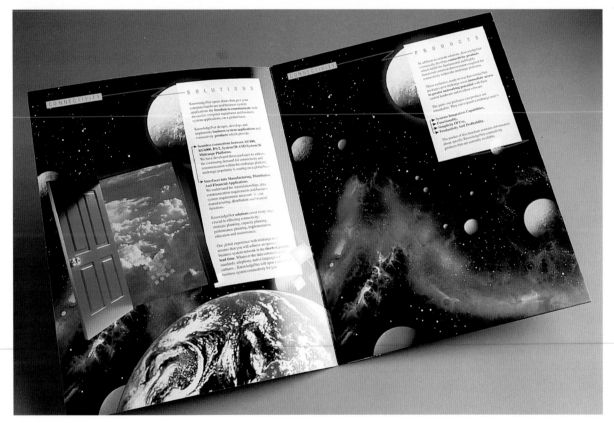

1
Design Firm, **PGM, Inc.**
Art Director, **Francis E. Shimandle**
Designer, **Mike Pantuso**
Photographer, **Stock Photography**
Copywriter, **Robert Stein**
Client, **KnowledgeNet, Inc.**
Printing, 5-color on Enamel Cover, die-cut
 pocket for inserts

Virginia, Massachusetts and the Blue Ridge Mountains in the 18th century. Grammar school history and Ralph Lauren's "classic" style (rumpled English weekend in the country house) are incomplete at best. American design owes its richness to the fugitives, visionaries and refugees from Poland, Vietnam and Ghana, as well as local rural expressions of daily life. European design is closely tied to the assumptions and traditions of the modern, even when it is heretical. Modernism and the International Style which welded form to function for eternity, has inspired great design. But Porsche sunglasses, a Hasselblatt camera or an Armani suit are no more common in Europe than Michael Graves' teapots or Frank Gehrys' chairs are common in America. Innovative and intelligent design does not penetrate society as a whole in Europe, Japan or the United States... unfortunately, artful things are not found lying artlessly about. Good design is

THE ENDURING SUCCESS OF KNOLL AND HERMAN MILLER, WHO SUPPORTED DESIGNERS SUCH AS CHARLES AND RAY EAMES, GEORGE NELSON AND HARRY BERTOIA, CONVINCED OTHER MANUFACTURERS OF THE PROFITABILITY OF INVITING DESIGNERS LIKE THE EAMES' TO SET STANDARDS OF AESTHETICS AND PERFORMANCE IN THE INDUSTRY. INVENTIVE, EFFICIENT AND BEAUTIFUL PRODUCTS HAVE KEPT USERS HAPPY AND MANU-FACTURERS IN THE BLACK.

1
Design Firm, **Vanderbyl Design**
Art Director, **Michael Vanderbyl**
Designer, **Michael Vanderbyl**
Photographer, **Michele Clement**
Copywriters, **Penny Benda/Michael Vanderbyl**
Client, **Champion Paper Company**
Printing, 6-color on Kromekote Recycled

COMMERCIAL METALS COMPANY

1993 ANNUAL REPORT

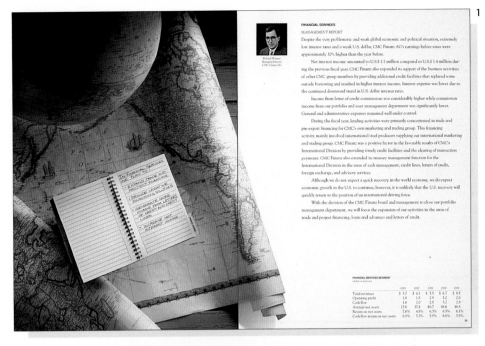

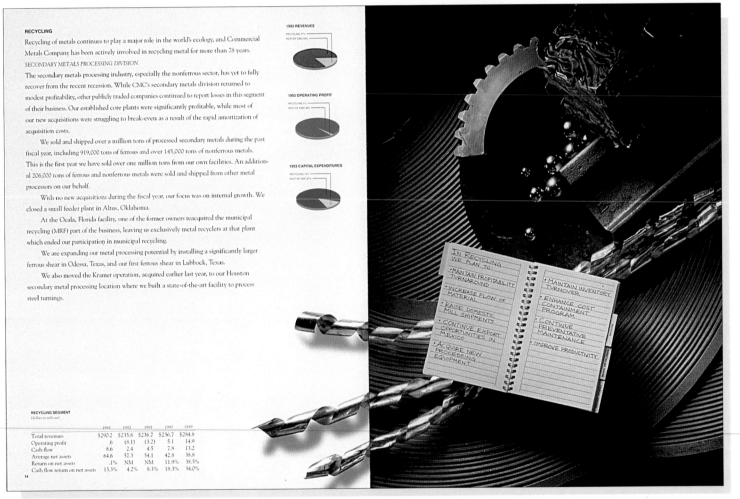

1
Design Firm, **SullivanPerkins**
Art Director, **Ron Sullivan/Mark Perkins**
Designer, **Dan Richards/Art Garcia/**
 Shaun Marshall
Photographer, **Tom Welch**
Copywriter, **Commercial Metals**
Client, **Commercial Metals**
Printing, 4-color plus 1 PMS with varnish on
 Warren Lustro Dull

1

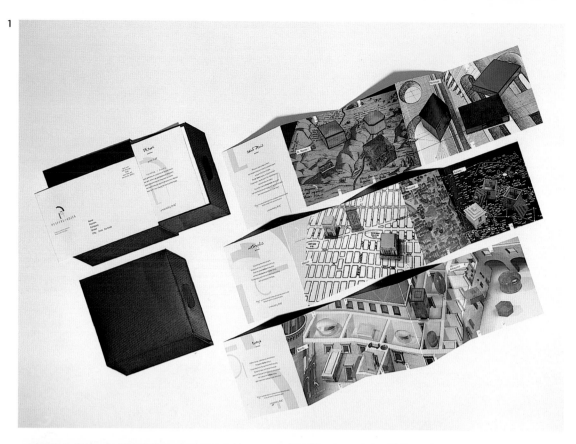

2

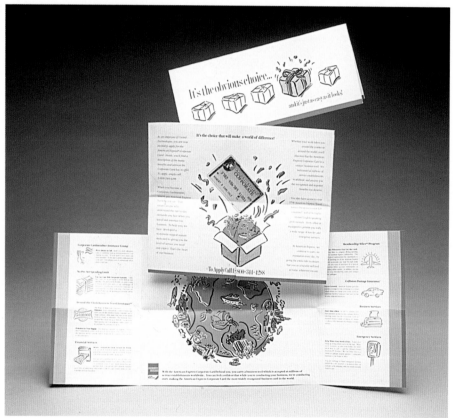

1
Design Firm, **O&J Design, Inc.**
Art Director, **Andrzej Olejniczak**
Designer, **Andrzej Olejniczak/Inhi Clara Kim**
Illustrator, **Seymour Chawst**
Client, **Sotheby's**
Printing, 6-color on Simpson Gainsborough
(cover), 4-color on Potlatch Vintage Velvet (text)

2
Design Firm, **Mike Quon Design Office**
Art Director, **Mike Quon/H. Samkange**
Designer, **Mike Quon/Erick Kuo**
Illustrator, **Mike Quon**
Copywriter, **Robin Jones**
Client, **American Express**
Printing, 4-color, unique fold

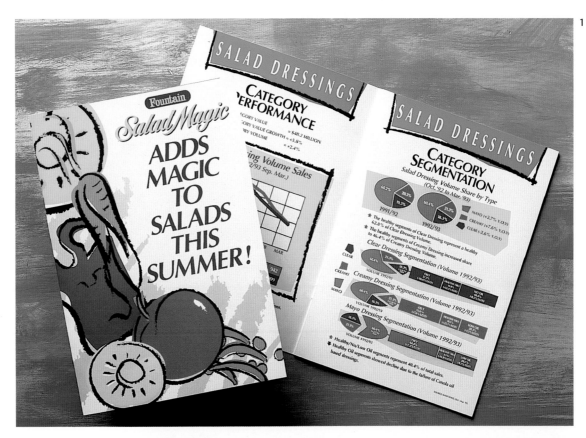

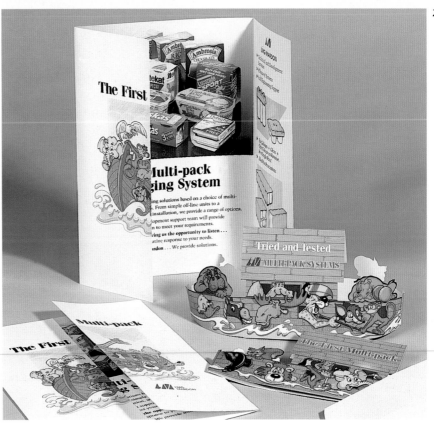

1
Design Firm, **Elton Ward Design**
Art Director, **Steve Coleman**
Designer, **Chris De Lissen**
Illustrator, **Chris De Lissen**
Photographer, **Natalie Arditto**
Client, **Cerebos Australia**
Printing, 4-color plus Celloglaze

2
Design Firm, **Plaza Design & Artwork**
Art Director, **Peter Howe**
Designer, **Peter Howe**
Illustrator, **Peter Howe**
Copywriter, **L.M.G.**
Client, **Lawson Mardon Group**

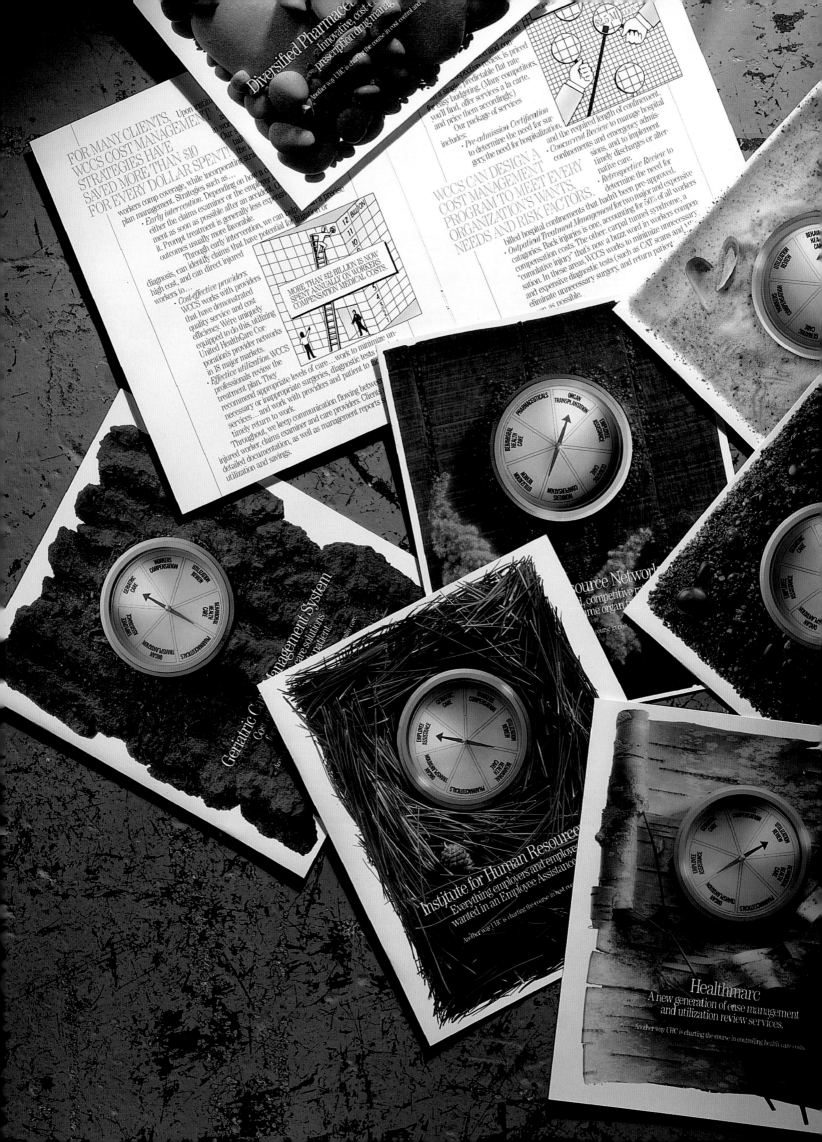

SERVICE BOOKLETS

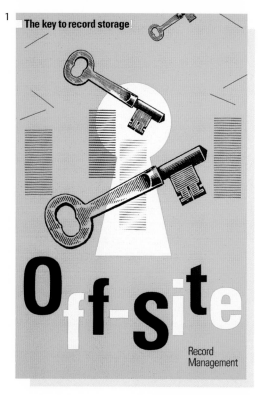

The key to record storage

Off-Site
Record Management

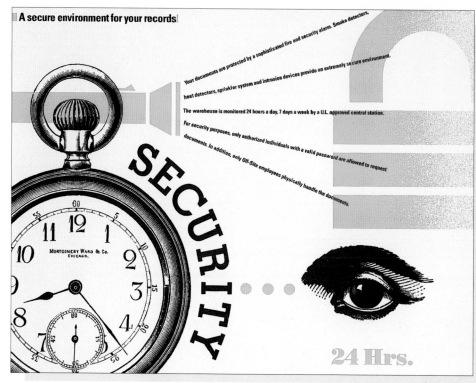

A secure environment for your records

Your documents are protected by a sophisticated fire and security alarm. Smoke detectors, heat detectors, sprinkler system and intrusion devices provide an extremely secure environment.

The warehouse is monitored 24 hours a day, 7 days a week by a U.L. approved central station.

For security purposes, only authorized individuals with a valid password are allowed to request documents. In addition, only Off-Site employees physically handle the documents.

SECURITY

MONTGOMERY WARD & CO. CHICAGO.

24 Hrs.

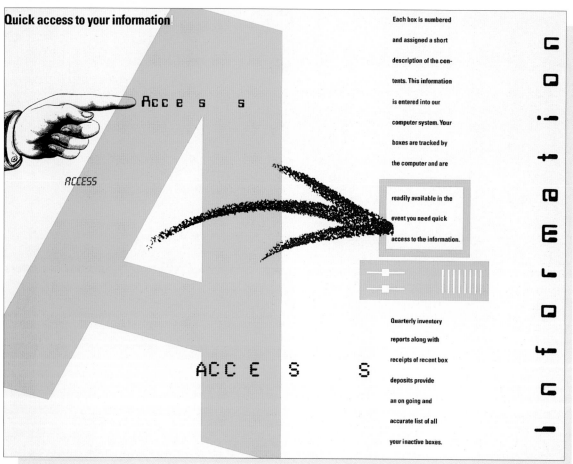

Quick access to your information

Access

ACCESS

ACC E S S

Each box is numbered and assigned a short description of the contents. This information is entered into our computer system. Your boxes are tracked by the computer and are readily available in the event you need quick access to the information.

Quarterly inventory reports along with receipts of recent box deposits provide an on going and accurate list of all your inactive boxes.

1
Design Firm, **Earl Gee Design**
Art Director, **Earl Gee**
Designer, **Earl Gee**
Illustrator, **Earl Gee**
Photographer, **Bill Delzell**
Copywriter, **Beth Siebert/Julie Fucilla**
Client, **Off-Site Record Management**
Printing, 2 PMS, Simpson Evergreen Matte
 80 lb. (cover)

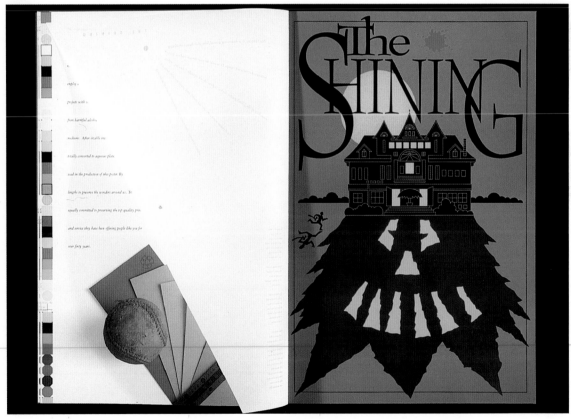

1
Design Firm, **Rickabaugh Graphics**
Art Director, **Eric Rickabaugh**
Designer, **Eric Rickabaugh**
Illustrator, **Eric Rickabaugh/Fred Warter/Michael
 Tennyson Smith**
Photographer, **Paul Poplis**
Copywriter, **Lauren Smith**
Client, **Byrum Lithographing Co.**
Printing, 16-color

1

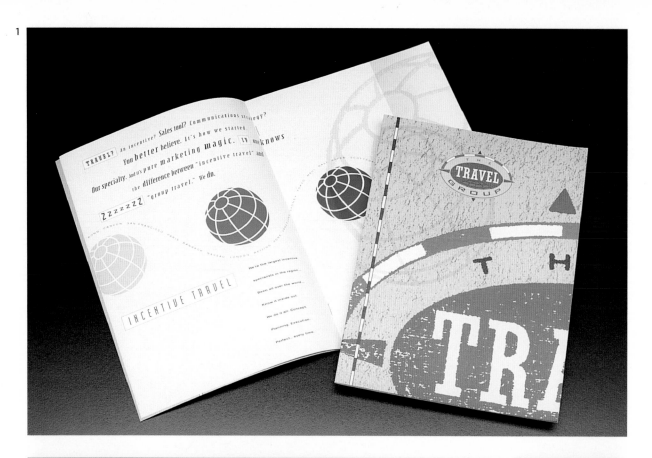

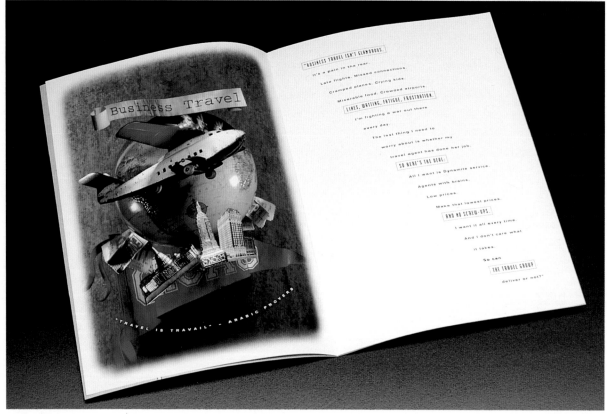

1
Design Firm, **Lee Reedy Design Associates, Inc.**
Art Director, **Lee Reedy**
Designer, **Lee Reedy**
Illustrator, **Lee Reedy**
Photographer, **Brad Bartholomew**
Copywriter, **Suzy Patterson**
Client, **Travel Group**
Printing, 4-color

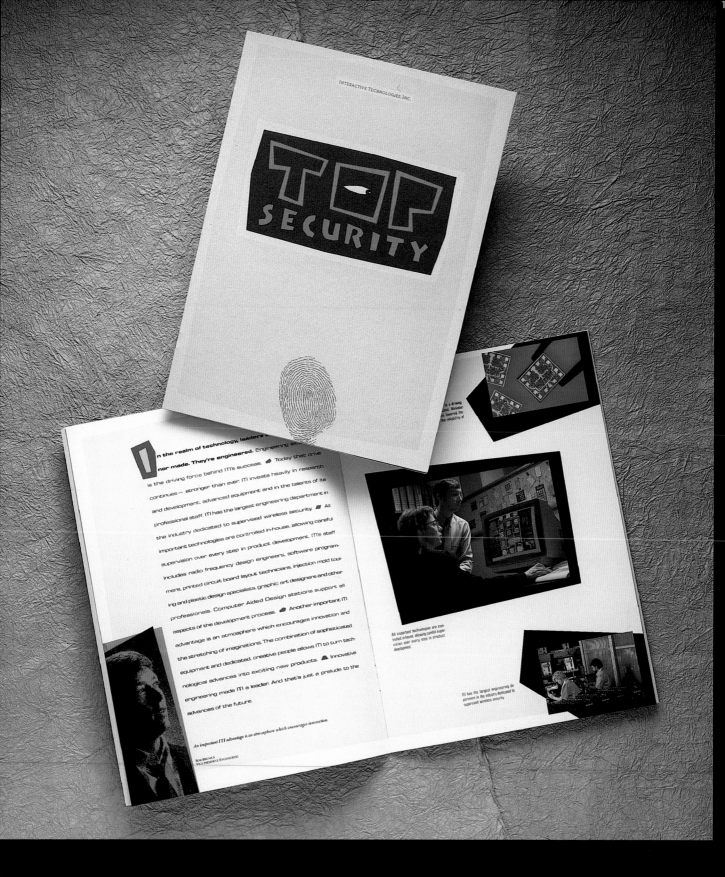

1
Design Firm, **GrandPré & Whaley Ltd.**
Art Director, **Kevin Whaley**
Designer, **Kevin Whaley**
Illustrator, **Kevin Whaley**
Photographer, **Mike Woodside**
Copywriter, **Tom Gibbons**
Client, **Interactive Technologies, Inc.**
Printing, 6-color on Strathmore (cover),
 Quintessence, 4-color and two varnishes (text)

*The "eye" in the middle of the "O" on the cover was
achieved with two passes of white.*

1

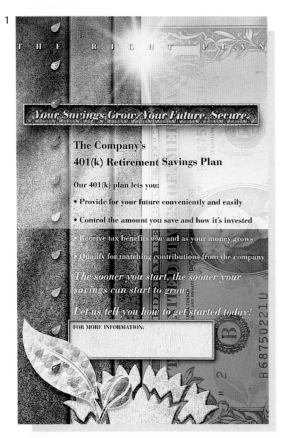

THE RIGHT PLAN

Your Savings Grow. Your Future, Secure.

**The Company's
401(k) Retirement Savings Plan**

Our 401(k) plan lets you:

• Provide for your future conveniently and easily

• Control the amount you save and how it's invested

• Receive tax benefits *now* and as your money grows

• Qualify for matching contributions from the company

*The sooner you start, the sooner your
savings can start to grow.*

Let us tell you how to get started today!

FOR MORE INFORMATION:

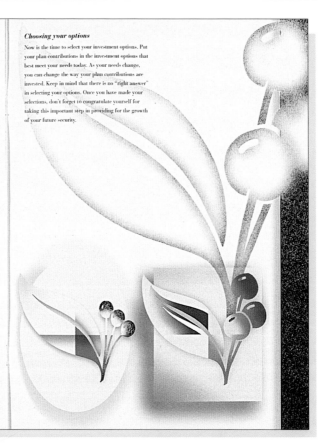

Investing in Stocks

If stocks perform so much better than bonds or Treasury bills, why doesn't everyone invest all their money in stocks? The answer is that stocks fluctuate more in value over the short term than other types of investments. In other words, investors must realize that along with the possible rewards of investing in the stock market comes added risk in the form of possible short term fluctuations in value.

Most experts strongly recommend that young investors invest a significant portion of their assets in stocks because they have the time to wait out the short term fluctuations in value. Even investors closer to retirement are usually encouraged to invest a portion of their assets in stocks in order to take advantage of the greater potential for growth.

You must decide how much "risk" you are comfortable with. You can invest some of your money in investment options that invest in bond funds or money market funds to reduce the risk of fluctuations in the value of your savings. However, you will also be giving up the potential for the higher returns that have historically been available only in the

stock market. In addition, keep in mind that if you invest *too* conservatively, inflation may eat up a significant part of your investment returns.

Finding a balance between high returns on your investments with minimal fluctuations in the value of your account can be difficult. But, your plan helps by giving you the opportunity to spread your money among a number of options with different degrees of risk. Try the ones you are comfortable with now and remember that you can change your options as your needs change.

How does inflation affect my account?

Inflation is a silent partner in all your investments. Each year inflation reduces the purchasing power of your dollar. This means that your investments must earn at least as much as the rate of inflation just to stay even. For example, if the rate of inflation is 3% per year and you earn 5% on your investments, you have gained only 2% in terms of additional purchasing power. If you earn only 2% on your investments you are actually losing purchasing power.

Choosing your options

Now is the time to select your investment options. Put your plan contributions in the investment options that best meet your needs today. As your needs change, you can change the way your plan contributions are invested. Keep in mind that there is no "right answer" in selecting your options. Once you have made your selections, don't forget to congratulate yourself for taking this important step in providing for the growth of your future security.

1
Design Firm, **Design Seven, Inc.**
Designer, **Debbie Hayes/Bill Calder**
Illustrator, **Bill Calder**
Client, **The Adam Network**
Printing, 4-color with varnish

*All illustrations, charts and textures created on the
Mac using Adobe Photoshop.*

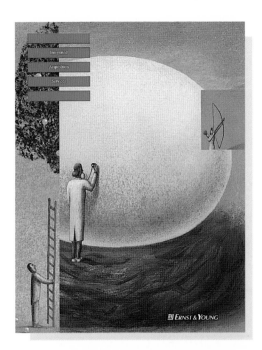

"We need this strategic acquisition. How do we get this deal done—and at a fair price?" That was the question facing a mid-sized manufacturing firm looking to simultaneously broaden its product lines and expand its manufacturing capabilities. Needing to evaluate the target and develop overall pricing parameters, the company—already a long-time Ernst & Young client—turned to our corporate finance professionals for assistance. Our preliminary analysis revealed that the ultimate pricing and structure of the transaction would be affected by a number of diverse, yet interrelated, issues. The appropriate Ernst & Young resources were pulled together and—working closely with the client's management and legal advisors—helped to quantify and assess these issues so the deal would be priced, structured and financed appropriately.

Health care benefits were reviewed by our employee benefits professionals. Based on this review, we were able to estimate the unfunded post-retirement benefits liabilities the client would assume as a result of the acquisition, and help the client ensure that these liabilities were properly reflected in the final purchase price. We also identified certain cost-saving opportunities that could be realized after the closing.

Senior and mezzanine financing were placed with the assistance of our corporate finance professionals. We helped develop the financing structure, a comprehensive financing proposal, and assisted management in preparing prospective financial information.

Manufacturing consultants helped client management assess plant layouts, quality initiatives, and global order fulfillment practices. We developed specific plans for reducing inventory and operating expenses, while simultaneously reducing cycle time. This ultimately resulted in increased cash flow that enhanced the client's ability to retire its acquisition debt.

Valuations of the target's tangible and intangible assets were prepared by our valuation services professionals. These valuations were key in determining a viable financing structure for the transaction.

Environmental issues surrounding the target's three manufacturing plants presented unknown liabilities that threatened the transaction. Our environmental professionals evaluated each of these issues, plant-by-plant, assessing the potential for additional unknown liabilities. The result? Compensation for potential liabilities was negotiated and an escrow was provided in the final purchase agreement.

a $22 million transaction

manufacturing

"The Ernst & Young team was instrumental in helping to build a final transaction structure and price that reflected the inherent risks of this acquisition. Also, their valuable input into our plan for integrating the target company helped ensure that our original objectives of broader product lines and expanded manufacturing capabilities would be met in an orderly and efficient way."

Industry dynamics and business transitions often affect a target's willingness to pursue a transaction. The client, a regional men's clothing chain, understood this when it asked us to approach a small chain of specialty outlets that was not being actively marketed. For the client, the $25 million proposal offered the chance to expand both its specialty market niche and its geographic territory. For the target—a family-owned business—the deal offered liquidity for the founders and substantial incentives to the second generation to improve the firm's operating performance. Ernst & Young professionals were engaged to assist the buyer with this transaction.

a $25 million transaction

retail
and distribution

Corporate Finance professionals helped develop strategies for approaching and negotiating with the target. We actively participated in the negotiations and we were instrumental in helping the buyer understand the target's financial and non-financial goals and develop a deal structure that achieved these goals.

Due Diligence consultants helped the client support the inventory balances and assess the reliability of the system of internal accounting controls and financial information. The ultimate purchase price was adjusted to reflect the results of our acquisition audit.

Valuation professionals worked closely with management to identify and quantify various purchase-price allocation opportunities.

Real Estate consultants of Halcyon Real Estate Advisors/Ernst & Young performed a lease review and cost analysis.

Employee Benefits professionals assessed the extent of the termination liability presented by a multi-employer pension plan. Also, we worked with the client to develop an innovative compensation package for second-generation family members of the acquired company who remained active in the business.

"We emerged from this transaction a stronger player on the retail scene. And the way we aggressively pursued the acquisition improved our standing among industry-watchers. Ernst & Young was with us all the way."

1
Design Firm, **Nesnadny & Schwartz**
Art Director, **Mark Schwartz**
Designer, **Mark Schwartz/Michelle Moehler/
Ruth D'Emilia**
Illustrator, **Blair Drawson**
Photographer, **Nesnadny & Schwartz**
Copywriter, **Ernst & Young**
Client, **Ernst & Young**
Printing, 8-color on Quintessence Dull 100 lb.

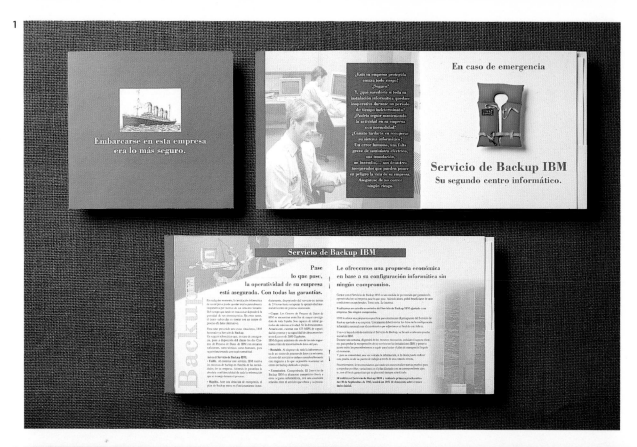

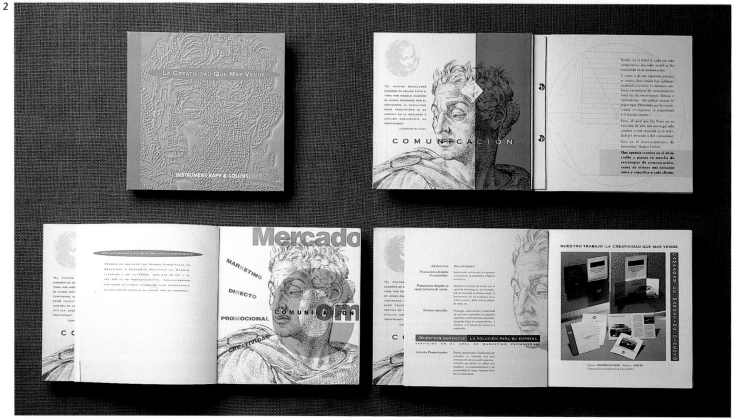

1
Design Firm, **Gabinete De Arte**
Art Director, **Javier Arcos Pitarque**
Designer, **Javier Arcos Pitarque**
Illustrator, **Jorge Salas/F. Quiroga**
Photographer, **Fernando Casarrubios**
Copywriter, **Victoria Segovia**
Client, **IBM, Spain**

2
Design Firm, **Gabinete De Arte**
Art Director, **Javier Arcos Pitarque**
Designer, **Javier Arcos Pitarque**
Illustrator, **Javier Muñoz**
Photographer, **Fernando Casarrubios**
Copywriter, **Victoria Segovia**
Client, **Rapp & Collins, Madrid**

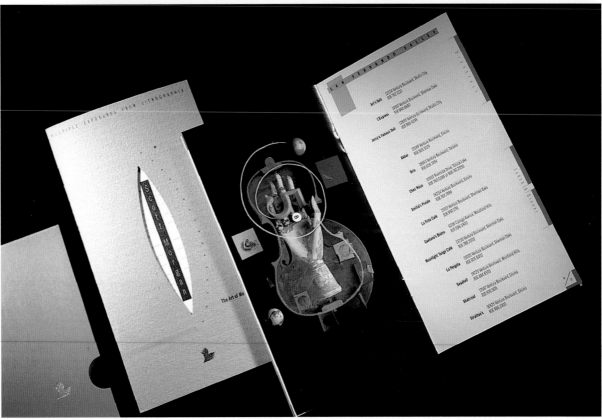

1
Design Firm, **Vrontikis Design Office**
Art Director, **Petrula Vrontikis**
Designer, **Petrula Vrontikis/Kim Sage**
Photographer, **Jeff Corwin/Burton Pritzker/
 Eric Myer/Scott Morgan**
Copywriter, **Candice Pearson**
Client, **Lithographix Inc.**
Printing, 6-color on Gilbert Esse and
 Consolidated Reflections

1

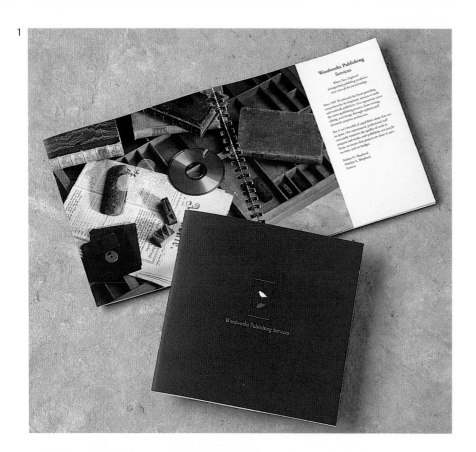

2

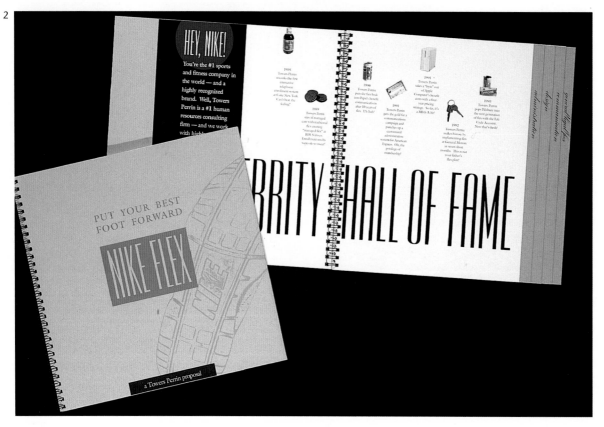

1
Design Firm, **Sara Day Graphic Design**
Art Director, **Sara Day**
Designer, **Sara Day**
Illustrator, **Robert Shepherd**
Photographer, **Michael Pratt**
Copywriter, **Wordworks Publishing Services**
Client, **Wordworks Publishing Services**
Printing, 2-color on Tomahawk cream white
 (cover) and 4-color on Text Lustral Offset
 Enamel dull cream (text)

2
Design Firm, **Towers Perrin**
Art Director, **Jim Kohler**
Designer, **Jim Kohler**
Photographer, **Bruce Quist/Stock Photography**
Copywriter, **Diana Salesky**
Client, **Towers Perrin**
Printing, 4-color

A proposal to Nike explaining our capabilities.

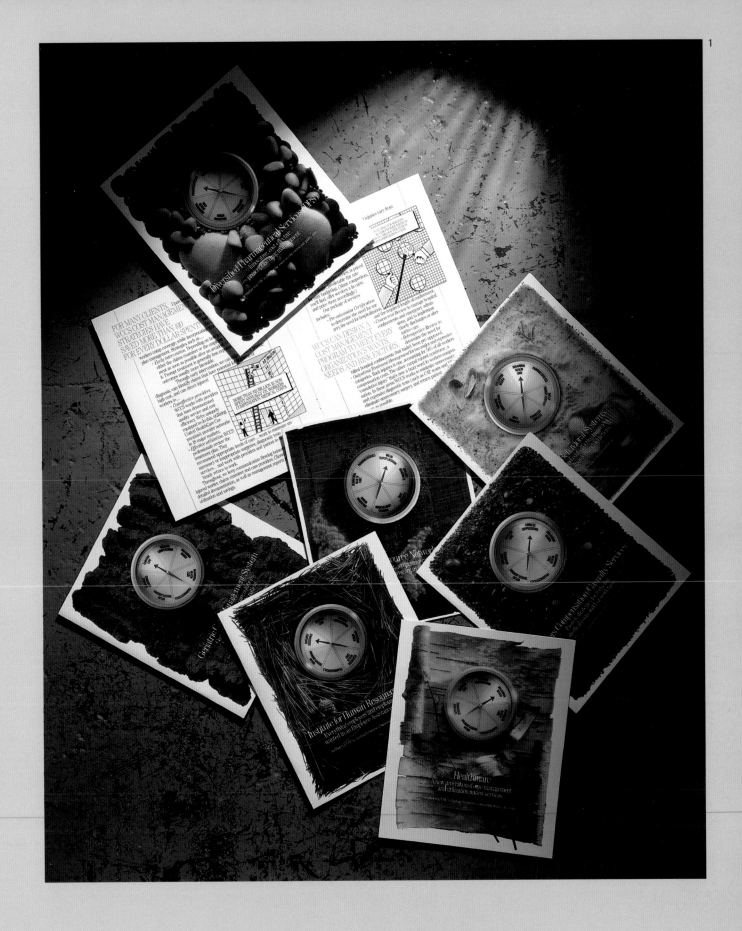

1
Design Firm, **Carmichael Lynch**
Art Director, **Peter Winecke**
Designer, **Peter Winecke/Dave Noonan**
Photographer, **Pat Fox**
Copywriter, **John Neumann**
Client, **United Healthcare**
Printing, 4-color (cover), 1-color (Text), 4 pages

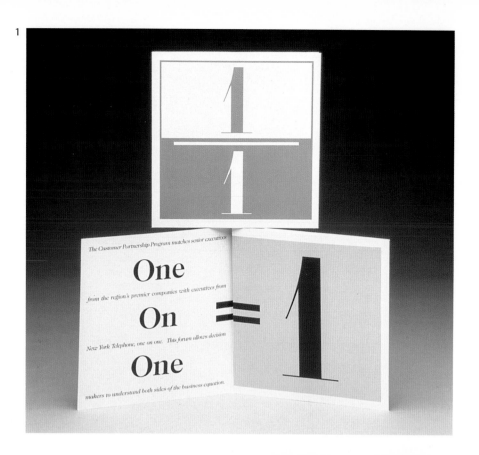

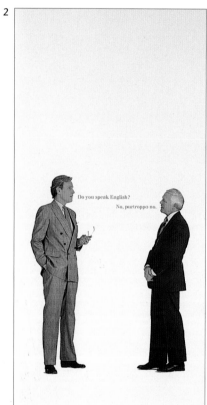

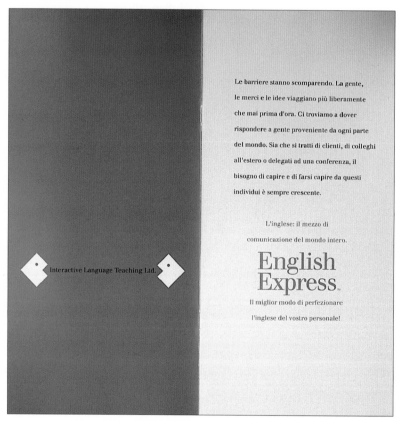

1
Design Firm, **Mike Quon Design Office**
Art Director, **Teresa Alpert**
Designer, **Mike Quon/Erick Kuo**
Illustrator, **Mike Quon**
Client, **Nynex**
Printing, 3-color

2
Design Firm, **George Tscherny, Inc.**
Art Director, **George Tscherny**
Designer, **George Tscherny**
Assistant Designer, **Michelle Novak**
Photographer, **John T. Hill**
Copywriter, **Patrick Friesner/Robert E. Davidson**
Client, **Interactive Language Teaching Ltd.**
Printing, 4-color process and warm red

This brochure was designed to accommodate text in 6 different languages. To make that economical, process colors were printed first for all versions, and the various languages were imprinted subsequently.

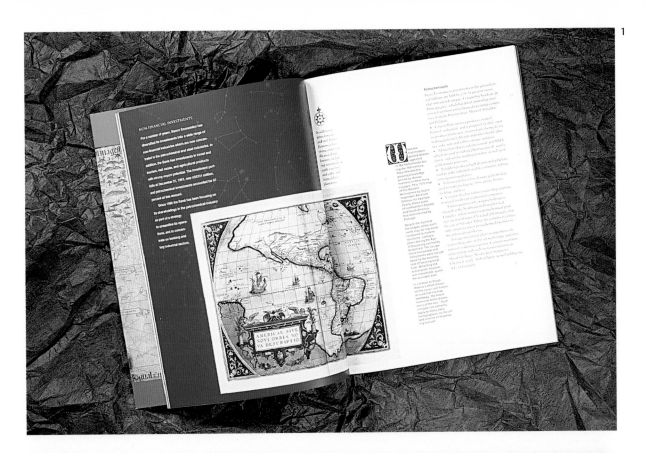

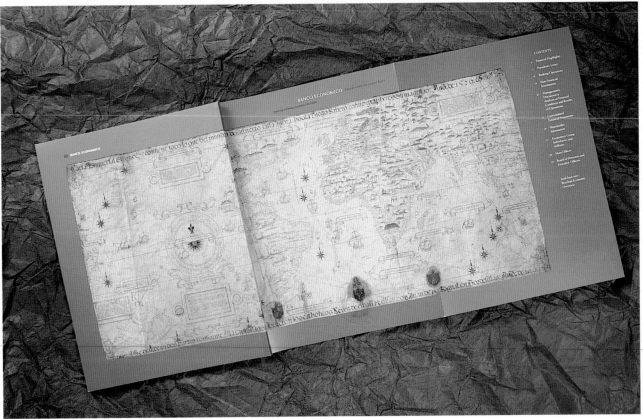

1
Design Firm, **The Wyant Group, Inc.**
Art Director, **Julia Wyant**
Designer, **Julia Wyant/Mark Mayland**
Illustrator, **Julie Berson**
Photographer, **James McGoon/Stock
 Photography**
Copywriter, **Michael McDermott**
Client, **Banco Economico**
Printing, 8-color on Consort Royal Osprey (cover),
 Graphika Vellum (text)

1

2

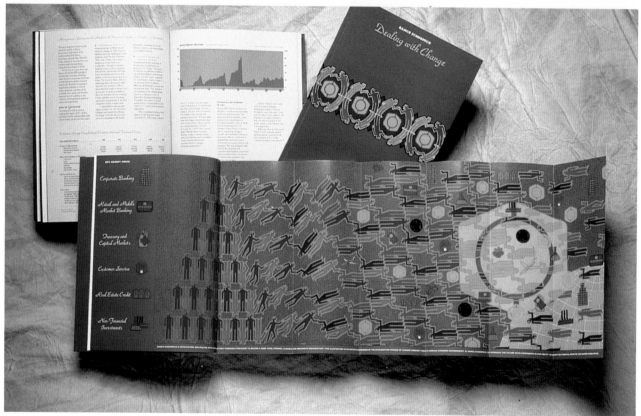

1
Design Firm, **Hornall Anderson Design Works**
Art Director, **Jack Anderson**
Designer, **Jack Anderson, Leo Raymundo**
Client, **Mahlum & Nordfors**
Printing, 1-color, black, confetti red (cover), Cougar
White (text)

2
Design Firm, **The Wyant Group, Inc.**
Art Director, **Julia Wyant**
Designer, **Julia Wyant/Jennifer Deitz**
Illustrator, **Stephan Daigle**
Photographer, **James McGoon/Bard Martin**
Copywriter, **Michael McDermott**
Client, **Banco Economico**
Printing, 8-color on Dorntar Sandpiper (text),
Parilux (cover)

*Annual report was also printed in Portuguese for
Brazilian offices.*

1
Design Firm, **Grafik Communications, Ltd.**
Design Team, **Gregg Glaviano/Judy F. Kirpich/**
 Claire Wolfman/Jennifer Johnson
Client, **Fairchild Corporation**

1

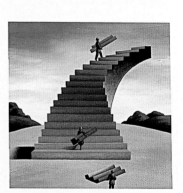

1
Design Firm, **Rickabaugh Graphics**
Art Director, **Eric Rickabaugh**
Designer, **Tim Zientarski**
Client, **Huntington**
Printing, 6-color (cover), 4-color (text)

2
Design Firm, **Metropolis Corp.**
Art Director, **Denise Davis Mendelsohn**
Designer, **Denise Davis Mendelsohn**
Illustrator, **George Abe**
Copywriter, **Booz, Allen & Hamilton, Inc.**
Client, **Booz, Allen & Hamilton, Inc.**
Printing, 5-color on Trophy

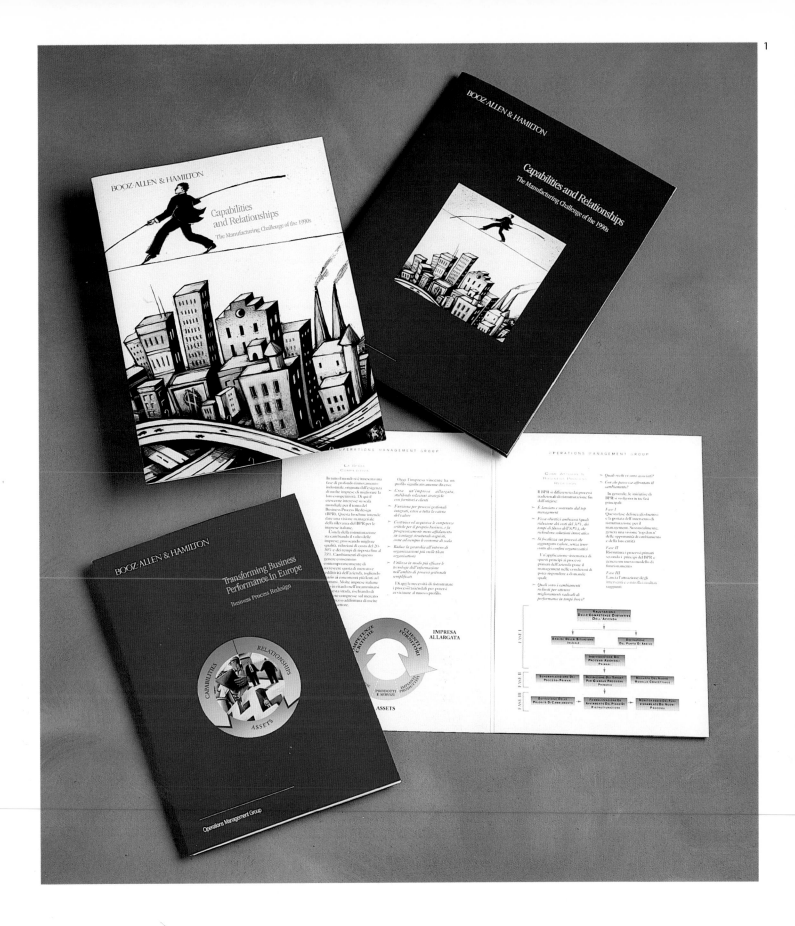

1
Design Firm, **Metropolis Corp.**
Art Director, **Denise Davis Mendelsohn**
Designer, **Lisa DeSeno**
Illustrator, **Judd Giteau/Katherine Kanner**
Client, **Booz, Allen & Hamilton, Inc.**
Printing, 5-color on 5-color and varnish on
 Reflections

*The cover illustration was later used in a t-shirt
design for a company meeting in Cap Ferrat, France.*

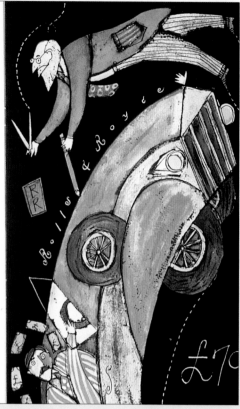

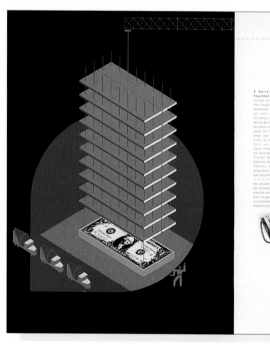

1
Design Firm, **SullivanPerkins**
Art Director, **Ron Sullivan**
Designer, **Linda Helton**
Illustrator, **Linda Helton**
Photographer, **Gerry Kano**
Copywriter, **Mark Perkins/Max Wright**
Client, **Artesian Press**
Printing, 6-color on Ikonofix

2
Design Firm, **SullivanPerkins**
Art Director, **Ron Sullivan/Mark Perkins**
Designer, **Kelly Allen**
Illustrator, **Kelly Allen**
Photographer, **John Dyer**
Copywriter, **Tabitha Zane/Mark Perkins**
Client, **U.S. Long Distance**
Printing, 5-color with varnish on Ikonofix Gilbert
 Oxford, foil stamped embossing on a double
 gatefold cover

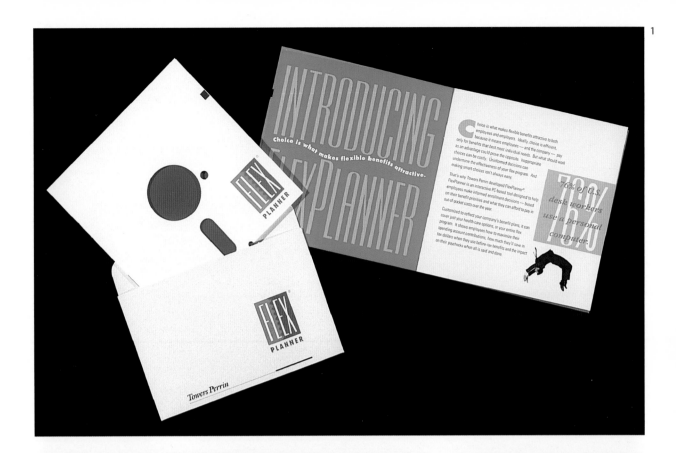

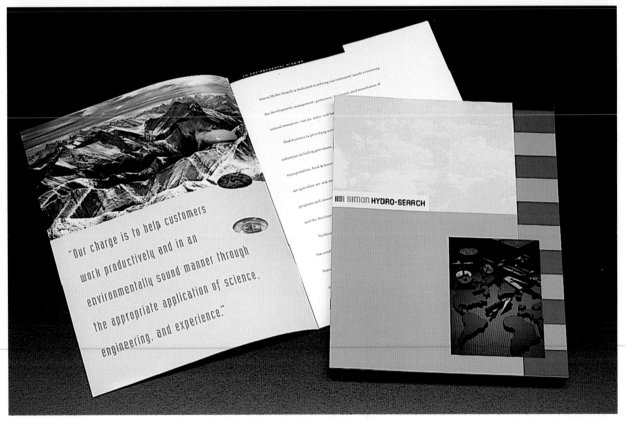

1
Design Firm, **Towers Perrin**
Art Director, **Jim Kohler**
Designer, **Jeanmarie Powers**
Illustrator, **Hal Betzold**
Photographer, **Stock Photography**
Copywriter, **Diana Salesky**
Client, **Towers Perrin**
Printing, 4-color

2
Design Firm, **Lee Reedy Design Associates, Inc.**
Art Director, **Lee Reedy**
Designer, **Heather Bartlett**
Photographer, **Stock Photography**
Copywriter, **Bob Haworth**
Client, **Simon-Hydrosearch**
Printing, 7-color

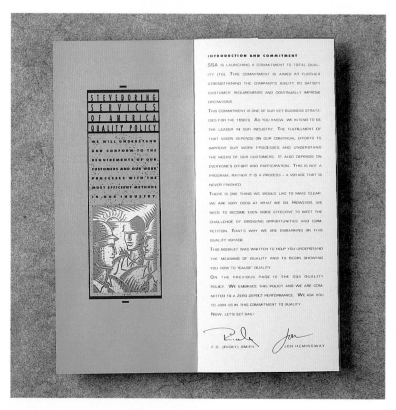

1
Design Firm, **Hornall Anderson Design Works**
Art Director, **Jack Anderson**
Designer, **Jack Anderson/Paula Cox/Denise
 Weir/ Lian Ng**
Illustrator, **Jerry Nelson**
Copywriter, **Stevedoring Services of America**
Client, **Stevedoring Services of America**
Printing, 4-color, 1 varnish on Potlatch Vintage
 Velvet, Cream

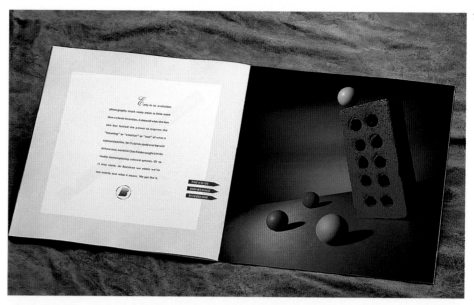

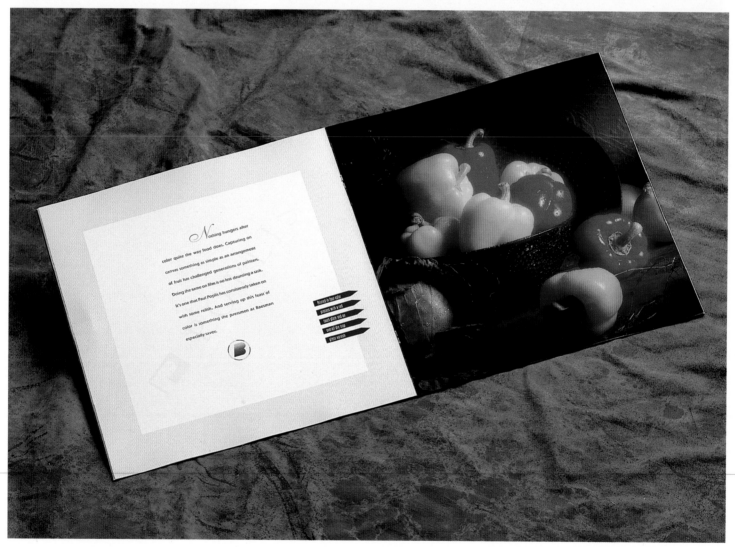

1
Design Firm, **Rickabaugh Graphics**
Designer, **Michael Tennyson Smith**
Photogrpahers, **D.R. Goff/Michael Houghton/
 Larry Hamill/Charles Krider, Tom Watson/
 Paul Poplis**
Copywriter, **John Hofmeister**
Client, **Baesman Printing Corporation**
Printing, 6-color on Curtis Tuscan Eloquebce Gloss
 (cover), Neenah UV Ultra II (flysheet)

*Each photographer's logo is subtly varnised behind
the type opposite his or her photo.*

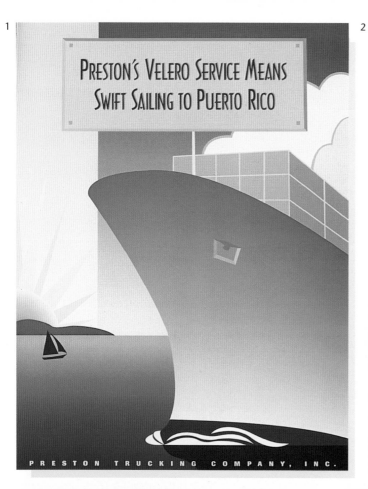

1

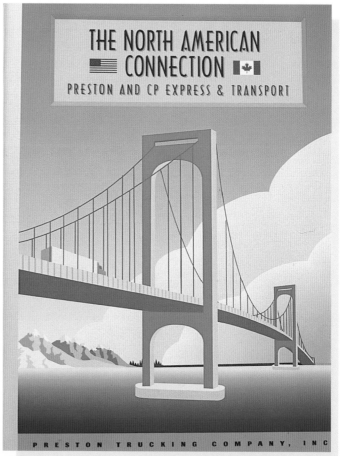

2

3

1
Design Firm, **Whitney Edwards Design**
Art Director, **Charlene Whitney Edwards**
Designer, **Charlene Edwards/Barbi Christopher**
Client, **Preston Trucking Co., Inc.**
Printing, 4-color and varnish on Vintgae Velvet, 80
lb. Cover

2
Design Firm, **Whitney Edwards Design**
Art Director, **Charlene Whitney Edwards**
Designer, **Barbi Christopher/Charlene Edwards**
Client, **Preston Trucking Co., Inc.**
Printing, 4-color and varnish, Vintage Velvet, 80
lb. Cover

3
Design Firm, **PGM, Inc.**
Art Director, **Francis E. Shimandle**
Designer, **Mike Pantuso**
Photographer, **Stock Photography**
Copywriter, **Robert Stein**
Client, **Forte' Computer Services**
Printing, 5-color Enamel Cover

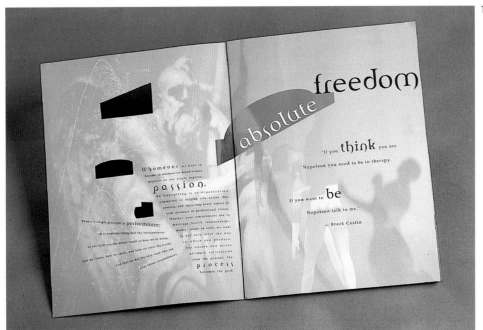

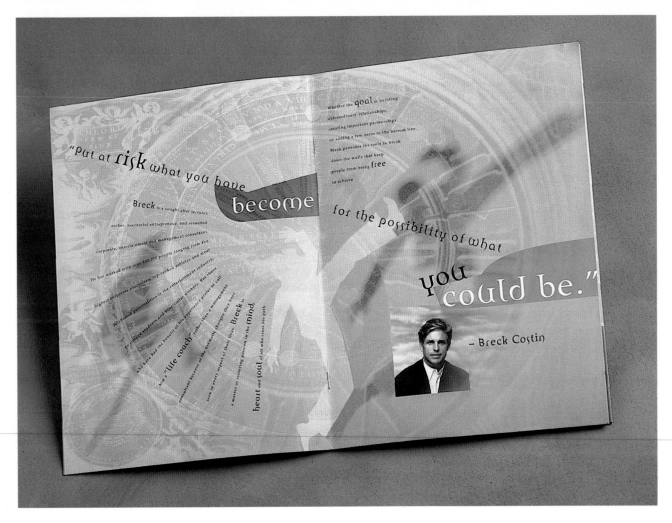

1
Design Firm, **Margo Chase Design**
Art Director, **Margo Chase**
Designer, **Margo Chase**
Photographer, **Margo Chase**
Copywriter, **Ron Taft**
Client, **BC Consulting**
Printing, 4-color over Confetti

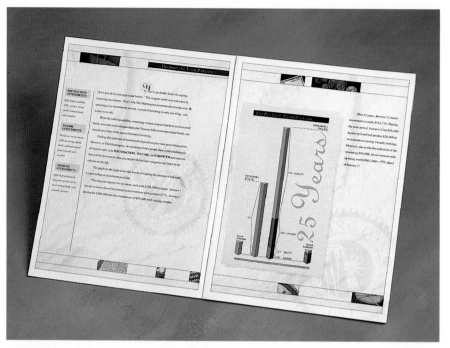

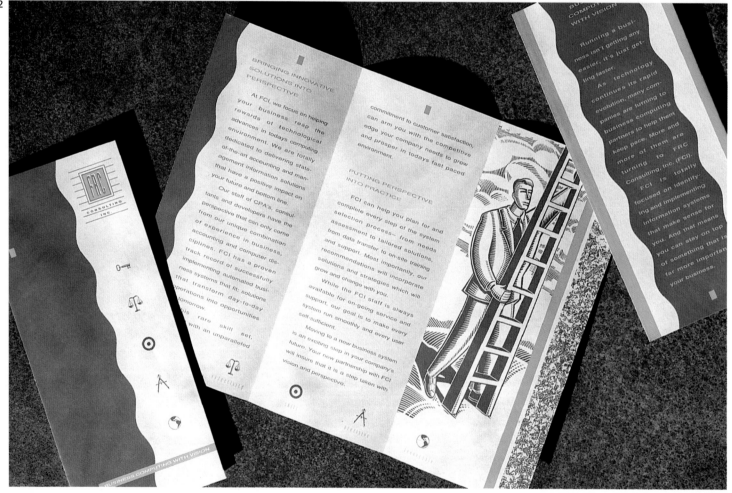

1
Design Firm, **Rickabaugh Graphics**
Art Director, **Mark Krumel**
Designer, **Mark Krumel**
Photographer, **Tom Watson**
Copywriter, **Beth Clem**
Client, **Huntington Investments**
Printing, 5-color and varnish, Zanders Chromulux
 (cover), Ikonorex (text)

2
Design Firm, **Lynn St. Pierre Graphic Design**
Art Director, **Lynn St. Pierre**
Designer, **Lynn St. Pierre**
Illustrator, **Kyle Raetz**
Copywriter, **Toni Voss/Voss & Co.**
Client, **FRC Consulting, Inc.**
Printing, 3-color on Environment Milky Way
 Parchment (cover), Potlatch Vintage Velvet (text)

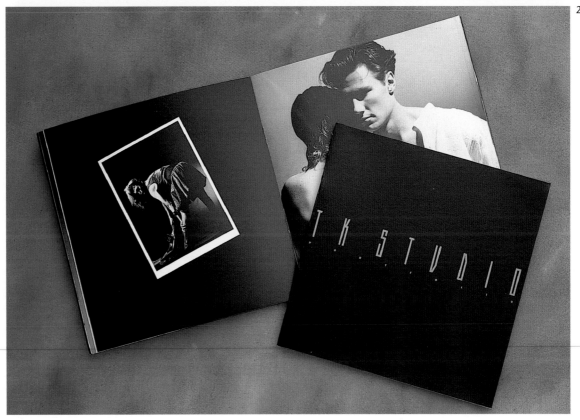

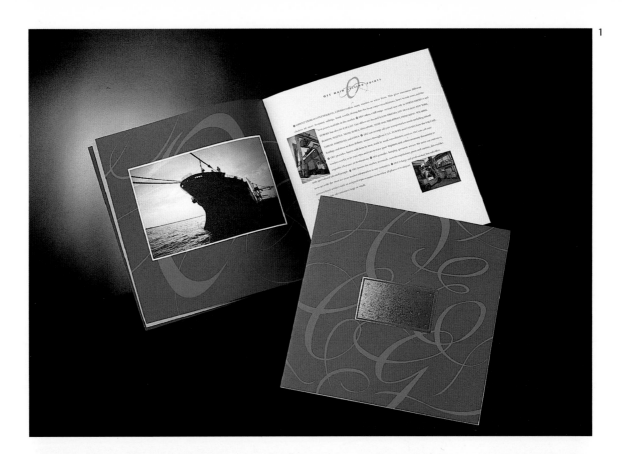

1
Design Firm, **Leslie Chan Design Co., Ltd.**
Art Director, **Leslie Chan Wing Kei**
Designer, **Leslie Chang Wing Kei/Tong Song Wei/ Toto Tseng**
Client, **Amway Taiwan Limited, Taiwan Branch**
Printing, 4-color, one metallic color/spot varnish and matt lamination on 250 lb.(cover), 4-color, one metallic and 2 PMS colors on 120 lb. (text)

2
Design Firm, **Leslie Chan Design Co., Ltd.**
Art Director, **Leslie Chan Wing Kei**
Designer, **Leslie Chang Wing Kei**
Photographer, **T.K. Studio**
Client, **T.K. Studio**
Printing, 4-color, one metallic color and matt lamination

1

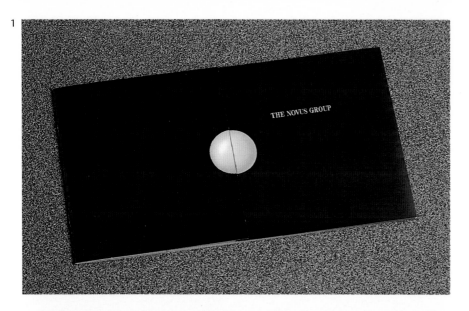

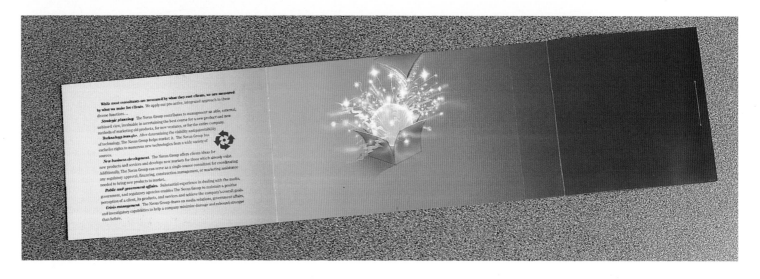

1
Design Firm, **Jill Tanenbaum Graphic Design, Inc.**
Art Director, **Jill Tanenbaum**
Designer, **Sue Sprinkle**
Illustrator, **Mark Negata**
Copywriter, **Jean Podgorsky**
Client, **The Novus Group**
Printing, 6-color on Vintage Gloss die-cut on
 front cover

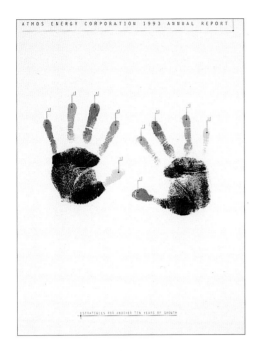

ATMOS ENERGY CORPORATION 1993 ANNUAL REPORT

STRATEGIES FOR ANOTHER TEN YEARS OF GROWTH

COMPANY PROFILE
Based in Dallas, Texas,
Atmos Energy
Corporation provides
natural gas service
to more than one-half
million customers
in Texas, Louisiana and
Kentucky through
its operating companies -
Energas Company,
Trans Louisiana Gas
Company and
Western Kentucky Gas
Company.

CONTENTS
2 Financial Charts
2 Atmos Overview
3 Financial Highlights
5 Operating Achievements
4 Message to Shareholders
10 Designing the Future
10 Revenue Charts
11 Texas Information
16 Louisiana Information
17 Kentucky Information
21 Financial Review

In October 1993, Atmos celebrated the anniversary of its tenth year as a public company. In this report for fiscal 1993, it may be natural to reflect on our first 10 years in business. But it is equally appropriate–and more important–to reflect on where we will be 10 or even 20 years from now. • *But how can we know the future?* • One way to find an answer is knowing who to ask. And perhaps we can find out more about our future by asking for guidance from our future customers and perhaps future employees and shareholders. • So we asked the children of current customers in the diverse markets we now serve–the children of West Texas farmers, homeowners, operators of automobile and truck fleets running on compressed natural gas, and managers of industrial plants–what they can tell us about our business and our future. • Where do the sons and daughters of our current customers say they will live 10 or 20 years from now? What do they think they will do? Where will they work? What will their farms be like, or their homes, or their factories? What vehicles will they be driving? Their answers may sometimes seem fanciful, but we recognize the seriousness of our need to serve them years from now. Children grow up; and as they change, they become part of markets that are constantly changing. In the life of our business at Atmos, growing up means planning for whatever changes the future will bring. • In the words of the children of our customers, we may be reading directions to the business we will be a decade or two from now. • • •

Revenues to date from natural gas vehicles are not significant for Atmos, but should increase over time. The market potential for natural gas vehicles is enormous. The year-round load from one fleet vehicle is estimated to equal that of two to three homes in our service areas.

Natural gas cooling also has significant potential for growth. Atmos is testing two prototype natural gas heat pumps in Kentucky, and a third in Lubbock, Texas. Electric heat pumps provide competition in our service areas, but the natural gas heat pump is proving to have many advantages over the electric model. The gas heat pump should be commercially available in 1994.

Interest by industrial users in cogeneration continues to grow. Cogeneration is the production of both steam and electricity from industrial processes. Atmos is working with several large volume customers to evaluate the feasibility of cogeneration fueled by natural gas.

Atmos is alert to opportunities in the marketplace in the short-term, but we operate the company with our eyes on the horizon. We are a long-term business, and we are working today to develop the markets of tomorrow. Tomorrow has a tendency to arrive much sooner than expected.

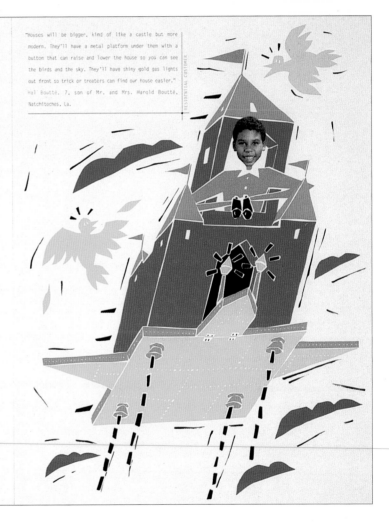

"Houses will be bigger, kind of like a castle but more modern. They'll have a metal platform under them with a button that can raise and lower the house so you can see the birds and the sky. They'll have shiny gold gas lights out front so trick or treaters can find our house easier." Hal Boutté, 7, son of Mr. and Mrs. Harold Boutté, Natchitoches, La.

1
Design Firm, **SullivanPerkins**
Art Director, **Ron Sullivan/Art Garcia**
Designer, **Art Garcia/Randy Sheya/**
 Shaun Marshall
Illustrator, **Art Garcia**
Photographer, **Stan Wolenski/Jim Olvera**
Copywriter, **Margaret Watson/Mark Perkins**
Client, **Atmos Energy Corporation**
Printing, 6-color over 6-color French Newsprint
 and Simpson Coronado

1

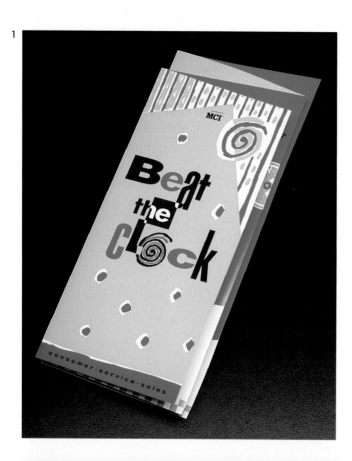

2

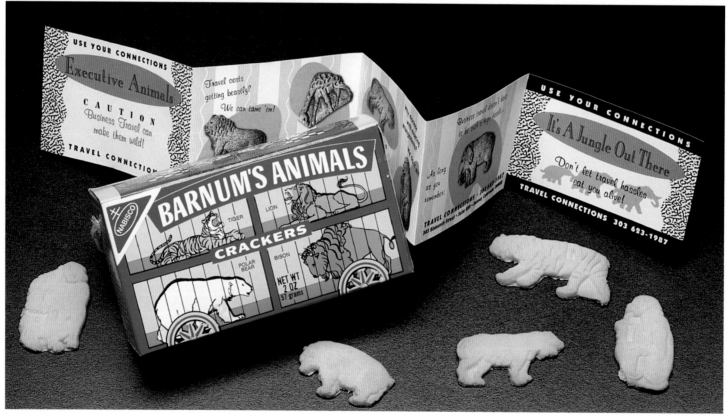

1
Design Firm, **Lee Reedy Design Associates, Inc.**
Art Director, **Lee Reedy**
Designer, **Heather Bartlett**
Copywriter, **Shawn Allegrezza**
Client, **MCI**
Printing, 3-color

2
Design Firm, **Lee Reedy Design Associates, Inc.**
Art Director, **Lee Reedy**
Designer, **Heather Bartlett/Jon Wretlind**
Copywriter, **Suzy Patterson**
Client, **Trave Connections**
Printing, 3-color

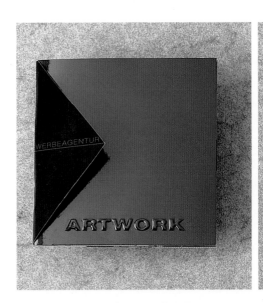

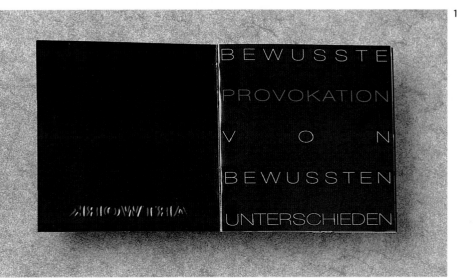

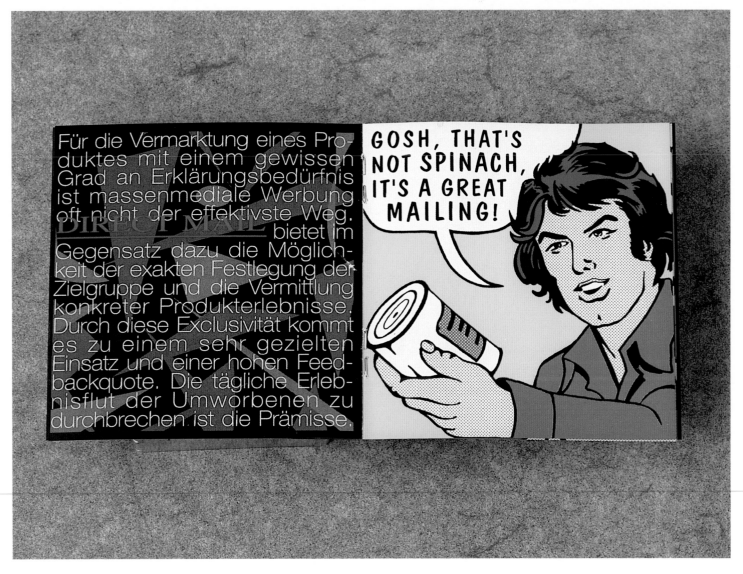

1
Design Firm, **Art & Joy**
Art Director, **Christian Hofbauer**
Illustrator, **Robert Möhner**
Copywriter, **Art & Joy**
Client, **Artwork Ges.m.b.H**

IMAGINATION
CREATIVITY
OPPORTUNITY

SELF-PROMOTIONAL

1

2

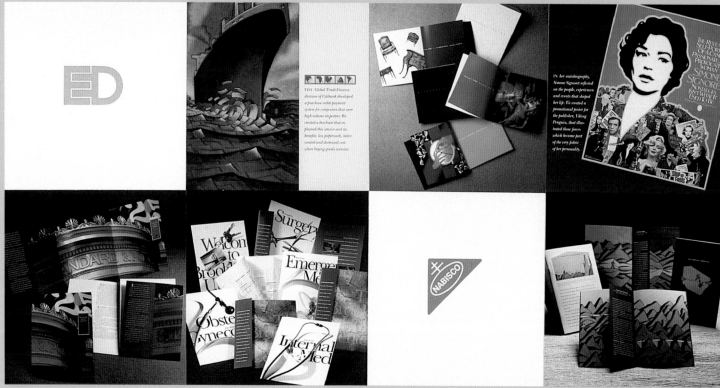

1
Design Firm, **Carol Lasky Studio**
Art Director, **Carol Lasky**
Designer, **Laura Herrmann**
Illustrator, **Sergio Baradat**
Photographer, **Dana Mills**
Copywriter, **Carol Lasky**
Client, **Self Promotion**
Printing, 3-color on Mohawk Splendorlux (cover)
 and 2-color on Appleton Jazz (Text) and 4-color
 label on cover.

2
Design Firm, **Bernhardt Fudyma Design Group**
Art Director, **Craig Bernhardt/Janice Fudyma**
Designer, **Bernhardt Fudyma Design Group**
Client, **Bernhardt Fudyma Design Group**
Printing, Individual pages were printed on the
 "waste area" of client's jobs, so colors and paper
 stocks were determined by those jobs. BFDG has
 been accumulating pages over 3 years and binds
 the books themselves.

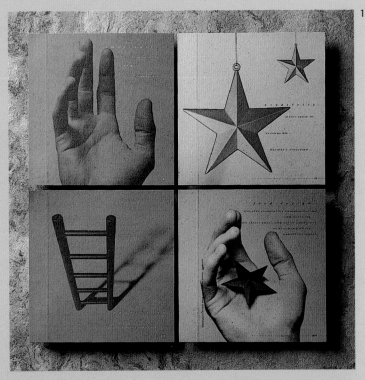

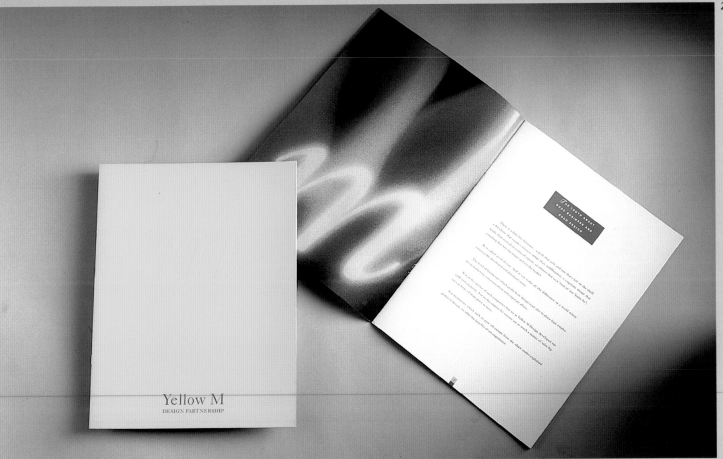

1
Design Firm, **JOED Design Inc.**
Art Director, **Edward Rebek**
Designer, **Joanne Rebek/Andrea Boven/**
 Ed Rebek
Photographer, **Paul Rung**
Client, **JOED Design Inc.**
Printing, 2-color on Black PMS 5747, Corrugated
 Brown Wyndstone, French Speckletone, hand
 assembled with twig binding

2
Design Firm, **Yellow M**
Art Director, **Simon Cunningham**
Designer, **Simon Cunningham**
Photographer, **Duncan Davis**
Client, **Yellow M**
Printing, Full color, blind embossed front cover

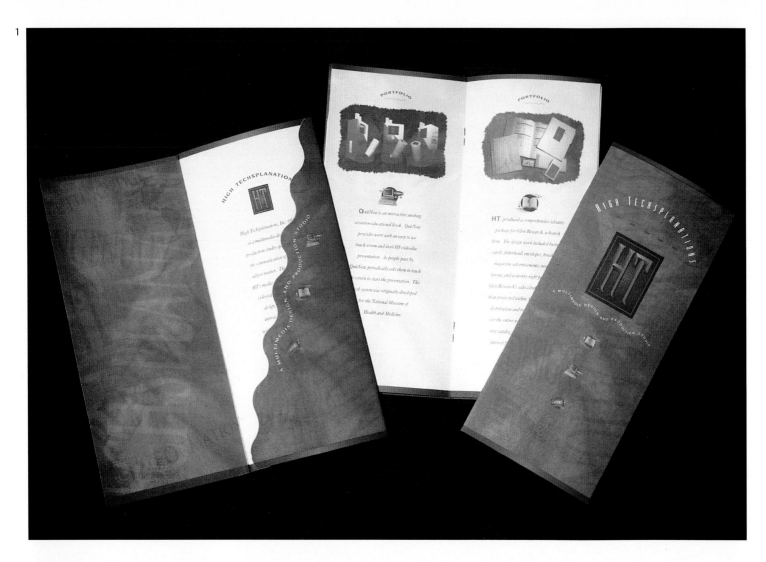

1
Design Firm, **High Techsplanations, Inc.**
Art Director, **Michael J. James**
Designer, **Michael J. James**
Illustrator, **Michael J. James**
Photographer, **Michael J. James**
Copywriter, **Greg Merril/Susan Malkus**
Client, **High Techsplanations**
Printing, 2-color on Esse Texture White

2
Design Firm, **John Kneapler Design**
Art Director, **John Kneapler**
Client, **John Kneapler, Self promotion**
Printing, 4-color on coated Carolina

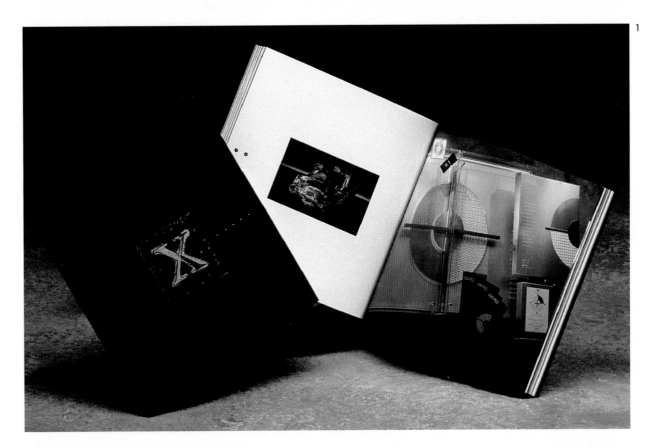

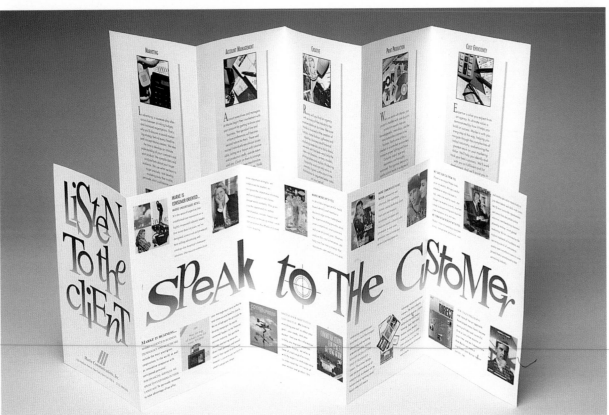

1
Design Firm, **Hornall Anderson Design Works**
Art Director, **Jack Anderson**
Designer, **Jack Anderson/David Bates/Lian Ng/
 Leo Raymundo**
Illustrator, **Yutaka Sasaki**
Copywriter, **Pamela Mason-Davey**
Client, **Hornall Anderson Design Works**

Printing, 4-color plus 1 PMS on Tuxedo Mystic
 (cover), Vintage Violet (text), metal tip-in on
 front cover, coating and engraving. Black dots
 on front cover are black foil stamped

2
Design Firm, **Marke Communications, Inc.**
Creative Director, **Darell Beasley**
Designer, **Bob Alese**
Photographer, **David Katzenstein**
Copywriter, **Anita Bartholomew**
Client, **Self promotion for agency**
Printing, Premium White Innovation, Cover
 Weight Gloss

1
Design Firm, **Art & Joy**
Art Director, **Christian Hofbauer**
Photographer, **Robert Müller**
Copywriter, **Art & Joy**
Client, **Art & Joy**

2
Design Firm, **Sayles Graphic Design**
Art Director, **John Sayles**
Designer, **John Sayles**
Illustrator, **John Sayles**
Copywriter, **Wendy Lyons**
Client, **Sayles Graphic Design**
Printing, 4-color on Fortune Matte White Cover

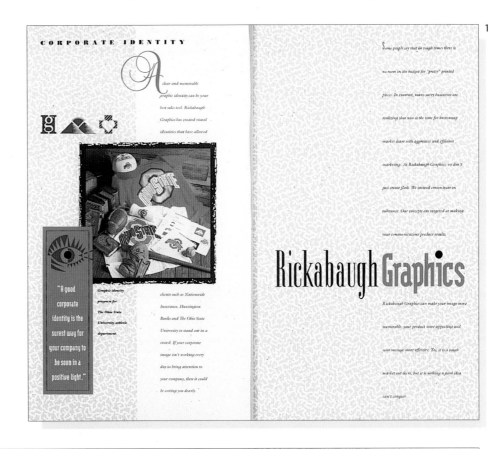

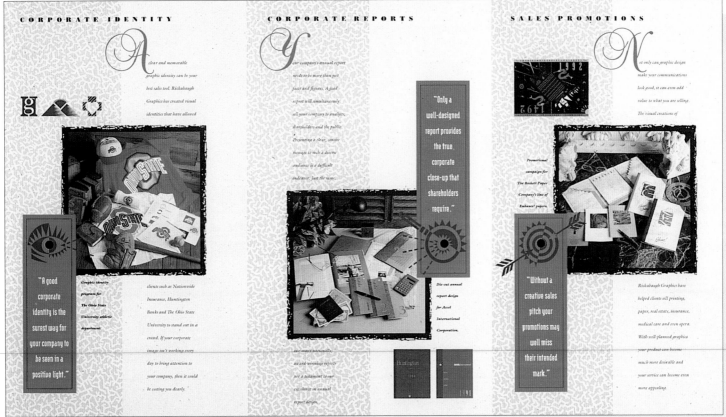

1
Design Firm, **Rickabaugh Graphics**
Art Director, **Eric Rickabaugh**
Designer, **Eric Rickabaugh**
Illustrator, **Eric Rickabaugh**
Photographer, **Paul Poplis**
Copywriter, **Eric Rickabaugh**
Client, **Rickabaugh Graphics**
Printing, 6-color

Brochures were drilled so that drill hole functions as pupil of eye, magnifying glass "hot spot," bullseye, and dot of "i" simultaneously.

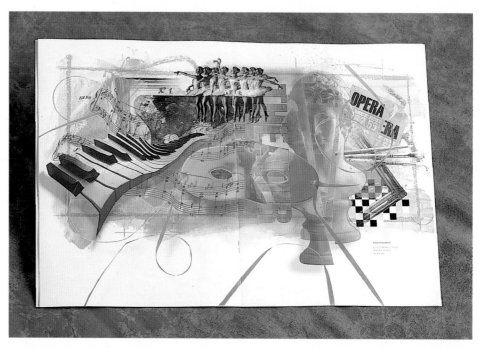

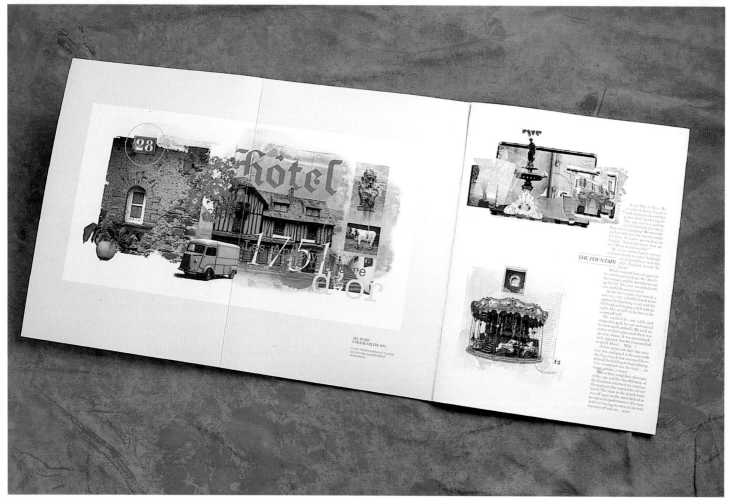

1
Design Firm, **Frank Miller Photo Illustration**
Art Director, **Frank Miller**
Designer, **Frank Miller**
Illustrator, **Frank Miller**
Photographer, **Frank Miller**
Copywriter, **Frank Miller**
Client, **Self Promotion**
Printing, 4-color printed in Japan

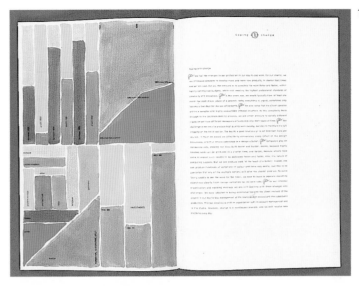

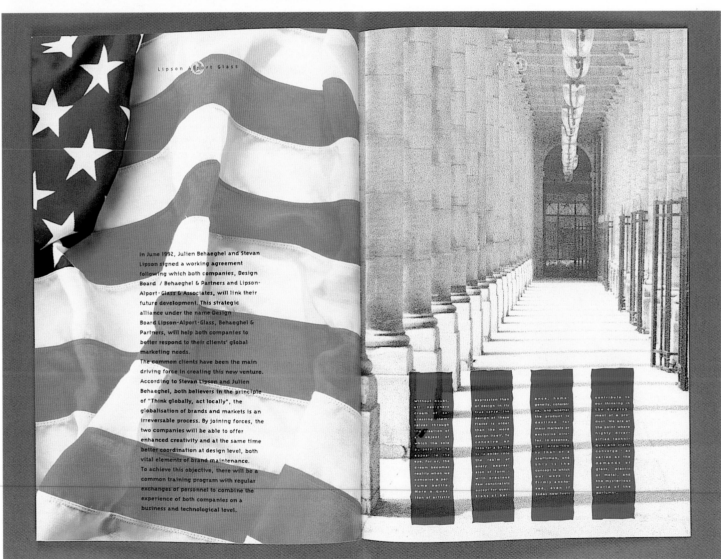

1
Design Firm, **Design Board Behaeghel &
Partners**
Art Director, **Denis Keller**
Designer, **Johan Corver/ Jack Rodgers/
Kevin Scarlett**
Photographer, **Bernard Tassier**
Printing, 4-color Quadri, 4-color PMS, Machine
Coated Paper 200g (text), Recycled Fridaflack
Paper 300g (cover)

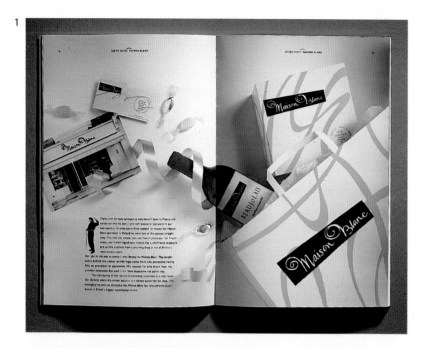

1
Design Firm, **Design Bridge Limited**
Art Director, **Keren House**
Designer, **Mike Harris/Daniel Cornell**
Illustrator, **Line & Line/Heather Calder/Wyatt Cattaneo**
Photographer, **John Stone/David Banks**
Copywriter, **Jacquey Visick/Steve Osborne**
Client, **Design Bridge Limited**
Printing, 5-color plus spot varnish, Tweedweave (cover),
 Silverblade (text), foil blocked on colored stock enclosed
 with printed disks and cord

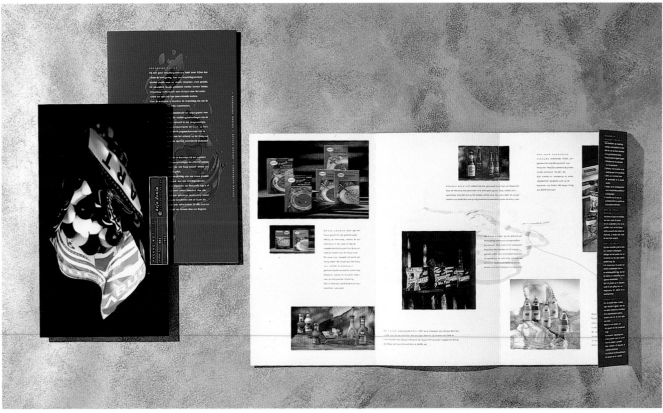

1
Design Firm, **Keja Donia Design**
Art Director, **Eric Nuijten/Monique Kuppers**
Designer, **Monique Kuppers**
Photographers, **Fred van den Ende/**
 Willem Groeneveld/Rien Bazen/Joost van Velzen
Copywriter, **Lex Donia, Wilco Kalbfleisch**
Client, **Keja Donia Design**
Printing, 5-color

SATURDAY, AUGUST 15

The Boulder Invitational Ten
Extravaganza (BAR BITE) gets
underway in the morning. It
should probably only take Dwi
about two hours to beat the r
of us, unless someone has bee
practicing. That afternoon,
ill go up to ELKHORN, A GHOST
WN about 12 miles away in th
untains, where we will have a
okout for supper. Can you
ell the CAMPFIRE and tast
roasted marshmallows
res yet?!?

MISCELLANEOUS

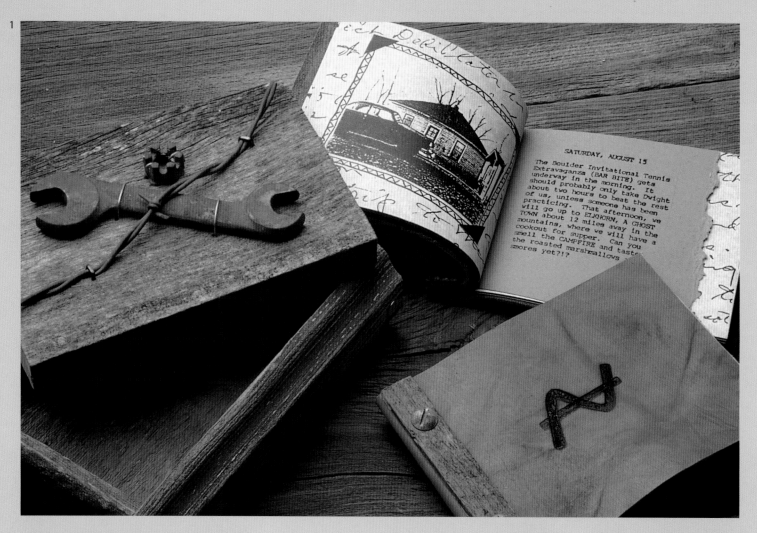

1
Design Firm, **Sayles Graphic Design**
Art Director, **John Sayles**
Designer, **John Sayles**
Illustrator, **John Sayles**
Copywriter, **Dorothy Anderson**
Client, **Anderson Family**
Printing, 1-color on James River Tuscan Terra
 Mulberry Cover, James River Graphika
 Parchment Antique Cover

2
Design Firm, **Muller + Company**
Art Director, **John Muller**
Designers, **John Muller/Shana Eck**
Photographer, **Dan White/Mike Regnier/**
 Hollis Officer/Nick Vedros/Dave
 Ludwigs/Darrel Bernstein/Steve Curtis
Copywriter, **David Marks**
Client, **The Advertising Club of K.C.**
Printing, 3-color on Quintessence Remarque

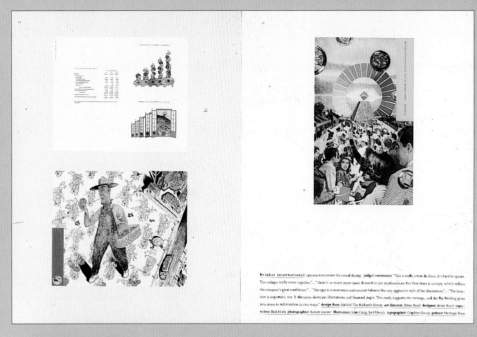

The Mead Annual Report Show 1993

A Celebration of Excellence

Over the years, many people have asked me what's new in annual reports. Questions have ranged from statistical information to design trends. In this summary, you'll find for the first time some practical answers.

Why this change? Because innovation is one of the keys to corporate success—and we at Mead want that quality reflected in our show that honors the most important printed piece produced by corporate America.

Here, then, is what's new:

A statistical summary of annual reports. Mead will add new data each year to create an on-going resource for the graphic arts industry. An essay on current trends. Business writer Bob Parker interprets how the Mead Show reflects current developments in annual report design. Judges' comments on the winners. Actual quotes tell why each entry won. Recognition of the writer for each winner. Judges cited the annual report message as a key to its success, and Mead salutes the creators of each message. An expanded format. More space allows larger reproductions and important new information. Addresses for each printer. The best message with the best design will fail without excellent printing.

The many innovations and the new format are the result of the coordinated efforts of Nesnadny + Schwartz and Mead. We also thank the judges: Dana Arnett, Michael Gunselman, Kerry Leimer, Lana Rigsby, and Tony Russell. They were impressed by the variety of design viewpoints in the Show. You'll be impressed by the variety of formats, budgets, and industries represented among the winners.

This year's annuals were both pared down and environmentally friendly, the judges noted. Matte coated and uncoated papers were common, even as the use of four-color graphics remained high. But as the judges summed up, what governs paper choice is its appropriateness to the design and the company's message.

For 37 years, the Mead Show has recognized creative vision in annual reports. In 1993, entries rose by 25 percent to nearly 800, confirming again the Show's pre-eminence in the field. As the 24 winners travel this year to more than 50 cities, we invite you to join in our celebration of excellence.

Shawn Palmer, Director, Mead Annual Report Show

1
Design Firm, **Nesnadny & Schwartz**
Art Director, **Joyce Nesnadny/Mark Schwartz**
Designer, **Joyce Nesnadny/Brian Lavy/Mark Schwartz**
Illustrator, **Nesnadny & Schwartz, Old Masters**
Photographer, **Roman Sapecki**
Copywriter, **Robert A. Parker**
Client, **Mead Fine Paper Division**
Printing, 6-color on Mead Signature Gloss 100 lb.

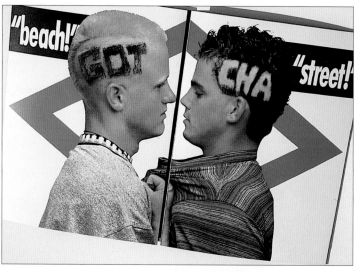

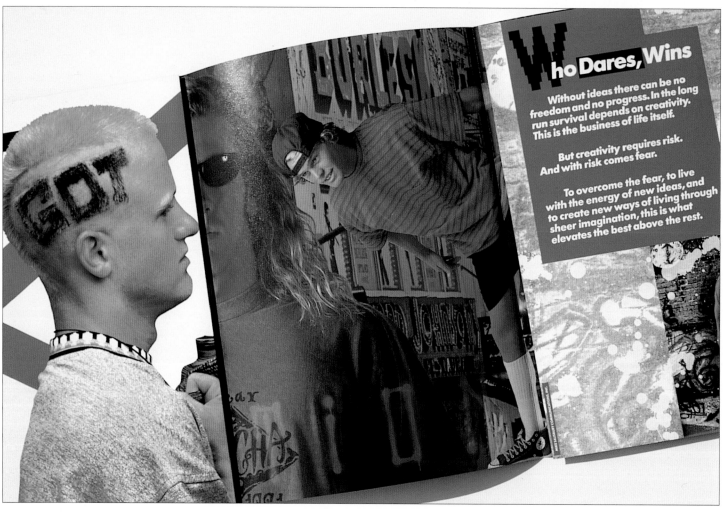

1
Design Firm, **Mike Salisbury Communications**
Art Director, **Mike Salisbury**
Designer, **Mike Salisbury**
Illustrator, **Jeff Wack**
Photographer, **Mike Funk**
Copywriter, **Mike Tomson/Mike Salisbury**
Client, **GOTCHA**
Printing, 4-color Cheap Coated

1
Design Firm, **Mike Salisbury Communications**
Art Director, **Mike Salisbury**
Designer, **Mike Salisbury/Terry Lamb**
Illustrator, **Terry Lamb/Pat Linge/Patrick O'Neal**
Photographer, **Elizabeth Salisbury/Mike Funk/**
 Mike Salisbury
Copywriter, **Mike Salisbury Terry Lamb**
Client, **MGM**
Printing, 4-color Cheap Coated

All art created with color xerox.

1

Patrick Whitney is a professor and the director of the Institute of Design (ID), one of six schools within the Illinois Institution of Technology. His research and consulting work focus on theories and methods of planning information and products. Professor Whitney has lectured in Australia, Canada, China, Japan and the USA and has had several articles and projects published in Europe and the USA. He is the President of the American Center for Design, a national professional association.

J. Williams is an interaction designer for several teams in the multimedia arts and entertainment group at Microsoft doing cinema and music-related interactive CD-ROM programs. J. has been both a motion-picture and record-company art director and has worked with interactive media for over a decade. He likes very big things and very small things.

With the publication of his first book in 1962, Richard Saul Wurman began to realize the singular passion of his life: making information understandable. In addition to his ACCESS world travel guides, Mr. Wurman's publications include Information Anxiety and Follow the Yellow Brick Road. His most recent publication is the Fortune Guide to Investing in the '90s. It is his 57th book. Mr. Wurman is the chairman and creative director of the TED Conferences in Monterey, California, and Kobe, Japan. A fellow of the AIA, a member of AGI and a Guggenheim & Chandler Fellow, Mr. Wurman regularly consults to major corporations concerned with the clarity and organization of information.

36

GENERAL INFORMATION

Bookstore
The IDCA bookstore, located outside the Main Tent, sells publications related to the Conference theme, many by speakers. It is open daily from 8:30 a.m. to 5:30 p.m.

Food and Beverage
Atomic Cafe: An informal meeting place for speakers and conferees located behind the Main Tent. Open each afternoon from 2:00 to 5:30 p.m., serving beverages and light refreshments.

The refreshment kiosk outside the Main Tent serves hot and cold beverages and healthful foods. Open daily from 8:30 a.m. to 5:30 p.m. and from 8:30 p.m. to 10:30 p.m.

Tapes
Audio tapes of major presentations will be available daily at the booth outside the Main Tent from 8:30 a.m. to 5:30 p.m.

T-Shirts
The T-Shirt booth located outside the Main Tent will be open from 9:00 a.m. to 5:30 p.m.

Special Activities
IDCA has organized special off-campus activities for those interested in rafting, fishing, a gondola ride up Aspen Mountain or sightseeing to the Maroon Bells. Information about these activities and sign-up sheets are located at the Information Booth outside the entrance to the Main Tent.

Lost and Found
Lost and Found is located at the Information Booth outside the entrance to the Main Tent.

Bus Schedule
Leaving Rubey Park: On the hour and 30 min. past the hour

Leaving Main Tent (from parking lot on Gillespie Street):
10 min. past the hour and 40 min. past the hour

Note: First run departs Rubey Part at 8:00 a.m. Last run departs Main Tent at 11:10 p.m. or after conclusion of evening program.

20

1
Design Firm, **Paul Davis Studio**
Art Director, **Paul Davis**
Designer, **Lisa Mazur**
Illustrator, **Paul Davis**
Photographer, **Paul Davis/Gamma One Conversions**
Client, **International Design Conference in Aspen**
Printing, 2-color on Commercial Cover 4-color on Champion Carnival Dividers

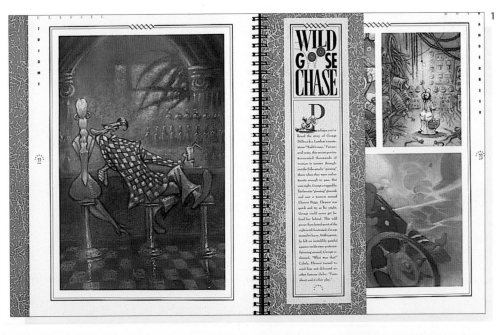

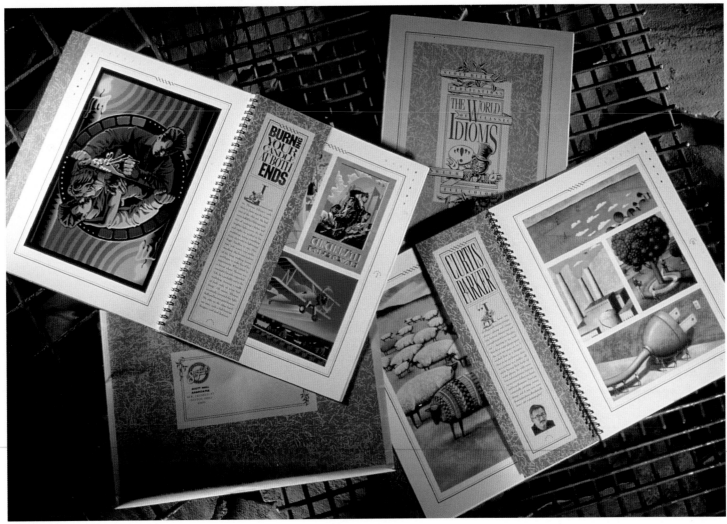

1
Design Firm, **Rickabaugh Graphics**
Art Director, **Eric Rickabaugh**
Designer, **Eric Rickabaugh**
Illustrator, **Scott Hull Associates**
Client, **Scott Hull Associates**
Printing, 6-color

1

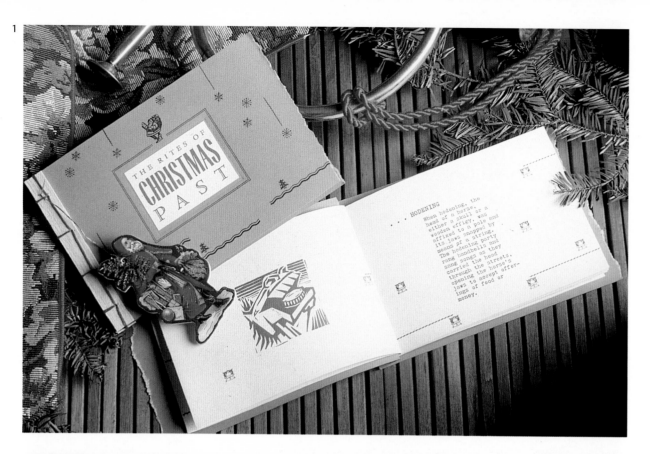

2

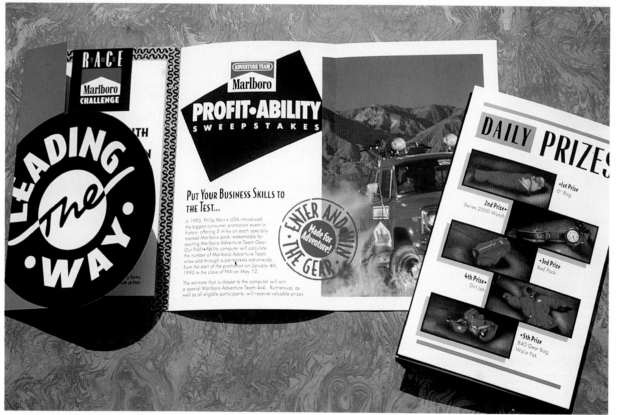

1
Design Firm, **Rickabaugh Graphics**
Art Director, **Michael Tennyson Smith**
Designer, **Michael Tennyson Smith**
Illustrator, **Michael Tennyson Smith**
Copywriter, **Michael Tennyson Smith**
Client, **Rickabaugh Graphics**
Printing, 2-color letterpress on Simpson Evergreen

Illustrations for this Holiday Card '92 are uno-cuts that were locked up with the type on press. Cut-out ornament was looped around handsewn wood binding.

2
Design Firm, **Mike Quon Design Office**
Art Director, **Elliot Berd**
Designer, **Mike Quon/Erick Kuo**
Illustrator, **Mike Quon**
Client, **Philip Morris**

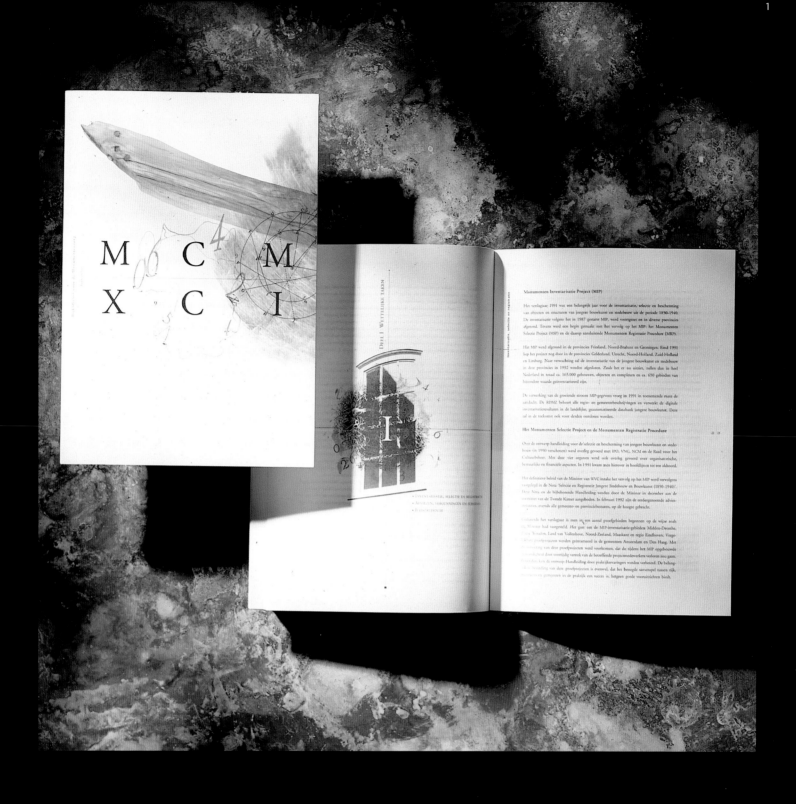

1
Design Firm, **Keja Donia Design**
Art Director, **Eric Nuijten**
Photographer, **Robert Shackleton/Rijksdienst voor
 de Monumentenzorg**
Copywriter, **Mr. R. Berends/Rijksdienst voor de
 Monumentenzorg**
Client, **Rijksdienst voor de Monumentenzorg**
Printing, 4-color

Annual report for the Dutch Historic Buildings Society

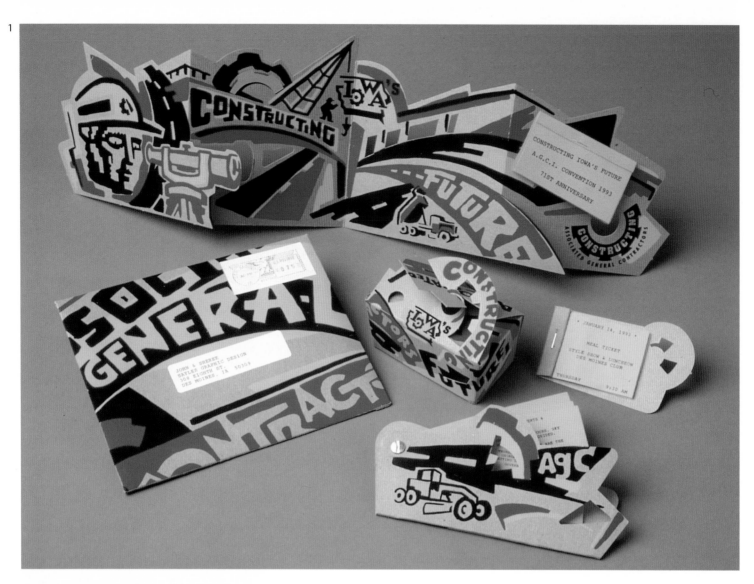

1
Design Firm, **Sayles Graphic Design**
Art Director, **John Sayles**
Designer, **John Sayles**
Illustrator, **John Sayles**
Copywriter, **LuAnn Harkins**
Client, **Associates General Contractors**
Printing, 3-color on Chipboard Astrobrite Kraft
 Paper and Chipboard

*Features multiple die-cuts and a small brochure
adhered to the end panel.*

2
Design Firm, **SullivanPerkins**
Art Director, **Ron Sullivan**
Designer, **Dan Richards**
Illustrator, **Dan Richards**
Copywriter, **CETV**
Client, **Conservationists for Educational Television**
Printing, 2-color on Champion Benefit, bound with
 a twig

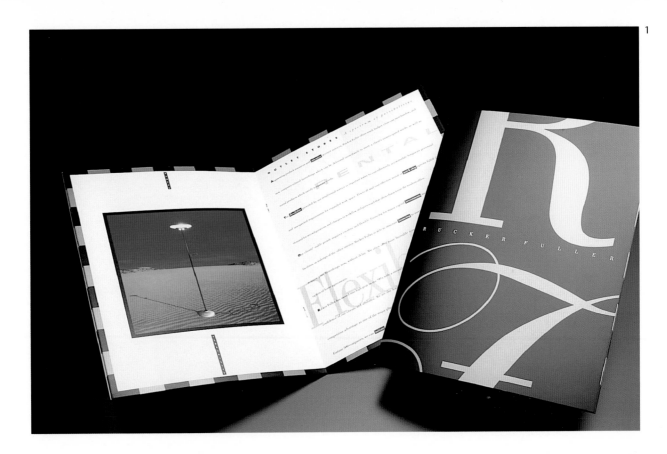

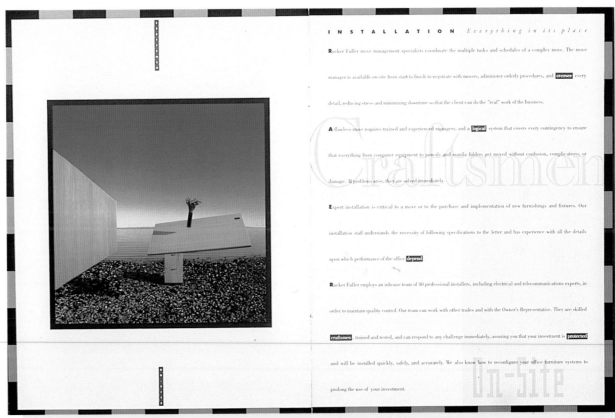

1
Design Firm, **Vanderbyl Design**
Designer, **Michael Vanderbyl**
Photographer, **Charley Franklin**
Copywriter, **Penny Benda**
Client, **Rucker Fuller**
Printing, 6-color on Karma

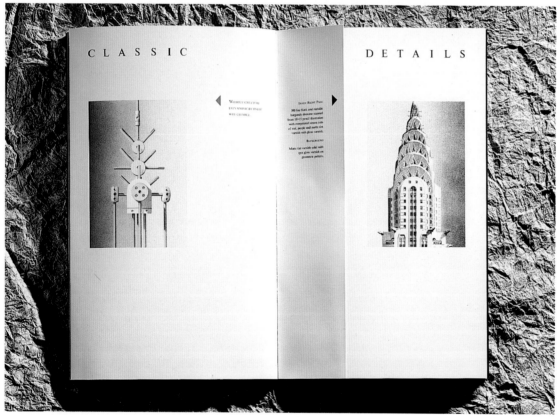

1
Design Firm, **Mervil Paylor Design**
Art Director, **Mervil M. Paylor**
Designer, **Mervil M. Paylor**
Illustrator, **David Wilgus/Gary Palmer**
Photographer, **Gerin Choiniere**
Copywriter, **Melissa Stone**
Client, **Classic Graphics**
Printing, 6-color on Curtis Flannel Burgundy
 (sleeve), Ikonolux Glass White (cover & text)

'Would you help me to become a Guide Dog?'

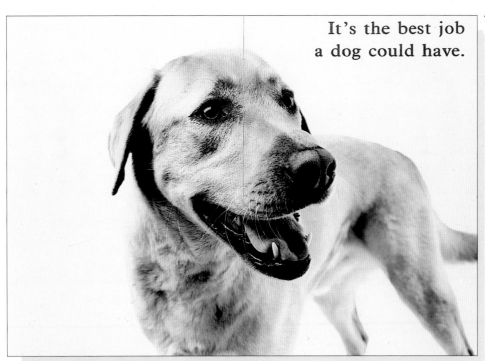

It's the best job a dog could have.

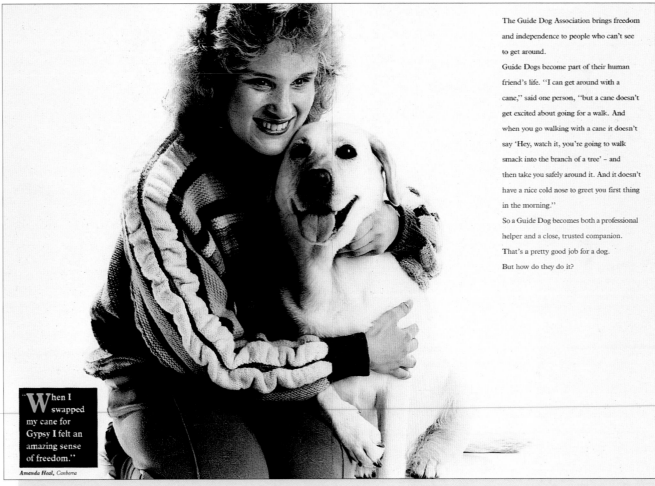

The Guide Dog Association brings freedom and independence to people who can't see to get around.

Guide Dogs become part of their human friend's life. "I can get around with a cane," said one person, "but a cane doesn't get excited about going for a walk. And when you go walking with a cane it doesn't say 'Hey, watch it, you're going to walk smack into the branch of a tree' – and then take you safely around it. And it doesn't have a nice cold nose to greet you first thing in the morning."

So a Guide Dog becomes both a professional helper and a close, trusted companion. That's a pretty good job for a dog. But how do they do it?

"When I swapped my cane for Gypsy I felt an amazing sense of freedom."

Amanda Heal, Canberra

1
Design Firm, **Raymond Bennett Design Pty. Ltd.**
Art Director, **Raymond Bennett**
Designer, **Raymond Bennett/Gina Batsakis**
Photgrapher, **Mark Llewellynn**
Copywriter, **Peter Ferguson**
Client, **Glen Butterworth/Guide Dog Association**
Printing, 4-color, 2 PMS Black and glear gloss
 tonal varnish on Shogun Premium Dull

LOUIS BLUES

Louis Blues is a one-of-a-kind jean shop. It understands that not everyone wants to look exactly the same. Just great.

ROBERT COMSTOCK'S DENIM DUSTER

34

IT'S 11:30 AM, SEPTEMBER 13, 1937
THE ECONOMY STINKS.
WHAT A GREAT TIME TO GO SHOPPING.

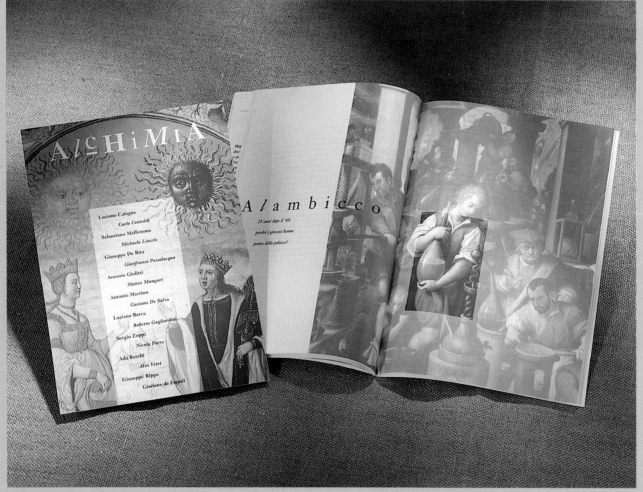

1
Design Firm, **Tyler Smith**
Art Director, **Tyler Smith**
Designer, **Tyler Smith**
Photographer, **John Huet**
Copywriter, **Geoff Currier**
Client, **Louis, Boston**
Printing, 5-color on Mead Signature

2
Design Firm, **AR&A Antonio Romano & Associates**
Art Director, **Claudia Neri**
Designer, **Claudia Neri**
Client, **Alchimia**
Printing, 1-color on 130g coated sheet

*A non-profit magazine written and directed by Young
University students who seek to involve
other young people in cultural and political life.*

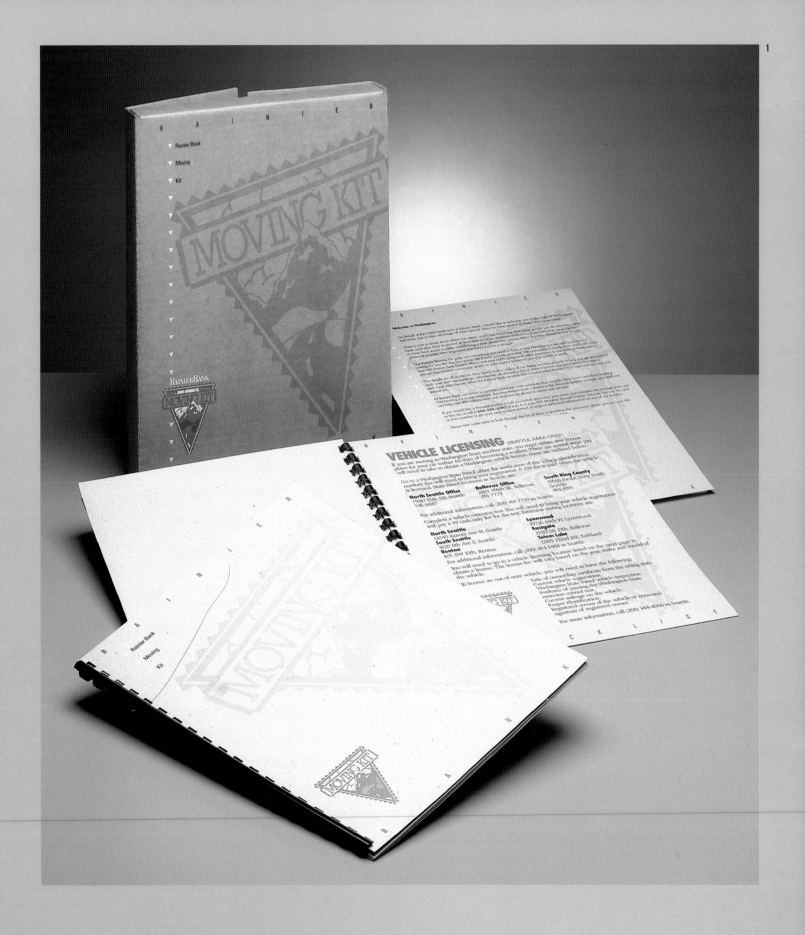

1
Design Firm, **Carmichael Lynch**
Art Director, **Peter Winecke**
Designer, **Peter Winecke**
Copywriter, **John Neumann**
Client, **Rainier Bank**
Printing, 2-color, 12 pages

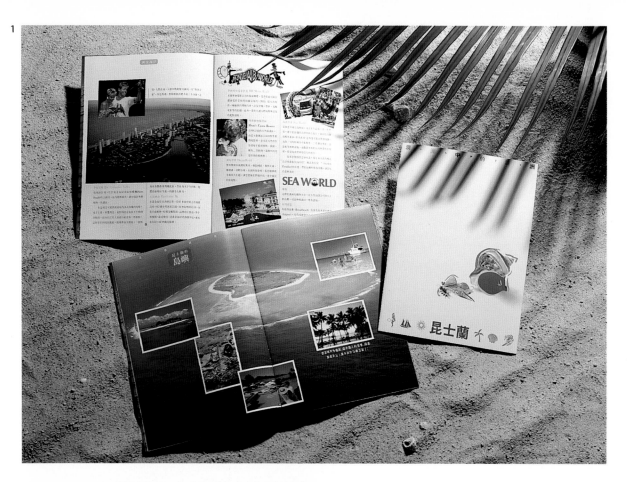

1
Design Firm, **Leslie Chan Design Co., Ltd.**
Art Director, **Leslie Chan Wing Kei**
Designer, **Leslie Chan Wing Kei/Toto Tseng**
Client, **Queensland Tourist & Travel
 Corporation**
Printing, 4-color and matt lamination on 200 lb.
 cover, 120 lb. text

2
Design Firm, **Mike Quon Design Office**
Art Director, **Gavin Smith**
Designer, **Mike Quon/Erick Kuo**
Illustrator, **Mike Quon**
Client, **Board of Elections**
Printing, 2-color, printed 4 million copies for
 NYC voters

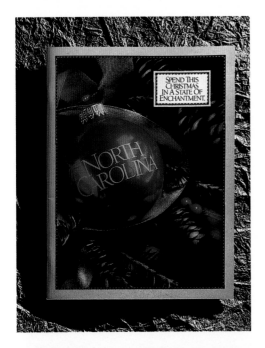

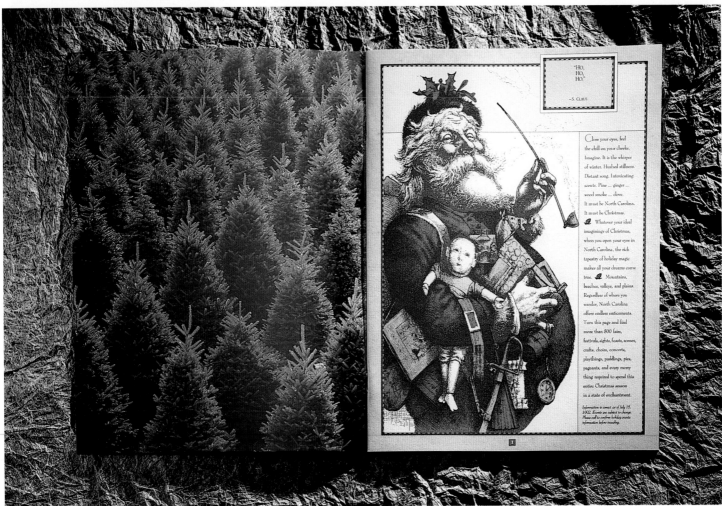

1
Design Firm, **Mervil Paylor Design**
Art Director, **Mervil M. Paylor**
Designer, **Mervil M. Paylor**
Photographer, **Steve Knight**
Copywriter, **Melissa Stone**
Client, **NC Travel & Tourism Board**
Printing, 4-color on Lustro Offset Enamel Gloss
 White (cover), Simpson Gainsborough Felt Spice
 Ivory (text)

1

Lasertechnics Annual Report 1992

back
to
basics

[a dramatic new direction]

Lasertechnics designs, manufactures and markets laser coding systems and digital image printers for use in industry. Our goal is to maximize shareholder value by leveraging technological know-how into commercial solutions, and by continually broadening the markets for our products around the world.

Letter from The Office of the Chairman

Dear Shareholders,

Lasertechnics took a firm new direction in 1992. The Board of Directors appointed Eugene A. Bourque as President and created a special management committee to oversee operations. It is comprised of Bourque, Chairman of the Board and CEO Richard M. Clarke, and Vice Chairman Harrison H. Schmitt. These changes were made after the resignation of Louis F. Bieck, Jr., former president and chief executive officer.

Our new management committee quickly refocused the efforts of all Lasertechnics employees on what the company does best. We went back to basics. We terminated our lease obligations on our old California facility, and sold or discontinued products that had reached the end of their productive life cycles. For example, our Fizeau wavelength meter, which we had sold for more than nine years, was not selling against better products with lower prices, and so we discontinued it. We also sold both the technology and service interest in our beam directed lasers to Hai Tech Electro-Optics, Inc., a California company. Furthermore, we discontinued the refurbishing business for the Blazer™ 5000, and concentrated

2

1
Design Firm, **Vaughn Wedeen Creative**
Art Director, **Steve Wedeen**
Designer, **Steve Wedeen**
Copywriter, **Nathan James**
Client, **Lasertechnics, Inc.**
Printing, French Durotone (packing carton), French Speckletone Kraft (cover), Simpson LaMonte Basketweave Gray Safety Paper

2
Design Firm, **Olson Johnson Design Co.**
Designer, **Haley Johnson**
Photographer, **George Peer**
Client, **Jane Jenni/Representative**
Printing, 1-color on French Durotone Blueridge Board

1
Design Firm, **Wood-Brod Design**
Art Director, **Stan Brod**
Designer, **Stan Brod**
Photographer, **Steve Murray**
Copywriter, **Mrs. Steve Murray**
Client, **The Hennegan Company**
Printing, 4-color foil stamping in gold embossing,
 Chipboard Speckletone cover, white water rib
 laid text, lustro gloss text

1
Design Firm, **Earl Gee Design**
Art Director, **Earl Gee/Fani Chung**
Designer, **Earl Gee/Fani Chung**
Illustrator, **Earl Gee**
Copywriter, **Laura Stener**
Client, **Community Partnership of Santa Clara
 County**
Printing, 2 PMS, Speckletone Cream 80 lb.
 (cover), and 70lb. (text)

1
Design Firm, **Metalli Lindberg Advertising**
Art Director, **Stefano Dal Tin/Lionello Borean**
Designer, **Stefano Dal Tin/Lionello Borean**
Client, **Dance City**
Printing, 2-color on Fedrigoni Paper

2
Design Firm, **Arra Antonio Romano & Associates**
Art Director, **Claudia Neri**
Designer, **Claudia Neri**
Illustrator, **Vesselius (1500)**
Client, **Bracco/CDA (Clinical Data Analysis)**
Printing, 2-color on Laminated Stock Matte
 Coated

A "classic" look is achieved with the use of 16th-century art engraving.

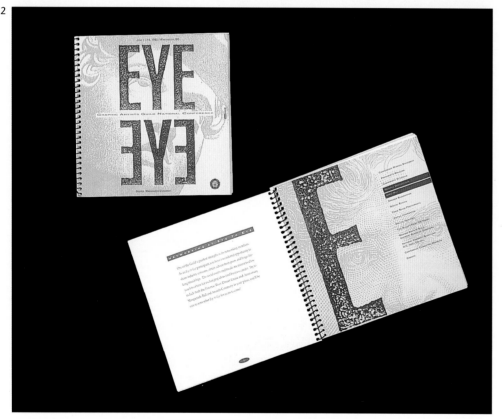

1
Design Firm, **Held & Diedrich**
Art Director, **Doug Diedrich**
Designer, **Doug Diedrich**
Illustrator, **Doug Diedrich**
Photographer, **Mike Roccaforte**
Copywriter, **Linda Lazier**
Client, **Irishmans Run Farm Inc.**

2
Design Firm, **Held & Diedrich**
Art Director, **Dick Held**
Designer, **Dick Held**
Copywriter, **Graphic Artists Guild National**
Client, **Graphics Artists Guild**

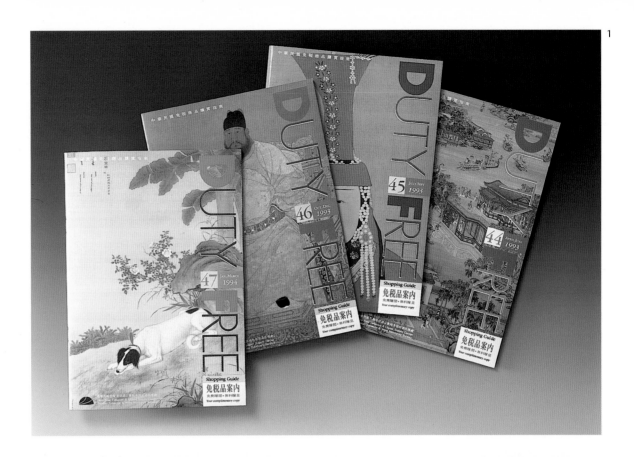

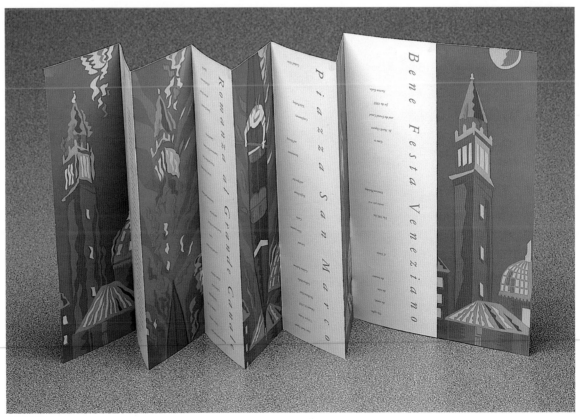

1
Design Firm, **Artailor Design House**
Art Director, **Raymond Lam**
Designer, **Raymond Lam**
Client, **International Travel Press**
Printing, 4-color and 4-color Coated Artpaper

2
Design Firm, **Joseph Rattan Design**
Art Director, **Joe Rattan**
Designer, **Joe Rattan**
Illustrator, **Joe Rattan**
Copywriter, **Joe Rattan**
Client, **500 Inc.**
Printing, 4-color, 2 PMS, Pagentry Porcelan
 by Champion

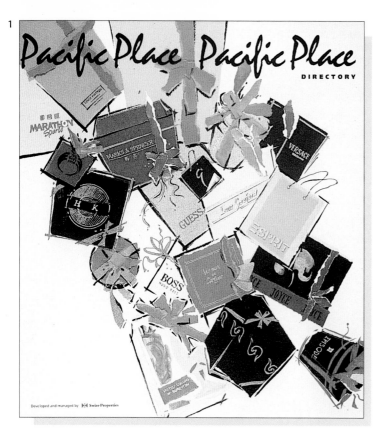

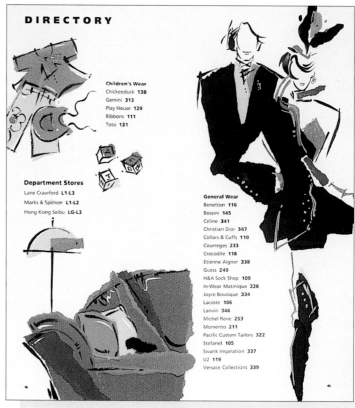

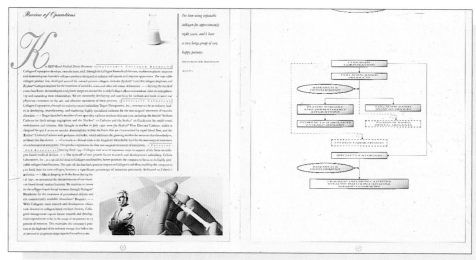

1
Design Firm, **Couldrey Jones Advertising**
Art Director, **Camellia Cho**
Designer, **Camellia Cho**
Illustrator, **Annie Lee**
Client, **Pacific Place**

2
Design Firm, **Earl Gee Design**
Art Director, **Earl Gee**
Designer, **Earl Gee/Fani Chung**
Illustrator, **Earl Gee/Fani Chung**
Photographer, **Geoffrey Nelson**
Copywriter, **Edelman Public Relations Worldwide**
Client, **Collagen Corporation**
Printing, 4-color, 1 PMS, spot gloss varnish,
 Speckletone Oatmeal 80 lb. (cover), Potlatch
 Quintessence Gloss 100 lb. (text).

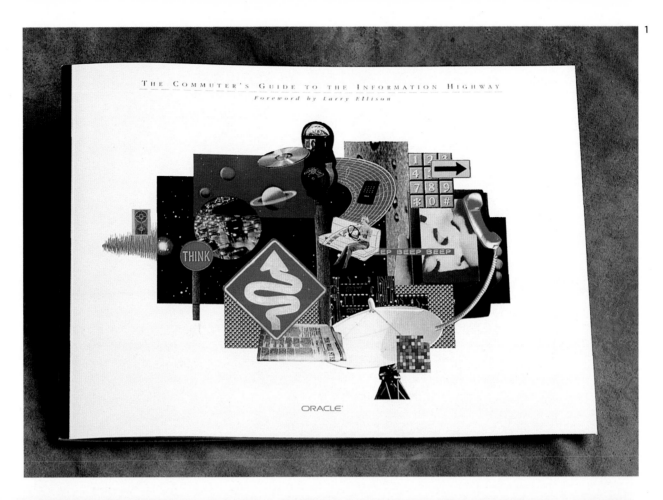

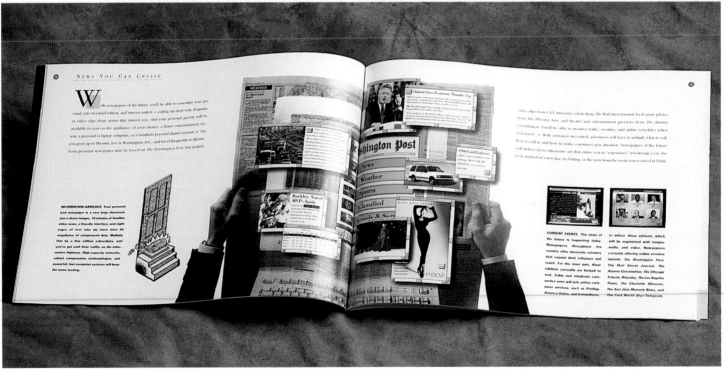

1
Design Firm, **Earl Gee Deisgn**
Art Director, **Robert Kastigar/Earl Gee**
Designer, **Earl Gee/Fani Chung**
Illustrator, **Jamie Hogan/Philippe Weisbecker/**
 David Wilcox/Darrel Kolosta, Steve Campbell
Photographer, **Henrik Kam/Geoffrey Nelson**
Copywriter, **Julie Gibbs/Dick Brass/Shirley Kraus**
Client, **Oracle Corporation**

Printing, 4-color, 1 PMS and Aqueous coating,
 Warren Lustro Gloss 80 lb. (cover), and
 100 lb. (text)

1

1
Design Firm, **Rickabaugh Graphics**
Art Director, **Mark Krumer/Eric Rickabaugh**
Designer, **Eric Rickabaugh**
Illustrator, **Michael Linley**
Client, **Huntington**
Printing, 4-color

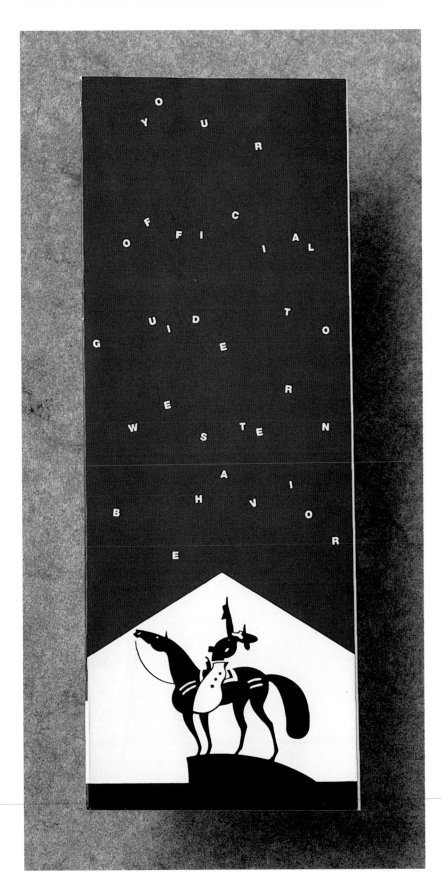

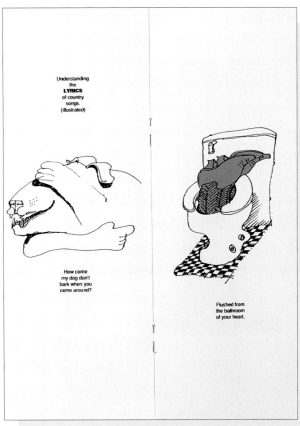

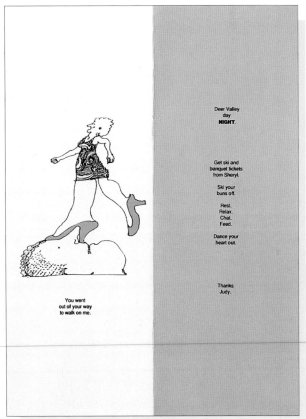

1
Design Firm, **The Weller Institute for the
Cure of Design**
Art Director, **Don Weller**
Designer, **Don Weller**
Illustrator, **Don Weller**
Client, **The Design Conference That Just
Happens To Be In Park City, UT 1994**
Printing, 2-color, Lustro Dull Cover

1
Design Firm, **SullivanPerkins**
Art Director, **Ron Sullivan**
Designer, **Jon Flamming**
Illustrator, **Jon Flamming**
Copywriter, **Mark Perkins/Hilary Kennard**
Client, **GTE Directories Corporation**
Printing, 6-color on Quintessence

2
Design Firm, **Hornall Anderson Design Works**
Art Director, **Jack Anderson**
Designer, **Jack Anderson/Cliff Chung/David Bates**
Illustrator, **Scott McDougall**
Copywriter, **Microsoft Corporation**
Client, **Microsoft Corporation**
Printing, 4-color on Moonrock Environment Text

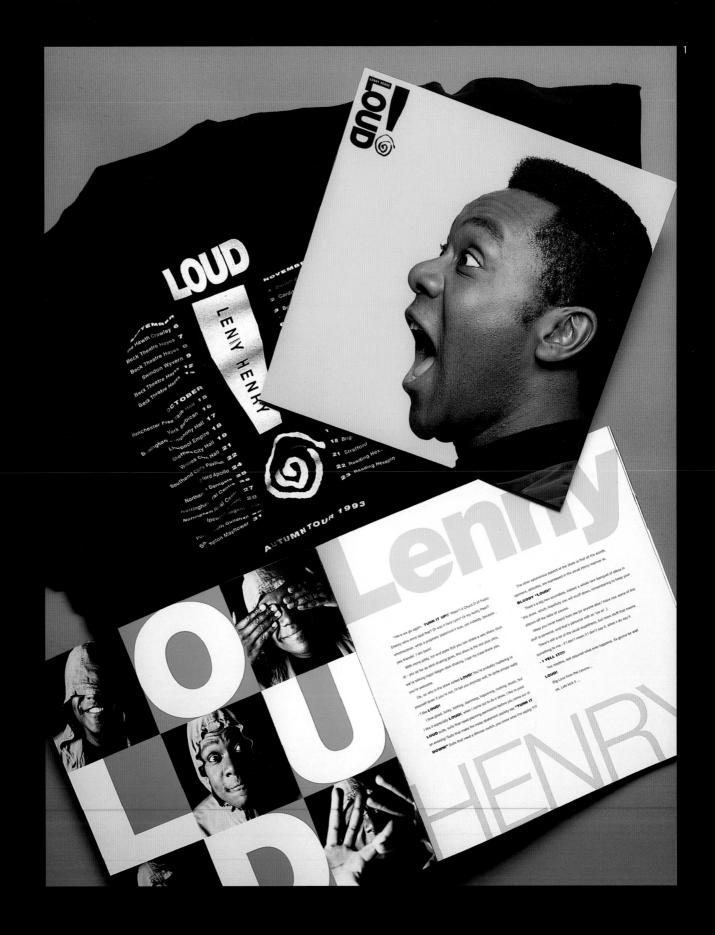

1
Design Firm, **The Green House**
Art Director, **Judi Green**
Designer, **Judi Green/James Bell**
Photographer, **Trevor Leighton**
Client, **Lenny Henry**
Printing, 4-color on Consort Royal

1

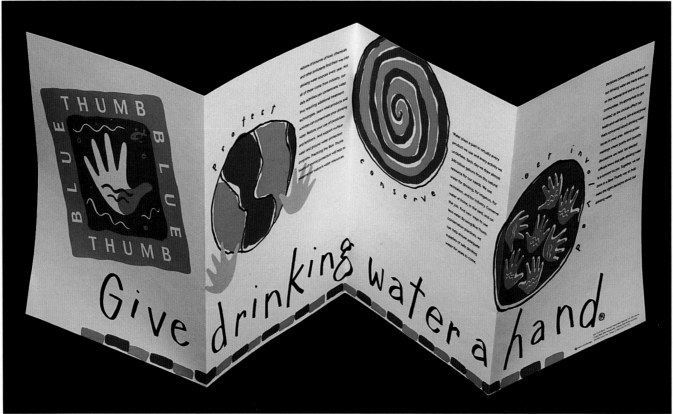

1
Design Firm, **Lee Reedy Design Associates, Inc.**
Art Director, **Lee Reedy**
Designer, **Lee Reedy/Heather Bartlett**
Illustrator, **Lee Reedy/Heather Bartlett**
Client, **American Water Works Association**
Printing, 3-color, some pieces in 2-color

1
Design Firm, **Sayles Graphic Design**
Art Director, **John Sayles**
Designer, **John Sayles**
Illustrator, **John Sayles**
Copywriter, **Mary Bell**
Client, **Insurance Conference Planners**
 Association
Printing, 3-color on James River Tuscon Terra
brock/brown cover; Chipboard

1

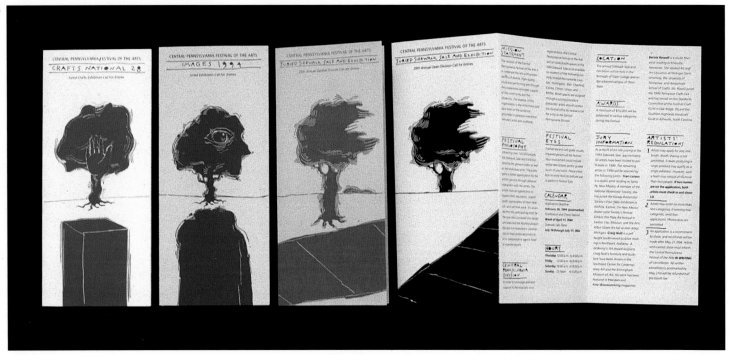

2

3

1
Design Firm, **Wolfram Research Publications
 Dept.**
Art Director, **John Bonadies**
Designer, **John Bonadies**
Copywriter, **Joe Grohens**
Client, **Wolfram Research, Inc.**
Printing, 6-color on Paralux

All graphics images created with Mathematica.

2
Design Firm, **Wolfram Research Publications
 Dept.**
Art Director, **John Bonadies**
Designer, **Jody Jasinski**
Copywriter, **Joe Grohen/ Caron Allen**
Client, **Wolfram Research, Inc.**
Printing, 5-color on Warren Recovery Gloss

*All graphics images created with Mathematica.
Japanese text created with Kanji PageMaker.*

3
Design Firm, **Sommese Design**
Art Director, **Lanny Sommese**
Designer, **Brian Hatcher**
Illustrator, **Lanny Sommese**
Copywriter, **Katherine Talcott**
Client, **Central Pennsylvania Festival of the Arts**
Printing, 1-color on Cross-Pointe Genesis
 (Recycled)

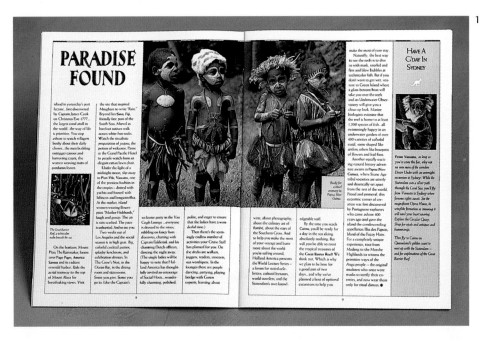

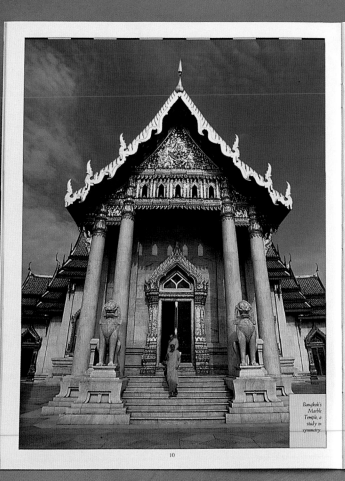

Design Firm, **Hornall Anderson Design Works**
Art Director, **John Hornall**
Designer, **John Hornall/Julie Tanagi-Lock/
 Mary Hermes/Cynthia Pearce**
Copywriter, **Joan Brown**
Client, **Holland America Line Westours, Inc.**
Printing, 4-color process and 1 varnish, Sterling
 100 lb. (cover), 70 lb. White (text)

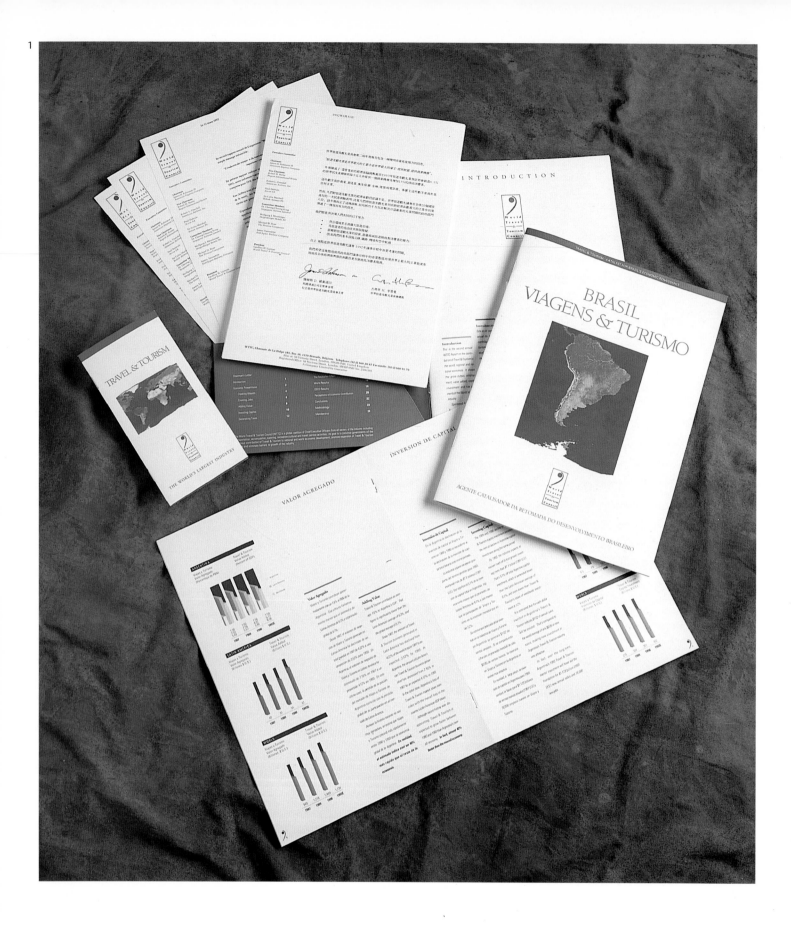

1
Design Firm, **Metroplis Corp.**
Art Director, **Denise Davis Mendelsohn**
Designer, **Denise Davis Mendelsohn**
Copywriter, **World Travel & Tourism**
Client, **World Travel & Tourism**
Printing, 5-color on Monadnock Caresse

While a challenge to avoid the "crowding" aspect of working with five languages, this brochure was successfully created for presidents and travel ministers of countries around the world.

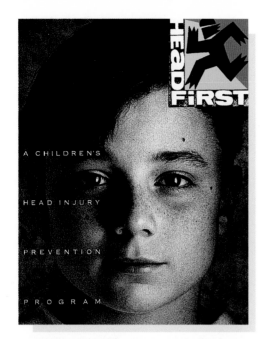

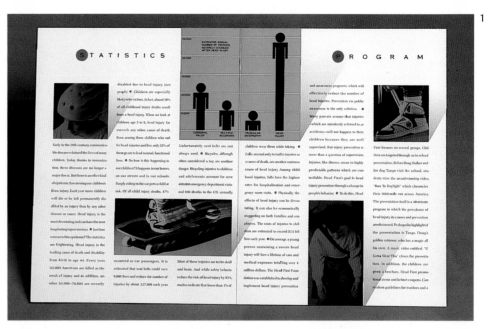

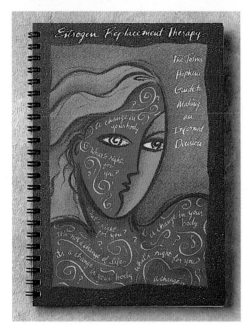

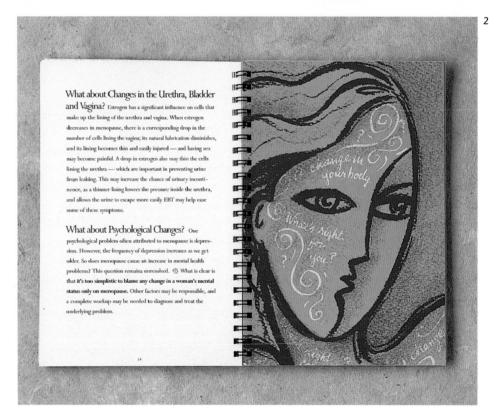

1
Design Firm, **Bartels & Company, Inc.**
Art Director, **Brian Barclay**
Designer, **Brian Barclay**
Illustrator, **Brian Barclay**
Photographer, **George Rodriguez**
Copywriter, **Donn Carstens/Scott Michelson**
Client, **EDS/GDS**

2
Design Firm, **Grafik Communications, Ltd.**
Design Team, **Melanie Bass/Judy F. Kirpich/**
 Claire Wolfman
Illustrator, **Melanie Bass**
Client, **Johns Hopkins Medical Institutions**
Printing, Esse 70 lb., 3-color (cover), 2-color (text)

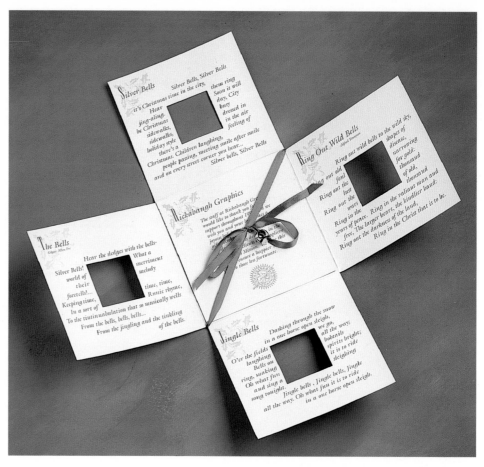

1
Design Firm, **Rickabaugh Graphics**
Art Director, **Eric Rickabaugh**
Designer, **Tina Zientarski**
Client, **Rickabaugh Graphics**
Printing, 2-color on Strathmore Grandee,
Holiday Card

2
Design Firm, **Modern Dog**
Art Director, **Jeri Heiden**
Designer, **Robynne Raye/Michael Strassburger**
Illustrator, **Robynne Raye**
Copywriter, **Madonna/J. Mascis/k.d. lang/Lou
Reed/Adam Sandler/Sammy Hagar & others**
Client, **Warner Brothers Records**
Printing, 3-color & black on Starwhite Vicksburg

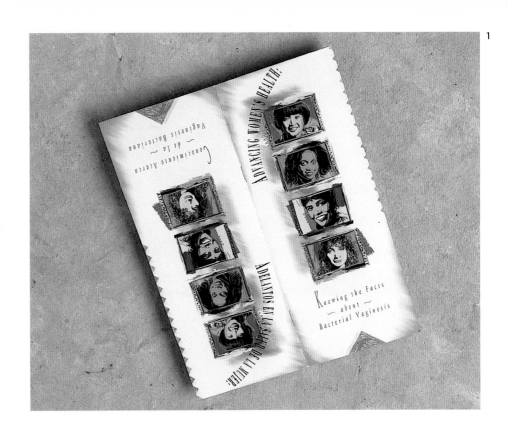

¿EXISTE UN TRATAMIENTO EFICAZ?

Sí. Los antibióticos que se prescriben ofrecen un tratamiento eficaz para la vaginosis bacteriana.

¿CUÁNTO DURA EL TRATAMIENTO?

La duración del tratamiento depende del antibiótico que le está recetado. Su profesional de la salud y el farmacéutico le explicarán cuánto durará su tratamiento.

¿SE ENCUENTRAN REACCIONES SECUNDARIAS ASOCIADAS CON EL TRATAMIENTO?

Sí. Pueden haber reacciones secundarias. Si usted experimenta cualquier efecto secundario durante el tratamiento, infórmelo a su profesional de la salud.

¿LOS PRODUCTOS DE VENTA LIBRE SIRVEN PARA TRATAR LA VAGINOSIS BACTERIANA?

No. Los productos de venta libre, tales como duchas o medicamentos contra las levaduras, no tratan la vaginosis bacteriana. Una mujer preocupada acerca de la vaginosis bacteriana u otra infección vaginal no deberá diagnosticarse a sí misma. En su lugar, deberá consultar a su profesional de la salud con el fin de confirmar una infección o mitigar especulaciones.

¿LA VAGINOSIS BACTERIANA ES UNA INFECCIÓN RECIENTEMENTE DESCUBIERTA?

No. En realidad, los científicos primero empezaron a estudiar los microorganismos de la vagina a fines del siglo XIX. Sin embargo, el nombre de la infección ha cambiado a través de los años a medida que se obtuvo un mejor

HOW LONG DOES TREATMENT LAST?

Length of treatment depends on which antibiotic is prescribed for you. Your doctor and pharmacist will explain how long your treatment will last.

ARE THERE SIDE EFFECTS ASSOCIATED WITH TREATMENT?

Yes. Side effects may occur. If you experience any side effects during treatment, inform your doctor.

DO OVER-THE-COUNTER PRODUCTS WORK FOR TREATING BACTERIAL VAGINOSIS?

No. Over-the-counter products such as douche or yeast medicine cannot treat bacterial vaginosis. A woman concerned about bacterial vaginosis or another vaginal infection should not self-diagnose. Instead, she should see her health-care provider to confirm an infection or alleviate speculation.

IS BACTERIAL VAGINOSIS A NEWLY DISCOVERED INFECTION?

No. In fact, scientists first began studying microorganisms of the vagina in the late 1800s. However, the name of the infection has changed over the years as a better understanding of its microbiology has evolved. Bacterial vaginosis has been previously known by other names, including Haemophilis vaginitis, Gardnerella vaginitis, nonspecific vaginitis, Corynebacterium vaginitis and anaerobic vaginosis. Most of these names refer to the bacteria thought to cause the infection.

1
Design Firm, **John Kneapler Design**
Art Director, **John Kneapler**
Designer, **John Kneapler**
Illustrator, **Mark Chicanelli**
Copywriter, **Jeanne Longo**
Client, **Manning Selvage & Lee/UpJohn**
Printing, 4-color LOE coated

Agnew Moyer Smith Inc.
503 Martindale Street
Pittsburgh, PA 15212

AR&A
Antonio Romano & Associates
V. Le Gorizia, 52
00198 Rome Italy

Art & Joy
Kielmansegg-Gasse 18
A-2340 Mödling

Artailor Design House
4th Floor 414 Section 4
Shin Yi Road
Taipei Taiwan R.O.C.

Bartels & Company
3284 Ivanhoe Avenue
St. Louis, MO 63139

Beauchamp Design
9848 Mercy Road No. 8
San Diego, CA 92129

Bernhardt Fudyma Design Group
133 East 36th Street
New York, NY 10016

Camellia Cho Design
13B Yolford Building, 52-58
Tanner Road, North Point
Hong Kong

Carmichael Lynch
800 Hennepin Avenue
Minndapolis, MN 55403

Carol Lasky Studio
30 The Fenway
Suite C
Boston, MA 02215

Clifford Selbert Design
2067 Massachusetts Avenue
Cambridge, MA 02140

Cooke, Kimberly
631 E. Jefferson
Iowa City, IA 52245

Corey McPherson Nash
9 Galen Street
Watertown, MA 02171

D & A Diego Bally AG
Weinbergstr. 95, 8006 Zürich
Switzerland

David Slaven Design
400 S. Beverly Drive
Suite 305
Beverly Hills, CA 90212

Debra Nichols Design
468 Jackson Street
San Francisco, CA 94111

Design Board Behaeghel &
 Partners
50, Avenue Georges Lecointe
1180 Brussels-Belgium

Design Bridge Limited
18 Clerkenwell Close
London EC1R 0AA

Design Seven
47 Perimeter Center East, N.E.
Suite 460
Atlanta, GA 30346

Earl Gee Design
501 Second Street
Suite 700
San Francisco, CA 94107

Elton Ward Design
4 Grand Avenue
Parramatta, NSW
2150 Australia

Frank Miller Photo Illustration
6016 Blue Circle Drive
Minnetonica, MN 55343

Gabinete De Arte
Serrauo 41, 60 P 28001
Madrid Spain

George Tscherny, Inc.
238 East 72 Street
New York, NY 10021

Giorgio Rocco Communications
Via Domenichino 27
20149 Milano Italy

Grafik Communications, Ltd.
1199 N. Fairfax Street
Alexandria, VA 22314

GrandPré & Whaley Ltd.
475 Cleveland Avenue N.
Suite 222
St. Paul, MN 55104

The Green House
64 High Street
Harrow On The Hill
Middlesex HA1 3LL UK

Hannum Graphics
3100 W. 2nd Avenue
Durango, CO 81301

Hartmann & Mehler Designers
Corneliusstrasse 8
60325 Frankfurt, Germany

Held & Diedrich
703 E. 30th Street
Indianapolis, IN 46205

High Techsplanations, Inc.
6001 Montrose Road
Suite 902
Rockville, MD 20852

Hornall Anderson Design Works
1008 Western, Suite 600
Seattle, WA 98104

Hunt Weber Clark Design
51 Federal Street
Suite 205
San Francisco, CA 94107

Jill Tanenbaum Graphic
 Design, Inc.
4701 Sangamore Road
Bethesda, MD 20816

JOED Design Inc.
559 Spring Road
Elmhurst, IL 60126

John Kneapler Design
48 West 21st Street
12th Floor
New York, NY 10010

Joseph Rattan Design
4445 Travis Street No. 104
Dallas, TX 75205

Julia Tam Design
2216 Via La Brea
Palos Verdes, CA 90274

Keja Donia Design
Koninginneweg 20, 1075 CX
Amsterdam
The Netherlands

Lee Reedy Design Associates, Inc.
1542 Williams Street
Denver, CO 80218

Leslie Chan Design Co., Ltd.
4F, No. 115 Nanking E. Road,
Section 4
Taipei, Taiwan R.O.C.

Lynn St. Pierre Graphic Design
3460 Country Village Lane
Trenton, NJ 48183

Marc English: Design
37 Wellington Avenue
Lexington, MA 02073

Margo Chase Design
2255 Bancroft Avenue
Los Angeles, CA 90039

Marke Communications, Inc.
105 Madison Avenue
New York, NY 10016

McGuire Associates
1234 Sherman Avenue
Evanston, IL 60202

Mervil Paylor Design
1917 Lennox Avenue
Charlotte, NC 28203

Metalli Lindverg Advertising
Via Garibaldi 5/D
31015 Conegliano (Treviso)

Metropolis Corporation
56 Broad Street
Milford, CT 06460

Michael Davighi Associates Ltd.
Elton House Powell Street
Hockley Birmingham
B1 3DH England

Mike Quon Design Office
568 Broadway #703
New York, NY 10012

Mike Salisbury Communications
2200 Amapola Court
Torrance, CA 90501

Modern Dog
601 Valley Street No. 309
Seattle, WA 98109

Muller + Company
4739 Belleview
Kansas City, MO 64112

Nesnadny + Schwartz
10803 Magnolia Drive
Cleveland, OH 44106

O & J Design, Inc.
9 West 29th Street
New York, NY 10001

Olson Johnson Design Co.
3107 E. 42nd Street
Minneapolis, MN 55406

Paul Davis Studio
14 E. 4th Street
Suite 504
New York, NY 10012

PGM, Inc.
640 North LaSalle Street
Suite 555
Chicago, IL 60610

Playboy
730 5th Avenue
New York, NY 10019

Plaza Design & Artwork
Mendip End, Chewton, N. Bath
Somerset, England BA3 4PD

Raymond Bennett
 Design Pty. Ltd.
Level 2, 349 Pacific Highway
Crows Nest NSW Australia 2065

RBMM/The Richards Group
7007 Twin Hills
Suite 200
Dallas, TX 75231

Rickabaugh Graphics
384 W. Johnstown Road
Gahanna, OH 43230

Riley Design Associates
214 Main Street Suite A
San Mateo, CA 94401

Sara Day Graphic Design
29 Middlebury Lane
Beverly, MA 01915

Sayles Graphic Design
308 Eighth Street
Des Moines, IA 50309

Sommese Design
481 Glenn Road
State College, PA 16803

Stawicki Werbeagentur
Lindwurmstr.88
80337 Munchen Germany

Stoltze Design
49 Melcher Street
4th Floor
Boston, MA 02210

Studio MD
1512 Alaskan Way
Seattle, WA 98101

Sullivan Perkins
2811 McKinney Avenue
Suite 320, LB111
Dallas, TX 75204

Tilka Design
1422 West Lake Street
Suite 314
Minneapolis, MN 55408

Towers Perin
200 West Madison
Suite 3300
Chicago, IL 60606

Tyler Smith
127 Dorrance Street
Providence, RI 02903

Vanderbyl Design
539 Bryant Street
San Francisco, CA 94107

The Van Noy Group
19750 S. Vermont Avenue
Torrance, CA 90502

Vaughn Wedeen Creative
407 Rio Grande NW
Albuquerque, NM 37104

Vrontikis Design Office
2707 Westwood Boulevard
Los Angeles, CA 90064

The Weller Institute for the
 Cure of Design
P.O. Box 726
3091 W. Fawn Drive
Park City, UT 84860

Whitney Edwards Design
3 N. Harrison Street
Easton, MD 21601

Winter Graphics
1310 Tradewinds Circle
West Sacramento, CA 95691

Wolfram Research, Inc.
100 Trade Center Drive
Champaign, IL 61820

Wood-Brod Design
2401 Ingleside Avenue
Cincinnati, OH 45206

The Wyant Group, Inc.
96 East Avenue
Norwalk, CT 06857

Yellow M
The Arch., Hawthorn House
Forth Banks,
Newcastle Upon-Tyne England